T0146628

Ekpe Efik

A Theosophical Perspective

B.E. Bassey

1998

 www.trafford.com
North America & international
toll-free: 1 888 232 4444 (USA & Canada)
fax: 812 355 4082

Contents

Figure & Table Reference

This book is dedicated to all seekers of truth.

Preface

EKPE Fraternity is a socio-political institution which evolved in the coastal rain forest communities of Central Africa, whose practice and influence stretched from south-eastern Nigeria to the Congo basin. Perhaps, the best known variant of this institution is that of the Efik who inhabit patches of territory on both sides of the Cross River Estuary. This is so because of centuries of precolonial contacts with the people of the region, European explorers, traders, missionaries, advent users and colonialists. Calabar, arguably, the capital of Efik land was the centre of such interactions. And as the main institutional organizer and manager of Efik society in the conduct of its local affairs and the regulation of external contacts, EKPE became a subject of intensive investigation, speculation and study. Unfortunately, the outcome of such enquiries often reflected frustration with the Fraternity's code of secrecy, the self-righteous moral superiority of the enquirer, and tended to dwell unduly on the readily observable but nauseating practices of the institution. Against this backdrop, EKPE was set up for root and branch condemnation, and possibly, destruction.

Furthermore, the passion which attended such condemnation and the zeal with which new Christian converts sought to distance themselves from the African cultural past, undermined any genuine effort to set aside prejudice and to appreciate what may be positive in this time-tested institution and to judge it fairly in its cultural context. However, as the twentieth century draws to an end and the euphoria of Christian conquest makes way for a new spirit of compromise between the foreign and the native, the modern and the old, the time is apparently right to revisit EKPE. This time the objective is to rend the veil a little to show

how Ekpe wisdom helped Efik society to make sense of its immediate environment and to find its proper place in the scheme of God's creation.

This study, therefore, seeks to bring into the open aspects of EKPE teachings that had hitherto been buried in the sands of time as a result of past wrong living by initiates and society. Besides, it exhorts all well-meaning people, particularly those with claims to truth to rise to the assistance of a culture that humanity should be proud of and to plead against its destruction by the very people whom God in His wisdom had elected to be its honoured custodians. Finally, it attempts to direct minds to the need for the custodians of Christ thought to inculturate within EKPE in order to bring to life the Christ teachings buried within EKPE doctrine over the centuries, and to assist initiates within to grow spiritually along the Christ path.

The task which this study seeks to undertake poses certain problems. Firstly, it sets out to cross the firm line between what is secret and what is not in EKPE. The hold of secrecy is such that even the mentally unbalanced is not known to have divulged its secrets. The consequence is that much of the wisdom teachings of EKPE have been lost to humanity. It is, however, plausible to state that as regards the esoteric teachings, great effort is employed to make certain that only arcane wisdom that had already been released to humanity through other sources are discussed. Such revelations will banish ignorance and its consequences from the ranks of initiates and demonstrate to the whole society that imported teachings do not necessarily possess superior merit.

Secondly, there is a problem of methodology. Although many books have been written on Old Calabar, the Efik and EKPE, where such books address the issues of the Fraternity, they have stopped short of addressing the inner teachings. This explains why much of what this study covers have come from first-hand knowledge and experiences of the author. Rather, a more strenuous effort was made to use literature that would highlight the value of EKPE teachings relative to similar but known teachings in other parts of the world and other religions.

This study is presented in ten chapters and an eleventh which serves as the conclusion. Chapters One and Two are essentially introductory. They attempt to explain the concept of christed culture, taking the quali-

ties of Christhood as the foundation of God-centred culture. This is to show the pure spirit which initially characterized EKPE, the drift from which caused the Fraternity to take the objectionable turn away from light into darkness.

Chapter Three attempts a brief account of how the Efik may have acquired their Ekpe. It further attempts to explain how this particular variant came to hold away in the Cross River basin where the Efik are often said to have instituted an empire of informal sway. But although this account acknowledges the controversy surrounding the origin of EKPE, it seeks to present the Efik perspective. Chapters Four, Five and Six represent excursions into the veiled symbolisms and reserved teachings of EKPE. They tackle the issues of EKPE socio-political activities, initiation and the philosophical underpinnings of some EKPE teachings. In doing so, the study comes menacingly close to courting the censure of the initiates. Chapter Seven is devoted to the mechanics of EKPE temple works and the choreography of its public presentations. Against the background of the foregoing, Chapter Eight looks at the value of Ekpe as a religion. Placed against other well known faiths, it becomes obvious that Ekpe fits into a universal mould and that its teachings were either distorted, misunderstood or misrepresented.

Beginning with Chapter Nine, this work begins to explore the way forward for the institution. It starts in Chapter Nine by reflecting on the discomforting practices of the past. In Chapter Ten the personal experiences of the author comes in to serve out lessons on the way the institution should not follow. And, finally, Chapter Eleven argues that although the past of Ekpe was not flattering, a foundation could be laid in the path of Christhood in the present to ensure a sustainable future. That future, it concludes, should be defined by a compromise between what is good in Ekpe of the past and what modern religious teachings borrowed from abroad conceive as the ideal.

The magnitude of this work has understandably left me in debts of gratitude to such a large number of people than I can possible list out here. It is therefore not for lack of appreciation that I have limited mention to those whose names appear below.

My primary gratitude goes to the Almighty God without whom this work would not have been possible. He has been with me at every turn

and facilitated my ability to dig up the past. I am also grateful to Monsignor J.P. Ekarika of University of Calabar on whom it fell to provide the final push to translate my seven years urge to write into reality. I wish to thank Dr. Effiong Edunam also of the University of Calabar, Chief Ekpe E. Oku and Efiong E. Ita of New Jersey, U.S.A. and others for their invaluable contributions. Furthermore, I am grateful to Victor E. Bassey for most of the illustrations, Miss Ini A. Udo, Miss Grace Uzong and Miss Agnes Archibong, whose patience and professionalism converted what was a very poor hand-written draft into legible types.

Finally, my most affectionate expression of gratitude goes to my dear wife, Dr. Elizabeth Henshaw Bassey, who has been most supportive from the time the idea came to me as a flash of inspiration. Aside of her words of encouragement and prayers, she invested financially on books that proved to be invaluable. Nevertheless, the entire credit for this work is mine and so are whatever faults that may still be evident.

<div align="right">

B.E.B.

Calabar, 1998.

</div>

Chapter One

Introduction: Culture and Christhood

Without prejudice to formal academic definitions, for the purpose of this discussion, we may see culture as a habit, a practice which when fused with religion and seasoned in a balm of love (Christ) in time becomes christed tradition. Man has to understand and appreciate culture. A good deal of space in the Old Testament of the Holy Bible and some books of wisdom of other faiths deal with culture. These prove that culture is important. The appearance of Christ in the scene did not in any way underplay the importance of culture and tradition, provided they were christed. The Christ said he did not come to abolish the law and the prophets but to fulfill the scriptures. This is part of the universal truth. It is not only among the Jews that the statement of Jesus relates. The cultural instructions to Abraham on circumcision of the flesh became the circumcision of the heart, a shift in consciousness but the same valid law. Following this, those who claim to be above culture and tradition need to re-examine their position truly and honestly. Or is language not part of culture? The journey of life should be from the old way to the new: from darkness to light; from human tradition to God's tradition, provided there is continuity of purpose. Contrary to popular belief, culture is not an expression of the masses but that of the mentally polarized people of the intelligentsia or those who constitute the link between the world of soul life and the outer world of tangible phenomena.[1] The soul is intrinsically good.

Consequently, Christianity, having been rejected by the majority of Pharisees and Sadducees, has several cultural roots. Despite this handi-

cap, the Church had succeeded until recently in convincing people of different cultures to surrender their cultural heritage by adopting very often without questions, the religious practices moulded from unrelated cultural practices of many lands. E. Bolaji Idowu puts it thus:

> *A not unfair assessment will see in the structure of Christian cultus something of the paraphernalia of the ancient Roman Pontifex Maximus, of the ancient cult of the Mother Goddess, and of the oriental mysteries of Mithra, the Christian Church began with no intention of involving its original Koinonia in any aspects of the Cultus of its surrounding religions. The early church adopted the rite of baptism which had taken various forms from the taurobolium of Mithraism to immersion by John the Baptist in the River Jordan: so also has the sacrament of the Holy Communion its ancient predecessors. Thus the church soon found itself caught in the web of the ancient practices with which it was surrounded at its birth with the result that a 'movement' not originally intended to be priestly in the traditional sense came to acquire priesthood: it began to speak of sacrifice, and brought itself under the suspicion of seeking salvation by magic.*[2]

To substantiate his point he quoted Bernard Shaw:

> *Anyone who has been in a mosque can testify that though there is normally no priest there, the Imams who lead the prayers and conduct the ceremonies fulfil, in the imagination of the worshippers of Allah, the place of the clergy and priests in the Christian churches, and that a Moorish Marabout has all the powers and all the sanctity of a medieval Christian bishop. True, there are not graven images or likeness of any thing that is in heaven above or in the earth beneath or in the water under the earth: but the elaborate decoration, the symbols and texts, the majestic architecture that is made homelike for Allah by the carpeted floor, are capable of influencing the minds of the spectators quite powerfully as the imagery in Christian Cathedrals. The mass of mankind must have something to worship that the senses can comprehend.*[3]

Misunderstood cultural practices taken by the profane as differences are believed to be partly responsible for the multifarious denominations

of the Christian faith worldwide. Like culture, true religion has no sect. Or is Christ divided?

The 1974 edition of Webster's New Collegiate Dictionary defines culture as "Cultivation of living material in prepared Nutrient media." In our case it was said that creation must by law proceed through the Christ (love) vehicle, the nutrient media for perfect products. Again the home of the manifested and unmanifested creations of God is the nutrient media of space in which the created attempts to remain alive in perfect harmony and balance according to law. The created whole is constituted atoms which are units of energy fracturable into yet smaller units of energy that are alive and conscious. All creations are the living materials. Arising from this is the conclusion that culture permeates all things and is therefore part and parcel of life and existence.

There is an upsurge in cultural awareness worldwide. The United Nations has acknowledged culture as an important world treasure, and this should be applauded. Unfortunately, the time reserved for bringing its import to bear on the psyche of nations is spent by most on frivolous activities that barely scratch the skin of nations. The upsurge in cultural awareness in Nigeria has coincided with the rise of new churches and other organisations with claims on Truth. More and more people are realising that their souls are at peace in a situation of balance of culture and religion. That is, when both are one in perfect and permanent marriage. This is, perhaps, the reason why christed music with local roots find natural accommodation during worship in churches. The environment into which a man is rooted is under normal circumstances the best for his personality and individuality. He is likely to respond to those energies that aspects of him by virtue of experience and implanted consciousness recognise. For success to be recorded, the people must search and discover the christed culture in their midst. The christed culture is a gift of God to society for the spiritual upliftment of the group. It transcends national borders leaving similar imprints in the sands of time.

Christhood is an attainable level of consciousness available for those who truly seek with their hearts, and soul. It does not depend on mounting the roof top to profess a religion; it is a matter of living, not much of talking. Since it is a matter of the heart, not of name-calling and does not rest on the opinion of the neighbour, Christ appears in the cavity of the

heart when God adjudges the man ready.

Working amongst the so-called primitive peoples of Africa, do-gooders, purveyors of materialism, colonialists motivated by national interests, and religious pundits, some with questionable bearing, compelled those they met to adopt modes of worship and beliefs that did not necessarily guarantee the path to higher consciousness and Christhood. In their view, all the practices of the people were evil and had to be abandoned. Little wonder as soon as the presence of the aliens and their agents were removed, most of what they brought went with them. God, it would seem, had been pictured as the Father of the privileged and the Israelites. For some time the people were confused. They recognised the quantum of the bad in the old. Soon the self resumed its normal roles influenced by man's continued presence in an environment close to original nature. He takes the side of christed tradition, howbeit, battered beyond recognition during centuries of impure thoughts and actions. For the benefit of the Jones', he frequents the local temple, church and others in a demonstrative manner, but slips into his culture to maintain his link with the past. This is why for most, religion is more of talking and less of living.

Arising from this is the emergence of churches and groups of questionable bearing that have reduced worship of the one God to consultative assemblies for disseminating stories of woes and fortunes. They perform rites based on claimed prophesies to a wide range of clientele. These operators see the church and other groups as providing the needed cover of respectability enabling them to carry on their nefarious practices openly. These acculturation and inculturation are pretentious. They are in reverse in that evil is attempting to wear a cloak of goodness by borrowing the culture of recognised faiths as cover for his pretensions.

For the benefit of those who see nothing good in their religion and culture, the remarks of R.S. Rattray about the religion and art of the Ashanti as given by E. Bolaji Idowu are relevant:

> *I sometimes like to think, had these people been left to work out their own salvation, perhaps some day an African Messiah would have arisen and swept their Pantheons clean of the fetish... West Africa might then have become the cradle of a new creed which acknowledged one Great Spirit, who, being one, nevertheless manifested Himself in everything around Him and taught men*

*to hear His voice in the flow of His waters and in the sound of
His winds in the trees.*[4]

The foregoing suggests that culture is critically relevant to religion
because every religion has a cultural context. Christianity itself is a good
illustration of this by its eclecticism. But those who introduced it into
Africa ignored this fact and rather focused on repudiating the local cul-
ture and whatever contributions it sought to make towards the enrichment
of the religion. Current trends suggest that theirs was a losing battle. The
positive and sublime are being highlighted in African culture and a com-
promise is being struck whereby the christed aspects of local cultural
practices are becoming celebrated peculiarities of African Christian wor-
ship. The succeeding chapters of this book attempt to promote this trend
by clearing the lack of understanding and misunderstanding among mem-
bers and non-members of the Ekpe Society regarding the place of Ekpe
in contemporary scheme of worship. Put differently, Ekpe as an element
of christed culture is a channel or outreach to God.

Chapter Two

The Concept of Christed-Culture

Definition of Christed Culture

There are many who erroneously believe that culture and religion do not mix. Those who have this view are, probably, not familiar with Church history. The truth is that the christed culture and christed religion are two inseparables. Christed religion means any religion that accepts Christhood as the precondition for spirituality. People could hardly be divorced from the music of their land. The human machine is tuned to respond to the christed culture of its environment. Even though most of the cultures are now poor images of their original selves, they could be restored if proper attitudes are consciously applied. This action may be termed "Unveiling of culture." Attitudes here mean right light, thoughts, words, music and to some extent, actions.

How can a christed culture be identified? Culture and religion in the absolute sense belong to a realm of consciousness in the mind of God. To manifest, they must pass through the Christ path and become christed. Together with religion they form part of the endowment of God to people everywhere. There is one christed religion, one christed culture, one christed tradition and one God. This christed endowment is also true for man irrespective of the colour of the skin, his language and environment. Nations, tribes and clans may manifest aspects of the one christed culture. Therefore, christed culture may be defined as one that:

(i) Is the leading Culture of the people no matter how defaced it
 may be:

The inner mind treasures it. The soul is alive to its responsibilities and
its goal. It recognises what should normally relate to its intrinsic good-
ness, a member of the same household as himself, a relation sort of, and
should react favourably unless the man is in his animal nature in which
case he is uncultural. Culture may be God-induced or man-made. If God-
induced, the channel through which it reaches man is Christ which in
the process imparts his characteristics to it. The actual process by which
that is done is not that simple. Should the christed culture not be culti-
vated, it will in time be withdrawn for lack of appreciation. Man-made
culture on the other hand, being imperfect, will follow the way of imper-
fect things and die.

(ii) Has Christ as its Central Theme:

Christ is the acknowledged way to God. Most of the world religions
and centres for the teaching of Truth acknowledge it to be true. Confu-
sion and dissention arise when the name Jesus is introduced. Let he who
holds himself to be wise ponder on the following statement of truth:
"Christ is the visible likeness of the invisible God..." [1]
Even though languages may differ, the fact remains the same. This
secret is not new. The ancients had known about it. Christ is the one to
feed the soul; without him the soul knows no happiness and could not be
comforted. For this reason, it was necessary for Christ to be planted at
convenient positions in the things men like doing often as a perpetual
reminder of the way to God. Christ had to have a central position in a
chosen culture.

(iii) Is not a new invention, but has origin dating back in time and
 space beyond ordinary memory:

Man made things do not last. Even nations rise and fall, and some
disappear completely from the face of the earth. Man's inventions are
passed away almost as soon as they are acclaimed, but the creations of
God being part of Truth last and last. The christed culture being part of
the gift of God as a perpetual reminder to man of the secrets of life and
the way to him, had been with man almost at the beginning of life. It is

not a new creation. The concept is passed on from generation to generation, initially almost mouth to ear.

(iv) Is the culture revered by most, aliens inclusive:

Man's fear of God arises not because of punishment but from his inability to fathom and control Him. God could neither be circumvented nor deceived. Man enjoys having one up on his neighbour. He cannot succeed playing that type of a game with God. Only those who submit to pay the price required up front are given the tools of higher perception and revelation. Even though the intention is for all to know, only a handful know of the need to know. The teachings are for he who can say like Socrates:

I know only that I know nothing.[2]

To most it is too much to bother. Howbeit, a creation of God remains a thing of beauty forever. It gingers in mind the thirst to know and understand, but its depth, like God himself, being not easily fathomed generates a feeling of reverence. What man is unable to understand, he tends to worship and keep as his treasure.

(v) Embodies within its fold the drama of life including the birth, baptism, transfiguration, death and resurrection of Christ as mandatory stations of spiritual attainment:

Life is drama consisting of several scenes within acts and an interlude between the scenes. It is an unusually long play and as is usual with long plays, both the actors and spectators may lose interest, and some may even give up. God is the play-wright and Director. Life is also an unusual drama in that the participants play the part of actors and spectators at the same time. In such seeming confusion in the eyes of men but order as purposed by God, the need to remind man of the main stations of life aptly demonstrated by the birth, baptism, transfiguration, death and resurrection of Christ arose. God took action and provided reminders.

(vi) Is part of Universal Truth. Similarities exist in other lands with respect to the intrinsic teachings:

God is not parochial despite the impression given by the teachings of some religious faiths. Even though he has more names than languages he

remains true to all and one to all. There have been misconceptions about other beliefs and mode of worship presented by foreigners to the culture who had tended to give the impression that some people are atheist or polytheist when in truth they may be monotheist. God's teachings and revelations, though often personalised, and tongues and creed may differ, remain the same in their intrinsic values. This has to be so because the soul is sexless and free from the limitations of language.

(vii) Involves worship of a monotheistic Deity and not its subsidiary powers:

The purpose of life is for man to offer himself as a living sacrifice dedicated to the service of God and pleasing to Him for this is real worship.[3] Most world religions and centres for the teaching of Truth subscribe to the need to worship God. Any culture worth its salt should conform.

Unveiling of Culture

God is consistent in his dealings with all across the globe. There could not be different standards East and West, North and South. A christed culture should incorporate within itself the universally acknowledged stations of spiritual attainment as a perpetual reminder to man of the way . These are:

(i) Birth

(ii) Baptism

(iii) Transfiguration

(iv) Death, and

(v) Resurrection and Ascension.

A. Birth

The ancients had always prescribed a probationary period for those who aspire to initiation. During this period the aspirant was expected to work on his morals and desires. He had to spend time cultivating good living so aptly presented by Jesus the Christ in the following words:

> Love the Lord your God with all your heart, with all your soul, and with all your mind... Love your neighbour as you love yourself.[4]

An aspirant who spends some time coveting the spirit will begin to experience the current of spiritual force that builds him up to receive initiation and obtain lifts in consciousness enabling him to know the beautiful things of this life which he never knew existed.[5] The practice in EKPE was not different. An aspirant was required to prove he deserved the honour of being initiated. He was directed to abstain from actions that may pollute his being particularly a day before initiation. He must not be a charlatan nor be available for visitation by violent temper, and should be able to control his tongue. In addition, he must have an OBONG EKPE willing to vouch for him and be his sponsor. Among the Efik the statement – 'ETE AMA EYEN ABAN EYE EKPE' meaning – 'A father will invariably initiate only his loved son into EKPE' – sums it all. Loved ones are those who are obedient, submissive and useful to the parents. They are those the parents will vouch for. At times an aspirant possessing skills that are useful to the fraternity may be initiated after a period of observation of his demeanor in public and during exoteric displays within EKPE circles. This period of training enables the initiates to correct any short comings they might have observed. Only those who take to correction are initiated.

The aspirant has to be prepared to be born to the new way that is EKPE by conforming to the tenets. He has to be willing to be BORN AGAIN. Sadly, noble preconditions have been relaxed. Now, what counts is a handsome wallet. Nevertheless, the opening of the way to initiation is in conformity with the energy released on the earth as a result of the crucifixion of Jesus. It rent the veil hung over the temple to keep out all but the chosen few, and it made the path of Initiation free to whomsoever will.[6] This does not mean the law of love should not continue to be the prerequisite of initiation.

B. Baptism

Baptism is an old ritual practised by the ancients across the globe. In Egypt and Greece, during the last ten days of the year, the statues of their gods, goddesses and idols were immersed in water by the priests for the purpose of washing away the sins of their worshippers which they had taken upon themselves and which remained on them until washed off. During the Ratty, the 'bathing ceremony,' the principal god of every temple was carried in a solemn procession to be baptised in the sea. The

Orphic hymn called water the greatest purifier of man and gods. Outside every temple in India, a naturally occurring body of water or a reservoir full of holy water is available for Brahmans and the Hindu devotees to bathe daily. Such places of consecrated water are essential at every temple for baptismal rites to be performed twice a year. A preliminary scene of death was simulated by the Mithraic neophyte of old and this was preceded by the scene showing himself being born again by the rites of purification which is of baptism. A portion of this ceremony is enacted by today's Masons on the neophyte as the Grand Master Hiram Abiff lies dead, and is raised by the strong grip of the lion's paw.[7]

An act similar to the Mithraic rite of simulated death of a neophyte is a recognised feature in EKPE and one of the few inner temple plays allowed in public. This is water baptism initiation otherwise known as the rites of purification. The colours of white, red and yellow – orange used in EKPE initiation are significant. White is the agent of purification, a baptismal agent. Both water and fire as agents of purification, are represented by White during initiation. The relevant divinities are EBONKO and NKANDA respectively lying within the realm of divine and formless world of spirit. Actual water baptism, "UYERE MONG EKPE" in Efik is now given to the privileged after normal full initiation is administered. As was with Christ, baptism is of two parts, namely Water baptism and Fire baptism.

Water baptism is a common Christian practice that envisages water baptism to take place before new birth. This is a variance with EKPE practice which promotes new birth before baptism. The EKPE practice is more in line with the Christ experience. In EKPE the practice of immersion of a neophyte in water to symbolically liberate him from sin is not now regular practice, but is reserved for the well guided. It is believed the insistence on having a temple close to a naturally occurring body of water was perhaps for the purpose of baptismal practice.

C. Transfiguration

Transfiguration is a change in state that occurs in man when his divinity has attained a certain level of spirituality, and his soul senses have become full grown. This is the whole thrust of esoteric and religious teaching of every faith with eyes focused on God. Ekpe is the way of the

ancients for bringing initiates before God perchance he declares them his sons and enkindle the latent aspects and attributes that will enable Him work his wonders and miracles through them at will to the glory of His name. Such phenomena form part of EKPE history and were perhaps responsible for the popularity of Mithraism amongst the Military and business class of the time.

D. Death and Resurrection

Death has been with man right from the beginning yet it remains the most feared experience that he must surely have. Death is inevitable. This fear arises from ignorance and the refusal of some to prepare up front to make it an enjoyable experience. Many cultures had evolved teachings for eradicating fear and preparing man for the transition that man erroneously calls death. Egyptians were amongst those who had the most elaborate rites for the preparation of the dead for life beyond death,[8] and this they did as a follow up of the serious training offered to initiates this side of life. To bring the lessons home to initiates, plays were designed and organised within the temple as part of the mysteries to implant in the psyche of initiates the true meaning of death and the opportunity it offers to those who deserve the honour of the unfolding life beyond. During these periods, lessons on renunciation were imparted to encourage initiates to work against sense enjoyment. These are the basic teachings of EKPE initiations.

It is a lesson that is repeated again and again as the neophyte climbs the ladder of initiation so the lesson may be planted in his soul. Man must sacrifice in order to gain, give up what is transient to reap what is permanent, and also give up sense enjoyment to enable the divine spirit to grow. The truth of life after death is the corner stone of Christian teachings. The EKPE rites that attend the death of a Paramount Ruler or an Eyamba EKPE confirm EKPE's belief in life after death.

E. Cultural Elements of Christed Culture

In keeping with the universality of the laws of God the prime culture is in reality an amalgam of cultural elements or units that are found in most cultures of the world and these are:

(i) naming ceremony

(ii) coming of age ceremony

(iii) marriage ceremony

(iv) harvest festival

(v) burial ceremony.

These five cultural elements are embodied in EKPE as its component units, and their presence further enhance the suspicion that EKPE might have been a christed culture before it acquired a culture of sin.

Classification of culture as christed and non-christed is both necessary and feasible. Biases, prejudices, discrimination, ignorance, superstition, miseducation, materialism and absence of awareness are constraints militating against proper operation of the classification. These constraints impede the wheel of progress, development and enlightenment. Unveiling of Ekpe offers the opportunity to compare its wisdom and teachings against those of other lands. The fact that Ekpe has been associated with evil thoughts and actions is no excuse for dismissing it. Man himself cannot lay claim to all time goodness.

The discussions so far were meant to be introductory and to provide a backdrop against which the story of Ekpe which follows may be fully appreciated. And as the unfolding story will show, this great institution did reach its lowest depth of infamy. But this is largely a story of hope, regeneration and regained lease on life. The course of its continued relevance will be determined by its adherents based on what wisdom they endow their decision with. This study attempts to provide the facts and tools by which the institution may be better understood and such a critical decision wisely made.

Figure 1 OBONG EKPE after initiation

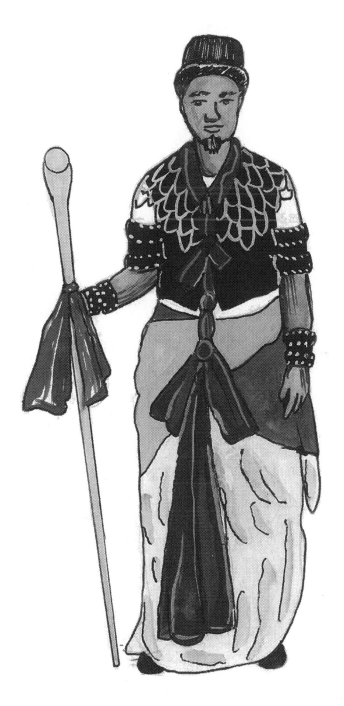

Chapter Three

Some Thoughts on Origin of Ekpe

Meaning of Ekpe

As a system, EKPE is part of universal truth that has been with man almost from the very beginning. It sprouts from the same arcane roots with others that ever existed. Its roots are founded on pure motives in its original form but have been corrupted over the years along with man. Worship is at the centre of EKPE activities. It is concerned firstly with the worship of the unity known in esoteric terms as EKPE (God), and subsequently, with the application of teachings and techniques for arousing and balancing the divinities located within the various EKPE Houses (globes) for activating related principles within the EYAMBA. Never are the divinities for the control of the individual EKPE Houses worshipped. Sacrifices are not made to them as a rule but some who are involved in sense gratification may have influenced some temples to default. The divinities within the Houses are not looked upon as gods, but the unity known as EKPE is God to the initiates. The EYAMBA is the High Priest at the mundane level representing the arch divinity bearing the same name.

Worship has to do with religion, belief, prayers and faith. EKPE is monotheistic as against the polytheistic status of most of the Eastern religions. Pantheism is perhaps the bed rock of most occultic practices and magic but not EKPE. According to H.P. Blavatsky, occultism accepts

revelation as common form of divine yet still finite beings, never from the unmanifestable one life, the God of Christians. It is an accepted fact that occultism does not admit the concept of God as the ONLY ONE but accepts pantheism. In this sense, EKPE is not a classical occult organisation. The fact that some of the techniques employed by EKPE fraternity for bringing initiates into conscious contact with the psyche may have parallels in occultism does not invalidate the contention that in practice EKPE is monotheistic and a religion. It has exoteric and esoteric aspects.

The word EKPE has several meanings. It will be necessary for the reader to decide for himself which meaning is appropriate in each case. The problem has its roots in the limitations of language. EKPE is God, the soul, the way, teachings, a system, a fraternity, creations in diversity, and a lion (leopard). EKPE institution is not dynamic although it may be found to fit life situations. It is restrictive, conservative, and unchanging in character, principles, organisation, imagery and EKPE form but time and profanity have taken their toll on it.

Enlightenment and awareness are spiritual gains that are not confined within geographical boundaries. Africans, or more appropriately, the Africans of the Equatorial zone could not have been denied the spiritual gains. God is omnipresent, omnipotent, and omniscient, and He is God to all. The vehicles of arcane teachings may be different but the important remains the same for all East and West, North and South. Environment and culture do have effect on the teaching methods and forms adopted. Also movement of peoples from one area to another is a vehicle for transportation of awareness and enlightenment. Under these circumstances, it is difficult to establish when EKPE took root in African society. The expansion of the influence of EKPE is observed to be from East to West. It is always, "a man from the east introduced it to us." This is in conformity with arcane knowledge. Wise men move from the East as the sun rises from the East.

EKPE embodies in its fold teachings on taming of the EKPE (Lion) in man. It involves a procedure for controlling the animal in man and for attaining self mastery so that man is freed from the bondage of his physical nature. These teachings are closely guarded secrets wrapped up in deceptions that are not easily unveiled even by many of the present day

adepts for whom the gains are more social than spiritual. The policy of keeping secrets is an ancient doctrine of the old religions. The mysteries were instituted pure, and proposed the noblest ends by the worthiest means but were jealously guarded and the penalty for divulging any secret was death. This was true amongst the Eluesinians, Chaldeans, Egyptians, Hindi, the Masons and others.[1] For these reasons the popular stories peddled should be taken with a pinch of salt.

The use of deceptions aimed at profanity is a common practice. It is a dangerous practice where no written records are kept, and reliance placed on oral tradition. In the context of the Efik, the deceptions have taken root and as the real adepts pass onto higher octaves existence, the arcane teachings are being lost to humanity. EKPE is a way to gain spiritual realization and bring man into oneness with God through Christ at the centre of Being. It is a way to eliminate the conflict in man.

Short History of Ekpe Efik

Some areas of the Equatorial Region of Africa extending from the Cross River to the Congo River Basins is the EKPE Zone, and the exoteric paraphernalia of the EKPE forms (Masquerades) are similar. The main differences are in their presentation. Some forms are more exotic than others. There is also the voiced language difference. From these, it may be said that EKPE Efik is a misnomer. The Efik are known to have engaged non-Efik adepts and initiates to tutor them on the intricacies of EKPE. This does not, however, imply that the Efik never had EKPE. It may well be that they lost it through carelessness. It is not unusual for such a loss to occur. The descendants of some of these tutors, even though assimilated into the families holding positions of influence in the EKPE lodges on Efik land, are recognizable personalities within these Efik families. It is not uncommon to discover that the voiced language is suddenly changed from Efik to Efut to accelerate the raising of the lodge and cause many to feel inadequate. There is really nothing unusual about the practice in that it is part of human nature to show off knowledge. The English are fond of punctuating their speeches and writings with words in French as proof of their status. It does not mean the French language is superior.

Paul Amaury Talbot, the author of *In the Shadow of the Bush*, acknowl-

edged that NSIBIDI writing of the Ekoi people exhibit traces of the earlier Egyptian hieroglyphs. He noted also that the early buildings of the area are circular, a form generally considered peculiar to savannah people and quite different from the rectangular houses of the forest people. According to him, the Ekoi are mainly of Bantu stock generally acknowledged to have arisen from a mixture of Hamitic and Negro blood.[2] D.M. Mcfarlan had also opined that Efik probably used circular buildings in the distant past.[3] According to Talbot, the Ekoi were probably amongst the first of the races so formed to split from the parent stem, and seem to have come straight from the lower end of the Nile Valley. The community swayed by powerful rulers indulged in what the author thought was ancestral worship, practically unknown to the tribes consisting of petty settlements. These lend credence to the view that the Ekoi came down from North-East, and probably from a land not so densely forested as Cross River State. Lion, the totem of EKPE, is certainly not common in the forest zone, but not extant. He is by and large grassland animal which figures very largely in Ekoi early folklores.[4]

The Ekoi claim to have originated the whole idea of EKPE Fraternity which has existed amongst them for centuries and is mentioned in their old folk tales long before the white man came. According to them, Ododop and other tribes like Akwa and Efut of the Cameroun acquired the art later but gradually became more powerful than the original Ekoi one and therefore more expensive to join. The power of EKPE in the olden days rested on the efficacy of the inner teachings, particularly amongst the people of outlying villages. Consequently, the claim of Ekoi to be the original custodians may be spurious. Although borrowing may not be ruled out, it is reasonable to think that the Efik of Calabar who were not slow to perceive the advantage of such institutions may have founded their EKPE fraternity which, with the growing importance of commerce, soon became the prime fraternity. Since AKWA and EFUTS are Bantus and both possess EKPE, it may be assumed they also migrated from the savannah region of the Nile valley. If possession of circular buildings can qualify the Ekoi to claim Nile Valley origin, Mcfarlan had shown that Efik also used circular buildings. The Efik are generally grouped along with others in the neighbourhood to be semi-Bantus.

Many now admit that the Efut people exported EKPE fraternity to

Efik. This is no longer in doubt amongst Efik themselves.[5] The names assigned to EKPE orders are Efut names. Exporters of EKPE namely: – ASIBONG EKONDO, MUTAKA and MBANG are of Efut origin, even though commonly referred to as Efik. In fairness, Efik see only minor distinctions between them and Efut. EKPE did not come amongst the Efik as a once and for all import. The cost of such an import could have been prohibitive in financial, material and human terms.

The Efik are known to have settled in Aro-Chukwu of Abia State and subsequently Uruan of Akwa Ibom State of Nigeria before moving to the present locations. Since their route of migration may be different from others of their present neighbourhood, it is probably that the route took them into areas where EKPE was either not known or was inactive. Consequently, they lost what they knew. Such a loss is not unusual. In modern times, the AMBO family of Creek Town of Cross River State, who had been the main custodian of EKPE Efik, allowed the power to slip to the extent that for years they completely lost the authority to own a fraternity. In short, they lost their nationhood. It was not until 1949 that the right to own EKPE was restored. Because of heavy demand on resources a step by step approach was adopted even in respect of initiation. Incorporation of higher grades of NKANDA and OKOPHO into Efik fraternity are attributed to King Eyo Archibong II and King Eyo Nsa Honesty II respectively.[6]

Even though Efik agree that the Efut introduced EKPE to them and USAK EDET is the actual source, there are at least four major differences between EKPE Efik and EKPE USAK EDET. In Efik land there is an established hierarchy of MBONG EKPE whereas in Usak Edet there is none. There, EYAMBA is all and all. He uses the initiates in accordance with the level of their awareness and enlightenment. The advantage of the Usak Edet system is that one attains the EYAMBA and adept positions by virtue of merit and births, whereas in Efik land, particularly now, almost anyone of the right birth who cherishes the position can have it. The disadvantage is that the system is autocratic and, perhaps, unnatural. The second difference rests on the fact that MBAKARA, a recognised EKPE divinity in Efik land, is not acknowledged in USAK EDET where there is BAKUNDI NYAMKPE which is not in Efik land. The third difference is that USAK EDET does not subscribe to EFAMBA.

The fourth is that full baptism is a mandatory requirement for the adept position in USAK EDET but not in Efik land. From this it may be concluded that EKPE Efik is, probably, not from one source. For example, it is said that NKANDA was obtained in 1842 from the Efiat people of Tom Shot Island located in the Calabar River Estuary. The enrichment of EKPE Efik by USAK EDET was in esoterics of MBOKO, a field that they were the acclaimed experts.

There is a determined effort at denying that the Efik who on self-admission claim to have lived amongst the Uruan people of present Akwa Ibom State of Nigeria for over 150 years, and with whom they spoke the same language until recently when the influence of the Ibibio became paramount, were involved with EKPE URUAN. Uruan are said to be the Efut who migrated from their ancestral home in the Cameroun with other Efut clans like EKONDO, ABUA, IBONDA, IDUNDU, UKEM, IFONDO and others during the great dispersal caused by war, but were separated from their kith and kin by the Cross River and subsequent war against the Okoyong people. As was the practice, it would have been unthinkable for these clans to move into the unknown without their EKPE, the symbol of manhood and nationhood. To the people, EKPE meant life. If the other Efut clans were able to move and retain their EKPE, it is unlikely that the Uruan people would have lost theirs, particularly as they are traditional seafaring people always on the move in their canoes from one port to another and to and from their original abode, a short distance away in the Cameroun.

The Efik have not denied that the Uruan people had EKPE when they were with them. What some are claiming is that they, Efik had an EKPE equivalent by the name NYAMA NYAKU.[7] If this claim were true why did they abandon it for EKPE? Proud people like Efik would not have abandoned their own thing for an equivalent unless they did not have what they are claiming or what they had was inferior, therefore, not EKPE. If they had their own thing they would at least have given it their own name. The words NYAMA NYAKU are certainly not Efik. If NYAMA NYAKU had any relevance of note in EKPE, it would have found acknowledgement in EFAMBA, a secret display of EKPE artifacts in cultural and historical setting. It is more likely that the Efik acquired some lower grades of EKPE either before or while in Uruan. The alterna-

tive would have brought them much distress. It would have been impossible for them to live for any reasonable length of time without it. Nor would they have been able to do business with the coastal tribes of Central Africa and others up the Cross River. It was the practice to move with EKPE and this was the way the ADIABOS, OBUTONGS and the DUKES moved from CREEK TOWN to their present locations in Calabar. The popular saying in EKPE, "NKA URUAN" meaning "I am going to Uruan" and "NDUK URUAN," meaning "I am in Uruan" which refers to NYAMKPE EKPE is a confirmation of the relevance of the Efut (URUAN) with regard to EKPE.

EKPE, the animal, is not a totem of the people but of the fraternity. Traditionally, only initiates were expected to own, use or display any aspect of EKPE form, artifacts or imagery. Others may do so at the pain of death. Leopard or Lion is a totem for initiates. It is not for everyone because all do not subscribe to EKPE. Employing mercantile experience, influence and gun powder, many people in the neighborhood who had EKPE were harassed by Efik into accepting to purchase NKANDA, if not the whole EKPE orders. Trade routes were blocked and war declared against those who failed to conform. When the prospect of successful military expedition could not be confirmed, the neighbors were hoodwinked into believing that what Efik had were totally different and superior. So "EKPE Efik" was exported using the carrot and stick principle, trickery, and at times gun powder. Exploitation of the ignorant was developed into an art and encouraged. This is how the Uruan people of present day Akwa Ibom State and Ekoi people of Oban in Cross River State were made to purchase NKANDA that they are now proud to possess.

In the case of Oban, the Efik insisted on the destruction of the old Ekoi equivalent "ISONG" and of another old grade "MUTANDA" of slightly less importance.[8]

Of late some Efik have peddled the Orientalist theory that claims that Efik are of the Hebrew stock. Between the middle of the 13th and 12th century B.C. a large portion of the African continent is believed to have been peopled by the races expelled by Joshua, son Nun, and the children of Israel.[9] Since then some writers have attempted to show that Hebrew cultures permeated Negro Africa either through normal commercial ties

or by diffusion brought by dispersion of peoples.[10]

EKPE, the Kabala, and ancient Egyptian theosophies are compatible, but EKPE being monotheistic is suspected to have been exported if at all, after the period of monotheistic practice introduced by Pharaoh Akhenaton, the husband of Nefertiti, the acclaimed Rosicrucian (1388 – 1358 B.C.). He was son of Pharaoh Amenophis III, and grandson of Thutmose III, the nation builder.[11] His openness and the introduction of Sun-Worship in place of a hierarchy of gods annoyed the powerful people of the land including the priests. After his death, Pharaoh Tutankhamen restored Amenism and the ancient gods, some of whom were regional gods, and ruthlessly executed the followers of the mono-theistic practice of Akhenaton. Since monotheism was the accepted sanctuary teaching, the real objection to Akhenaton may have arisen from the openness of his teachings and, perhaps, bringing the teachings re-served for the special few to some of those who would normally not have been entitled. Some of Akhenaton's followers might have escaped and spread across the continent.

At the time Joseph, son, of Jacob, the Israel Patriarch was ruling Egypt, the masses were probably polytheistic. He married the daughter of the Priest of On. He would not have been able to exercise much power if he was not an initiate of at least the Temple of On. Moses who exported Egyptian Theosophy into Israel after the Exodus of about 1290 B.C. was himself an initiate of an Egyptian Temple.[12] He was instructed by Batria the initiate wife of Pharaoh Rameses (1292 – 1225 B.C.), and the mother of Princess Thermuthis.[13] The Bible record has it that he was instructed in all the wisdom of the Egyptians "becoming powerful in words and deeds."[14] Wisdom teachings were imparted in the temples to initiates only. The Egyptian theosophy of the time was probably polytheistic in the open and monotheistic within the temples.[15] It was the spring from where the Jewish Kabala drew its water.

The mane is one of the main features of EKPE form, an indication that EKPE had probably received considerable influence of the savannah and relates more closely to the lion than leopard, a common animal of the devotees' present habitat in the Equatorial forest region of Africa. The rarity of lion in the people's present habitat must have compelled them to adopt leopard, an animal of their present habitat with similar

characteristics as the lion. Rarity does not imply non-existence. It enhanced the value. Efik know it as ANAWIRI EKPE. The use of the mane could not be sufficient and adequate reason for concluding the EKPE has its roots in ancient Egypt as some would wish others to believe.

About eighteen million years ago when the sun was in the zodiac sign Leo whose symbolism is the Lion, the first instances of coordination between human brain and mind took place and human being was self-conscious. The sign is the symbol of individuality and under its influence the race of men arrived at self-consciousness and men functioned as individuals. At least by name this is perhaps the origin of EKPE (Lion) religion, a path to self-consciousness. Also the "face of the OX", the Biblical symbol for the zodiac sign Taurus the Bull, signifying the religion immediately antedating the Jewish revelation; is a common feature of UKARA, the EKPE Sacred Cloth. Probably, it may be taken as an indication that EKPE is an ancient religion akin to the Egyptian and Mithraic mystery religions. Another symbolism in EKPE worthy of consideration is frequently used in astrology as the symbol for the sign of Scorpio, the serpent of illusion from which the Christ nature finally frees man.[16] EKPE is concerned with all aspects of life. Using mundane things it x-rays principles operating the physical, ethereal and the spiritual. For example, the NKANDA form is dressed in ukara, the EKPE secret cloth signifying it is the seat of wisdom. It also signifies that there was a time man was close to God, and at that time his body was ethereal. Then the body and soul were for all intent and purposes very close, if not one. The UKARA designed specially for NKANDA, bears evidence of fire power inherent in that order. Of the six equipment attending the NKANDA form, the loop or 'EKPO' as it is called, is perhaps the most important. With it the form's movement could be restricted and the process of men going into and out of manifestation demonstrated. The loop also functions as the norms of society, moral code and above all the spirit of God in man manifesting as conscience. Man is not on his own. (See Fig 19).

The primary or basic elements in creation for the time fully manifesting on the terrestrial plane are water, air fire and earth, and man is a product of canny fusion of these elements. Since EKPE is concerned with all aspects of life, it may be concluded that these elements are also important to EKPE. Applying the reflection of Trinity given in the Golden

Dawn by Israel Regardie,[17] the relationship of EKPE Houses and the elements are as given in Fig 2.

Figure 2 EKPE and the elements

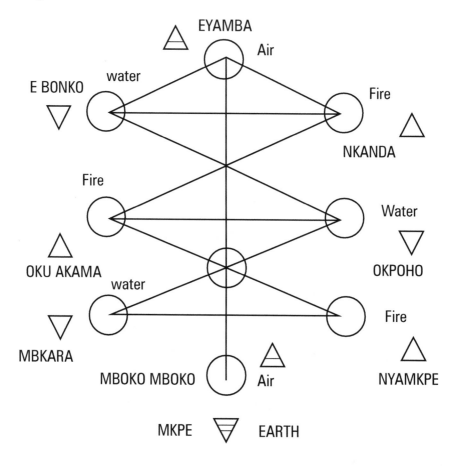

The elements at the higher planes of consciousness are not of the form man on earth is familiar with. These are of a much finer texture and operate in the fluid region of life.

In the context of EKPE fraternity, EKPE the animal is strictly not the logo of the fraternity. It is 'ANAWIRI EKPE,' the lion, that is the logo. A representative mane is a prominent feature of most EKPE forms (masquerades). There are ten main units or divisions or orders of EKPE fraternity, each governed by a divinity, the other name for principle after

which they are named: – MKPE, MBOKO, MBOKO MBOKO, (M)BAKARA, EBONKO, NYAMKPE, OKU AKAMA, OKPOHO, NKANDA and EYAMBA. Exoterically, the first five orders are classified as the lower orders. In reality, the ordering is incorrect. If it were correct, OBONG EBONKO, the Head of the EBONKO order, would not be accorded the respect he enjoys within the lodge. He is normally addressed EKA EKPE, meaning mother of EKPE. In the absence of the EYAMBA the fraternity may not be properly constituted and raised without the EBONKO power, the presence or absence of MBONG of some of the supposed higher orders notwithstanding.

Figure 3 EKPE on the Kabalistic tree of life

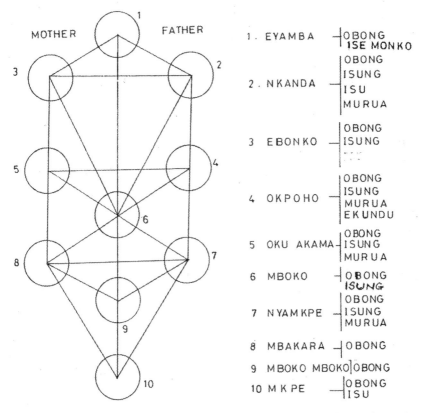

Fitting the EKPE forms and the principles they embody to the Kabalistic tree of life show that the EKPE hierarchy commonly accepted had

been jumbled up, probably, to misdirect the profane. Applying Kabalistic principles it is found that NKANDA heads the father of force column; EBONKO – the mother column; and EYAMBA – the middle or balancing column. In light of the above, the correct order is as posted in Fig. 3.

Many of the stories told about the origin of EKPE are myths. Variants of these stories exist. It depends on the narrator. There exist the temptation for the narrator to extol his lineage. Those commonly accepted as being prima inter pares amongst the Efik are EYO EMA, ESIEN EKPE, NKUK AFUTA and MUTAKA even though the last two are Efut. MBANG, the wife of NKUK AFUTA and sister of MUTAKA is reputed to be the discoverer of EKPE. The first four names are usually displayed behind the veil during EFAMBA display, an indication that the names may be used allegorically perhaps to represent Tetraktis of Pythagoras. According to Efut folklore Sirkan the daughter of the Lord of Northern Efut named Mokuire discovered EKPE.[18]

Chapter Four

Socio-Political Aspects of EKPE

In the years that Efik community has stayed in contact with the outside world, a lot has been written by scholars, missionaries, colonial officials, traders and travellers about Ekpe. Such writings tended to emphasise the objectionable practices of the Fraternity. Often such practices were judged out of context and the need to force compliance and conformity with the evolving new order. In the process, the underlying principles behind such practices were little understood or considered unworthy of civilized people to pry into as though to say, if the practices were wrong, then the principles behind them must be equally wrong. This chapter attempts to explain some of the philosophies behind practices the Fraternity came to be closely associated with.

Libation

Libation is very much part of Black African culture. Up to the advent of Christianity, the practice was rampant and in some places, including Efik land, the day began and ended with it. It is a heritage accepted by many to be the key that locks and unlocks door for the family and the group. The Efik practice stems from several beliefs.

Firstly, there is communication between the living and the dead to this side of life. The Efik saying "EKPO AKPA EYIN IKPAHA UTONG' – meaning 'the dead may be blind but not deaf'– confirms their belief.

They also believe that black magicians could under certain circumstances arrest soul for their evil purpose. In the world of the occult – the belief that disembodied soul is available for use by who is able, is an acknowledged practice.

Secondly, deceased members of the family or tribe having been helpful and caring during their sojourn on earth, will continue in the service of the people even when they are dead to this life.

Thirdly, the good must call on the good. Only those who are respectable are assigned the responsibility of pouring libation. This improves communication and efficacy of prayer.

Fourthly, it is improper to summon the assistance of he who was not a member of the family when alive.

Fifthly, being spirit, the deceased possesses enhanced freedom and power of operation than the living.

Sixthly, death does not improve the character of the deceased. A man who was heady, unreliable and selfish while alive cannot become a saint in the world of the dead.

A typical libation proceeds as follows: An eldest male and respectable member of the family or his surrogate is chosen to be the supplicant, and a young male member nominated to be his aide. If the setting is strictly cultural and traditional, the supplicant and his aide must dress traditionally. This promotes evocation. The aide picks up a suitable receptacle of convenient size, for example, a tumbler, and a fresh bottle of gin; the drink must be colourless. With the bottle of gin in the left hand and the tumbler in his right, he follows the supplicant to a well appointed position in the open, preferably within hearing distance of the gathering. The aide presents the tumbler to the supplicant who receives it right hand to right hand followed by the gin. The supplicant orders the seal to the gin broken by gently touching the cover. That done, the supplicant holding the tumbler in his right hand presents it to the aide who pours in an ordered quantity of gin. The ceremony is right handed, the left hand being reserved for evil. All these are preliminaries.

Libation proper is attended by grave yard silence when the supplicant steps forward, tumbler of gin in hand. Looking upwards to heaven and around, he offers a short prayer of adoration and thanksgiving to God

and seeks his approval and blessings. No drink is poured. That done he summons the acknowledged NDEM of the family by name for assistance and offers a drop or two of the gin. Should the occasion be tribal in coverage, all the acknowledged NDEM of the tribe are called out one after the other. The supplicant proceeds to make an offering of gin which he pours out in trickles as he proceeds with the naming and eulogizing the departed ancestors. The eloquently restates their caring and supportive roles in the past and invites their presence and attention. He proceeds until he has inner satisfaction induced by their presence. This is evocation of good ancestors.

As the tumbler is emptied it is quickly charged at the instance of the supplicant who then switches the tumbler from his right to this left hand, and a frugal drink offering is poured out accompanied by a brief but pungent rebuke of the evil ones in the world of the dead. By this action evil spirits are appeased lest they feel ignored to the point of being obstructive (This process is similar to the immobilising process employed in magic against evil power). With the tumbler back to the right hand the supplicant continues in praise of the good ancestors. This beings evocation to an end and unfolds the stage for pleadings to be lodged. The supplicant continues by pouring out his mind on a catalogue of requests that are to the point and which relate to the purpose of the gathering. His address is punctuated by drops of gin poured out from the tumbler, as drink offering. That finished and with an empty tumbler in his hand, he walks back to the gathering and orders the tumbler to be generously charged, which contents he briskly empties into his throat. Taking the gathering together, the supplicant standing, symbolically requests the gathering to symbolically confirm that he had performed well on their behalf. To this gathering assents. The ancestors remain till the end of the meeting when a little quantity of gin left in the bottle for this purpose is poured out to dismiss them.

Much had been written on whether libation is ancestor worship. The real problem over this subject has to do with inadequate understanding and appreciation of the import back of actions, forms, rituals and rites. Strangers to the cultures and customs of Black Africa conclude after fleeting visits to a few spots that African culture is infantile and unrewarding, yet proceed to conclude that the practice of libation tantamounts to ances-

tor-worship. Idowu[1], Opoku[2] and others have adequately dealt with this subject and have posited that:

i) Ancestors are not worshipped, but revered, honoured and respected.

ii) Ancestors do not constitute a power block possessing authority over any matter but as concerned spirit-citizens of the tribe are available to assist the pleadings filed for the ultimate attention of God.

At local level the active objectors to the practice are some members of the Christian faith who claim that the practice does not have scriptural approval. To examine this problem, it is necessary to understand the difference between libation of drink and drink offering. Libation implies pouring out action of the drink by a supplicant, whereas drink offering may or may not involve pouring out of drink. Howbeit, many are against it for several reasons, namely: –

i) The veneration given to NDEM is unacceptable. This practice has its root in ignorance of the fact that NDEM are elemental spirits requiring neither veneration nor worship.

ii) Some of these ancestors are disembodied souls of pure materialistic persons that are irresistibly attracted to the earth, where they live a temporary and finite life amid elements congenial to their natures. Such people having not cultivated spirituality but indulged themselves in material and gross matter have suddenly found themselves unprepared for the career of pure disembodied being. The disembodied souls of such materialistic ancestors are unlikely to be of much use to the family unless the supplicant is a black magician or sorcerer.[3] Efik are aware of this problem.

iii) It is not in the interest of disembodied soul for it to be earthbound. The soul should be encouraged to move on. Libation retards the movement of the soul away from the earth. It causes the soul to be earth hungry. The lesson of Saul is relevant. Samuel said to Saul when evoked – "Why have you disturbed me by bringing me up?"[4]

iv) In the minds of the people libation results in evocation of spirit of dead ancestors, an activity that is against principles. The procedure adopted is a watered down occult practice. Such practices may back fire to produce evil rather than good especially as one is never sure of the inner constitution of the ancestor before death nor that of the supplicant.

However, libation is the curtain raiser of EKPE. It signals the beginning and the end of all meetings, ceremonies and rites, exoteric and esoteric. Its use in EKPE is not bedevilled by the arguments on ancestor-worship for the simple reason that the real meaning of EKPE activities are buried in allegories, symbology, forms, Nsibidi and rituals, amongst others. The system does not encourage the use of names of ancestors except on rare occasions when there is the need to refer to the four who sit behind the veil at EFAMBA in which case they are used allegorically to refer to the four externally self existing ones known in esoteric teachings as the Second Logos or Tetraktis of Pythagoras. These are not ancestors. The only other exceptions are the uncommon and restricted use of names of ancestors in eulogies and dirges, but in these instances the use of libation is not the practice.

Law and Politics

Western education, populist government and the Christian Church have together subscribed to the weakening of the power of EKPE Fraternity to the extent that nowadays EKPE laws mean very little. The position is slightly different in outlying villages far and removed from government presence. Except for the more draconian laws, the fraternity is still a force to be reckoned with in outlying areas.

As late as 120 years ago EKPE was the acknowledged symbol of manhood and statehood. Its status and rights had to be defended with blood, if need be. Without it neither the man nor the community was accepted to possess defendable rights. Both could be plundered, enslaved or simply done away with almost at will by those in possession of fraternity rights and privileges. From these reasons, membership and ownership of the fraternity was a much sought after commodity, and the community was willing to pay for it with blood and this was invariable demanded.

Often communities were made to pay reparation for alleged misdeeds in addition to the fee of purchase. The reparation was a way of buying oneself out of slavery to become a free person. When once the sale was firmed, the purchaser was no longer discriminated against.

In Efik land, the journey to deliver EKPE to a purchaser was often a riverine affair. A fleet of dug-out canoes appropriately adorned for the purpose set sail from the EKPE beach, a beach so designated by the fraternity, for a predetermined beach of the purchaser. To avoid interference of unwanted powers, the journey may be turned into a war game, a hunt for MBOKO (Osiris), the child of EBONKO (Isis), the mother of EKPE. Should the purchaser be land-locked, delivery was effected using an improvised vehicle adequately camouflaged to resemble a canoe. It was mandatory for IDEM NYAMKPE to provide security for the fleet. Consequently, it was on the bow of the leading canoe on departure from and arrival at the ports. The journey was never easy. It was deliberately designed that way to enhance the value and prestige of EKPE. A successful journey was usually preceded by at least two unsuccessful ones. Repeats were expensive.

Oath is important in EKPE. It is mandatory to take oath of secrecy before initiations and before inner teachings are volunteered. By this important habit, discipline and silence were cultivated with attendant benefits to the initiate, fraternity and the community. Initiates were the ones entitled to full citizenship and engagement on important community assignments. They were the trusted ones. Even though children were admitted they were barred from the secrets. EKPE served as the conscience of the people and also as its government. Ordinarily, EKPE laws took precedence over customary law, but EKPE was at times compelled by the greater will of the people to enforce laws that may not be in concert with its values. For example, the weight of the culture was too heavy on EKPE to the extent of preventing early action against the practice of destroying twins or leaving them at the mercy of wild animals and inclement weather away from the village. EKPE imbibed that culture and barred twins from taking initiation.

As government, it was involved in law-making and enforcement, adjudication, soldiering and politics. In the olden days, EKPE was no respecter of person. Breakers of its more important laws, particularly those

considered to be treasonable offences for which punishment was death, were attended to with despatch, irrespective of whose ox was gored. Treasonable offences included:

i) Disclosure of the inner secrets of EKPE to unauthorized persons which included some categories of initiates.

ii) Proven cases of unauthorized indecent assault on females.

iii) Proven cases of adultery.

iv) Promiscuous sexual behaviour. Defaulters may easily become security risk.

v) EKPE initiation carried out on foreign land by and Efik.

vi) Unauthorized sale of EKPE.

vii) Falsely claiming to be an initiate.

viii) Initiation carried out by non-adepts.

ix) Unauthorized entry into the inner chamber.

x) Armed robbery and piracy, and

xi) Refusal of military service or desertion from such a service.

Murderous practices to which EKPE lent its support were many and included the administration of ESERE bean, burying of wives and slaves alive on the death of their master, human sacrifices and authorised defrocking and indecent assault of women in public. All these were banned by the treaty of 1878 between Adam, King Archibong III, the King of Calabar, and Queen Victoria of England, represented by the British Consul.[5] Minor offences like stealing and insulting behaviour did earn some lashes of IDEK EDEM, a specially treated whip made from the body of manatee which as a rule always left its mark on the miserable offender.

EKPE fraternity served as the final court of the land. It was an appellate court with regard to civil matters but could be a court of first and final instances in respect of offences against EKPE, criminal matters and those that concerned the state. In civil matters it was advisable to first seek redress before a court under the jurisdiction of a recognised respected chief. The matter could subsequently be brought before the Paramount Ruler's court. This served as a court of second instance, and may finally

be brought for the Fraternity's adjudication. EKPE pronouncement was a finality that the wise would do well to accept and respect. Disagreement was an aberration deserving immediate severe response which normally included a visit by EKPE to the home of the offender. Such a visit invariably resulted in plundering of the offender's household in addition to other indignities. Should the defendant be living outside the jurisdiction of the temple where the case was filed, two options were open to the fraternity. It may order its initiates to lay ambush and seize the offender any time he strayed into its area of authority or, in the alternative, request in the prescribed manner to the temple of competent jurisdiction for his extradition. Should the defendant be an initiate, he was entitled to be accompanied by EKPE advocates to answer to the charge. It was the responsibility of the advocates to put all they had into the matter and see to it that the defendant gained his discharge. Should the defendant not be satisfied with the judgement he may take the matter before a recognised neutral fraternity of the tribe. There are prescribed ways for doing that. A price was demanded whether he won or lost.

In the early days equity held sway but now-a-days what is good could be ruined by EKPE and what is bad could pass as good; it all depends on what influence can be mustered. It is now possible to influence judgement. At the beginning EKPE concerned itself with order, discipline and truth. Communities with renowned EKPE fraternities were highly respected. Prowess in EKPE correlated with political power, and the fame that went with it attracted many visitors to witness and study. Initiates were taught to be poor speakers and good listeners, and to be on the alert. The art of guerrilla warfare was taught and encouraged. Such a teaching became a useful tool during funeral obsequies of an EYAMBA or a high adept. By it a hosting fraternity protects its EKPE from being snatched by a visiting fraternity employing the same tactics. The normal procedure adopted is given below:

Following the announcement of the date for the commencement of funeral obsequies and when visiting fraternities are expected, intending visiting fraternities respond by indicating how they intend to arrive. It is either by river or by land. This done, it behoves the celebrant to expect and receive his guests on the appointed day either at the beach or at the village boundary where welcoming rituals involving the hosts and guests

are performed.

The land approach had very often been a problem for the hosts in that the guests may arrive when the guards placed by the hosts are asleep after much feasting and dancing. The visitors might attempt to sneak in and seize the clapper of the EKPE bell and strike it abruptly to arouse surprise. The visitors would in the circumstance be around to defend their man at the bell from being lynched. This action of the visitors tantamounts to the hosts losing their EKPE and nationhood. It meant that the funeral obsequies could not proceed until the EKPE was redeemed. Unless the visitors had a hidden agenda, the EKPE was released on payment of a nominal fine in the form of extra entertainment for all the initiates present.

The river approach is more convenient because the aspect of surprise is almost absent. The visitors would normally cause the MBOKO to roar when the EKPE beach is signed. This serves as the arrival signal that enables the hosts to rush to the beach where welcoming ritual is performed and the visiting MBOKO received for safe keeping until the relevant visiting group is aboard and ready to sail for home. Departure may not take place until and unless a send-off ritual is performed. This normally includes take-home gifts. In practice the send-off ritual is the reverse of the welcoming ritual. It involves the return of the MBOKO to the owners. Unless this is done, the visiting group will be unable to move. They cannot move without their EKPE as this would mean a loss of their freedom and nationhood. It is in the interest of the celebrants to take custody of MBOKO of the visiting groups on arrival. Failure to do so may result in an enterprising visiting group laying siege to the MBOKO of the celebrant to cause them to lose their freedom and nationhood.

About 120 years ago, it was not possible for any important appointment to be made or business concluded without the prior approval of EKPE. If care was not taken, such actions could be construed as attempts to test the resolve of EKPE. In such situations EKPE response was usually high-handed and uncompromising. In 1875 King Archibong III of Calabar invoked EKPE power to ban trade on the Calabar River for a period long enough to cause Henshaw Town, Calabar, to lose heavily on salt contract involving some European traders.[6] Again in 1876 the missionary compound at Duke Town, Calabar, was sealed off my EKPE law

because three suspected criminals who sought refuge at the mission were not handed back, and work at the mission was paralyzed. EKPE proclamation read as follows: –

1. No one to carry provisions to the Mission house for sale or otherwise.

2. All gentlemen who had children or slaves residing with the missionaries must take them away instantly.

3. No one must visit the missionaries.

4. No child or slave to be sent to school.

5. No one to attend Church or Sabbath meetings on the Lord's day and no gentleman to allow God's word to be preached in his house.[7]

Over the years, EKPE fraternity has progressively lost its bearings as to what its true responsibilities should be. It started as a select group of people genuinely interested in the upliftment of souls but through pride and misuse of power, the fraternity degenerated into an instrument of oppression and terror. Unwittingly it was by the same token preparing itself for burial.

Nsibidi Cult

NSIBIDI are secret writings that employ symbolism, hieroglyphs, secret signs, sounds, colours and dance forms for secret communications and rituals. They are not limited to EKPE. In the past, they were extensively used in communication by all and sundry, men and women. Some made a game of it. Irrespective of the application it was essential to put oneself forward to be taught the NSIBIDI relevant to individual needs. Each NSIBIDI school had its area of specialization. The curriculum and characters were different. Individual needs and preferences had to be met. For example, EKPE being a secret society, its NSIBIDI are not open to non-initiates. For the reason of these peculiarities it may not be strictly correct in this instance to talk of NSIBIDI cult as this implies that once one had gained admission he or she is free to have as much of the NSIBIDI as he or she wishes.

In practice NSIBIDI cult was a publicly recognised group of rascals and hire-lings, usually second sons of blue blooded families, brought together by some influential people in society who having taken oaths of secrecy of membership, purpose and action, were released on society preferably in the silence of the night, as the need arose, to operate as executioners, extortionists and what have you, ostensibly working as the conscience of the people and for the good of society. Sign language enhanced their stealthy operations.

NSIBIDI EKPE is a natural ingredient of EKPE culture. Its use prevents unwanted intrusion of non initiates and the profane into EKPE secrets. To protect the secrets, voiced discussions about EKPE were not encouraged, except for songs and exoteric matters. The position is now different and profanity has taken root particularly in cosmopolitan areas. NSIBIDI literacy is no longer an attraction. The language characters were thought to bear some resemblance to Egyptian hieroglyphs and these have caused many to conclude that EKPE has links with Egypt. The original language is disappearing and those versed in it are not now readily available. For this reason work bearing on NSIBIDI EKPE requires further in depth research. There was a time when EKPE had secrets for the control and use of the elements, and created their hearts' desire out of nothing as it was meant to be at the beginning. This is not black magic. Man, even though he may not realise it, is continuously creating his heart's desires either through divine support or powers in rebellion.

In EKPE, as amongst the esoterist, the circle represents unlimited unmanifest or space and the dot the first manifest. EKPE rod signifies God's mind, thought and power. No. 3 indicates God's mind hovering above the unlimited unmanifest conjecturing whether to create and what to create. No. 5 shows that he has created. No. 6 is an indication that creation has progressed and there is variety. The series of actions may be taken as the descent of light into matter. At the mundane level No. 7, the EKPE drum, symbolises the universal womb and the rod by its side, the dormant spirit waiting to be powered or actualised. The word or power behind creation and the created are symbolised by EKPE sounds in variety. Each time the word issues forth out, a wish manifests as a child born with characteristics wished.

Figure 4 Some Esoteric Nsibidi

Colours play important role in EKPE and there is correspondence between tone and colour. Initiations and other rituals may not proceed without them. The colours are white, yellow, green, blue, orange, red, indigo and violet. An EKPE neophyte at the portal of initiation is routinely but carefully adorned with signs and symbols in colours of white, red and yellow – orange. White represents purity, red – suffering, and yellow – orange, spiritual endowment. The import is to imprint the teaching – "spiritual endowment will manifest on the psyche of initiates only through life of purity and sacrifice or renunciation."

During initiation signs and symbols of appropriate colours are painted on designated areas of the bare-bodied neophyte as the drums accompanied by songs bring forth music relevant to the grade into which the neophyte advances up the ladder of initiation. Music is Nsibidi. It aids evocation particularly when attended by dance forms, and helps to leave a near permanent imprint on the psyche of the initiate such that aside of the pass word, his status could easily be observed as he enters a really active EKPE Temple. Full initiation rites take a long time to complete. One has to have patience and allow oneself to be blind-folded with cloth tied over the eyes till the end of the exercise, when the initiate becomes aware, his eyes cleared and he is no more ignorant of the path. There should be a follow up bath of purification, 'UYERE MONG EKPE' as it is known in Efik. It is water baptism in EKPE. This is now no longer mandatory but is carried out discriminatingly. Ekpe forms are in insibidi.

Ndem Affiliation with Ekpe

The Efik believe that EKPE originates from NDEM, and the ancients believed in the existence of lives that control the elements of fire, air, water and earth known in Jewish Kabala as salamanders, sylphs, undines and gnomes.[8] These elements or nature-spirits known as NDEM in Efik are acknowledged in EKPE to correlate with human principles. (See Fig. 6) Although the existence of salamanders and sylphs may not be commonly acknowledged in Efik land, they nevertheless do receive some attention in EKPE at the EBONKO and NKANDA grades in their music, dance, EKPE forms, artifacts, EFAMBA and IKOT EKPE. These lives are confined to their own element and preferred habitat, never transgressing into or infringing the sanctity of the territory of others. To some extent, this is also the belief of the Efik. But unlike the Kabala, they do not openly confirm the existence of races and hierarchies within each habitat. According to the Efik, these elemental spirits are male and female. The earth spirits are believed to be mostly males whereas water spirits are females as a rule. Each city state of Efik has its NDEM, particularly the elemental spirit of water, a finny life many claim to have seen and which seems to be more popular, perhaps, because Efik are seafaring people. Pythagoras also believed that finny tribes swarm natural bodies of water, some friendly and some not.[9]

The various NDEM of the water element or goddesses as some would wish them to be addressed, have their habitat or domain detailed in Table 1. The land gods or gnomes are called EKPEYONG and are reputed to be demanding and stubborn.

Table No. 1 – NDEM and Their Domains

CITY STATE	NDEM
HENSHAW TOWN	SUNKO MONGKO
CREEK TOWN	AKPA UYOK
COBHAM TOWN	IBOKU ANWAN
OLD TOWN	ANANSA
MBARAKOM	EKA NDITO
IKONETO	AFIA ANWAN

Each city state of the Efik has its NDEM or god(dess) but no commonly acknowledged hierarchical relationship exist between one god(dess) and another of a different habitat. The fact that there are many such NDEM to which sacrifices are administered discriminatingly, especially as each NDEM has its High Priestess and devotees, may be proof that they possess polytheistic structure. This is confirmed by the practice of offering sacrifices at different times and at the habitat of the individual NDEM. To compound matters each city state extols its god(dess) and is unwilling to accept an inferior position for what it owns. Chief Ekpe Ekpenyong Oku who was regularly involved in the offering of sacrifices to NDEM during the reign of late Edidem Edem Esien Ekpe Oku, the OBONG of CALABAR (1973 – 81), when questioned about the hierarchies of NDEM replied:

> All the NDEM were taken as equals and so we sacrificed to all individually. It is not true that ANANSA is superior to the others. The others will not accept that ranking.

Exoterically, the opinion of Chief Oku is the more commonly accepted belief amongst Efik and it seems tenable when consideration is

given to the sanctity of each habitat as a preferred and reserved accommodation for each NDEM not known to have a hierarchical structure within the preferred domain. In practice, some NDEM of Efik are known to possess power of choice and seem to be capable of extending their area of jurisdiction beyond the relevant city limits recognised by the devotees to be the area of authority of their god(dess). Cases abound where people are proclaimed to be under the influence of an NDEM that should naturally not operate within the city unit of the victim, thus giving impression that some NDEM have leave to operate outside their normal domain but within the confines of their elemental nature. Should it be true that in reality such incursion into the territory of another do occur, it may be conclude that a hierarchical structure exist amongst NDEM of the same elemental nature. Although the concept of hierarchies of NDEM is not presented directly in EKPE, it could be inferred from the way EKPE is structured and organised.

Aside of the finny lives, the other most commonly assigned forms of NDEM are Python and White Bird. In general Efik believe, NDEM can take any form. In Blavatsky's opinion, they have neither immortal spirits nor tangible bodies but take forms that relate to the elements they belong in some distinguishing degree and are a combination of sublimated matter and a rudimental mind. They are therefore lower on the cosmic ladder than man. Some are changeless and have no individuality but others of certain elements and species change form. Also Efik, Blavatsky[10] and Prophet[11] all agree that under certain circumstances NDEM have the ability to make tangible bodies for themselves. Blavatsky went further to state that tangible bodies may assume a likeness of its choice by taking face portraits they find stamped in the memory of persons present. According to her, the most solid of their bodies is immaterial enough to escape common perception but may be recognised by inner vision. Stories abound in Efik land about goddesses of the sea presenting themselves as woman-fish lives before human.

An assessment of the value of NDEM in Efik society is a contentious affair. The majority of Efik tend to look at NDEM as worthy of worship and do worship them regularly for benefits. They believe that natural disasters, and most societal and personal problems are the responses of the NDEM to the people's nonchalant attitude toward them. The vocif-

erous minority take them to be devils. To appreciate the correct situation, it is necessary to examine some non-Efik opinions on the subject. It was stated earlier that Pythagoras considered the elemental spirits (NDEM) to be of two types, some friendly and some not. Tertullian called the elemental spirits of the air, princes of the powers of the air. Clement the Alexandrian, one of the greatest Catholic authorities, opined that it was absurd to call them devils, for they are only inferior angels, "the powers which inhabit elements, move the winds, and distribute showers and as such are agents and subject to God."[12] Origen is known to have subscribed to the same opinion.[13] It is Blavatsky's view that the elementals bring to light long forgotten events of the past, "preserved in the inscrutable depths of our memory."[14] Elizabeth C. Prophet is more forthright. She sees them as useful agents of God toiling for the good of man and therefore deserving the appreciation and gratitude of man.[15]

Should one think well of the elementals? Blavatsky disclosed that even though Baroness Adelma Von Vay of Austria saw and recognised the elementals and found them always friendly, many others did not fair so well at the hands of these spirits.[16] It all depends on the mind quality of the person attempting to relate to them. Naturally the bad must attract the bad; and the good, the good. This is a natural law. Therefore, according to Blavatsky, the Baroness was successful in cultivating friendly response because she was a good woman.[17] Many in Efik land have had terrible experiences with NDEM and are living in fear and deprivation even though they offer sacrifices and invest much in terms of time and money. According to Prophet the elementals as unascended beings are subject to the influences of the spectrum of relative good and evil. Therefore interaction would depend on the spirituality of the person establishing contact.[18] The writer is aware of one who nearly lost his life at the hand of NDEM were it not for the intervention of God. It did not arise from the man coveting it, but by it suddenly making his presence felt in a belligerent manner. Having the benefit of the hind-sight to this episode, it may be concluded that the man probably deserved what came upon him. He was not pure.

In another instance, the writer in the company of an aunt paid a visit to a senior family member he had never met before. The man, now deceased, was a headmaster of a renowned school in Calabar. The writer

was surprised to find him living in a state much below what his status should have endowed him with. The threads that made up what he wore barely held themselves together and his living room confirmed that he was living in want. After a brief discussion, it had to be so because the sight was disturbing, the visit was about to be terminate when the man announced – "never name your child EKPENYONG." It was a shot out of the blue and the writer was shocked into retorting – "Why not?." He then took us behind his residence to a small hut to which a door of convenient size was fixed. As all stood, he bent forward and administered three knocks to the door with his right hand. Each knock was followed by him seeking permission to present the guests. Not knowing what to expect, the writer was well positioned to move back on the double should it become necessary. After the third knock, he opened the door that gave access to the hut. Suddenly, we were before a roughly sculptured wooden bust bearing a hawk feather secured firmly to the head with a red ribbon. There was grave yard silence. The writer was overwhelmed with amazement having not had such an experience before. After allowing the shock to firmly register on the guests, he spoke with abandonment – "That is him. I spent all I ever had sacrificing to him but he will not let me go. Since it was affecting my job the priest got EKPENYONG's permission for me to take him home so that I may be able to attend to him regularly and properly." Here again the indication is that the man was probably not a good person.

Reverend Father Offiong is of the opinion that NDEM are beautiful and useful. In this he seems to share, to some extent, the opinion of Elizabeth Prophet. Offiong states that NDEM –

> *has nothing whatsoever to do with human sacrifices or destruction of human life in any shape or form. On the contrary it aims at saving life and bringing more children from the deities into the world.*[19]

In contrast Elizabeth Prophet states "that some category of these elementals wield the fire of atom and molecule and hold the balance for the continents through cataclysm, flood and fire."[20]

Even though the usefulness of these elements is acknowledged by the majority of Efik is it right to worship them? Does show of gratitude recommended by the Prophet imply worship? Is there any substantial

difference between an offering and a sacrifice? If there is, which is the offensive aspect? Is it the intention and purpose back of action or the action per se? On its own, an offering does not imply worship but recognition. Appreciation, gratitude, and, perhaps, respect not occasioned by acknowledgement of superior status of the recipient. Few, if any, will consider the action offensive because the purpose and intention back of action is clear and pure in this case. This is not so when sacrifice is involved. Sacrifice implies worship even though no blood may be spilled. Some may not accept that difference exists between offering and worship. To them it is an exercise at splitting of hairs. Be it as it may, the purpose and intention behind the actions determine classification of the activity as either good or bad. There could be no other simple or rightful criteria. In Efik land, the intention of NDEM devotees is worship. To them, he is god(ess). It is doubtful if Elizabeth Prophet intended that the elementals (NDEM) should be worshipped. EKPE initiates sacrifice only to EKPE, the God of the earth, but recognising the roles played by these elementals, show recognition and appreciation through the medium of music, dance, EKPE form, EFAMBA, IKOT EKPE and appropriate acclamations.

Admission of NDEM Efik, as presently visioned, into EKPE pollutes it and encourages conflict. Firstly, EKPE tradition does not encourage worshipping of any power except God known esoterically as EKPE. Secondly, sacrifices are offered separately and at different places to EKPE and NDEM. Thirdly, women are often the High Priestesses of NDEM. It is unthinkable for a woman, no matter how elated, to be allowed to direct EKPE affairs. For these reasons, the relationship between NDEM and EPKE should be examined more closely. The injection NDEM into EKPE the way it is now done probably arises from a misunderstood role of NDEM in life. Worthless teachings assign god status to NDEM whereas as agents of God and servants of man they endow the elements with life and maintain the balance of life. When salamanders fail to perform the process of decay and disintegration is immediately set in motion. Gnomes are the transmitters of the love of the Comforter through the beauty and caring of nature for God's children. Sylphs serve as giant transformers, conductors of the currents of the Mind of God unto the mind of man and are the students of the mysteries of the concentration and contain-

ment of the life-forces. Water represents the subconscious mind and the undines bring out the memory bank materials and records for the soul to perfect the divine plan of life. Salamanders, sylphs and gnomes are believed to carry the burden of darkness in order that Light may be revealed.[21] The conclusion is that the elemental spirits (NDEM) are useful as:

i) agent of EKPE our God;

ii) Servants of EKPE, the man in his quest to become a son of God;

iii) EKPE in microcosm. These are elemental lives charged with responsibilities for the good of man provided man subscribes to a life of purity and service.

Initiates of EKPE are encouraged to deliberately apply their genii to understand the workings of the elementals (NDEM) for the good of society. Understanding the workings may lead to the control and use of the elements from which all things were made. It may then be said that the elementals (NDEM), the power behind the elements, the agents of God and servants of man, originate EKPE, the swarm of created beings. The initiates learn early to look with shuddering fear at physical fire, the manifestation of the spirited fire worked upon by the Holy Spirit. This is out of respect for the consuming fire of God. According to Prophet, "the elementals of the sacred fire are capable of wielding the most intense fires of the physical atom as well as the spiritual all-consuming fires of God and are the connecting link for the service of sylphs of the air, the undines of the water, and the gnomes of the earth."[22] When these are considered along with the fact that uncontrolled and destructive fires correlate with the existence of uncontrolled and destructive energies of mankind, it would not be surprising if a call is made for the law of compensation to exact the price for mankind's misuse of energy. The likelihood of that occurrence causes EKPE the man, to be afraid of the outcome. The need to be careful is the more relevant and necessary when it is realised that the elements are fires of one form or the other, namely: – Fire; fluidic fire (air); liquid fire (water) and solid fire (earth).

Ekpe Temples

The respect and recognition given to an EKPE Temple depend on the assessment of its worth in exoteric and esoteric terms. During the process of exchange of visits, much learning and examination take place. The oneness that is EKPE is organised under ten departments or houses (UFOK) as is commonly called in Efik. Each of these houses accommodates keys to differentiate principles or divinities cared for by the EYAMBA and which are acceptable and respected by temples across the land and beyond.

At the head of each EKPE house is the OBONG for that House. He is assisted by other title (IDAHA) holders of subsidiary grades who may be addressed as: ISUNG (Master of ceremonies); MURUA (announcer, communicator); ISU (harbinger) and EKUNDU (transporter) as may be appropriate. For example, there is 'EKUNDU OKPOHO' and never 'EKUNDU ISUNG OKPOHO'. Each IDAHA subsidiary to the OBONG holds keys to subsidiary principles to be activated under the assistance of relevant EKPE House or divinity as they may be called. Classically, there is but one OBONG per House. The other title holders are addressed in accordance with their roles e.g. ISUNG NKANDA, MURUA NYAMKPE, EKUNDU OKPOHO, as the case may be. In Efik land, the OBONG is the adept. As it has turned out in practice, an OBONG is not necessarily an adept. The conditionalities for acquiring the adept status had long been dropped. The result is that the fraternities are invariably without adequate guidance. The boat is now rudderless!

In the physical body situation and correlating with the Kabala, EYAMBA represents nature; NKANDA – life; EBONKO – organic organisations; OKU AKAMA – anabolic process; MBOKO – central nervous system; NYAMKPE – administration; (M)BAKARA – communication systems; MBOKO MBOKO – automotive system and MKPE – special sense organ. In terms of government, EYAMBA represent the people; NKANDA – the genius of the people; EBONKO – the constitution; OKPOHO – powerful elders of the land; OKU AKAMA – the warriors; MBOKO – the parliament; NYAMKPE – general administration operating irrespective of which party is in power; MBOKO is the foundation of the nation and MKPE represents the kingdom. The com-

monly appreciated function of EKPE is governance and this is errone-
ously taken as the only serious purpose of EKPE.

EKPE Temple is a functional 4-sided building. The architecture signi-
fies solidity and completeness. It has an open hall to which entry may be
gained through a veranda with a low wall of about 1.00 meter high fronting
it. Two entrances that may be locked link the veranda to the open hall.
The wall facilitates the use of NSIBIDI to test the awareness of those
seeking entry. The front and back of the hall have full height walls. There
are rooms behind for arcane studies. There is usually a connecting door
leading from the general hall to the reserved section and there is a secret
exit door serving the inner chambers. An appropriate UKARA hanging
over the door covers a good area of the back wall to the hall, and cordons
off the inner chamber from unauthorized persons. Two non-load-bear-
ing pillars, usually of wood permanently engraved with NSIBIDI EKPE,
are founded on the veranda and stand between the two entrances. These
are the OKPOHO (wisdom) and OKU AKAMA (strength) pillars known
in Jewish Tradition as Jachin and Boaz and in Masonic Tradition as Solo-
mon (wisdom) and Hiram (strength) pillars. The third pillar, if it exists,
is either within the hall or at the MBOKO room. This is the MBOKO or
Hiram Abiff (beauty) pillar[23] where according to the Egyptian legend,
Isis (EBONKO) is supposed to have hidden the body of Osiris (MBOKO)
at Byblos from Typhon.[24] Below is the list of EKPE Titles in Efik land.[25]

1. OBONG EYAMBA EKPE

2. OBONG EBONKO EKPE

3. OBONG NKANDA EKPE

4. OBONG OKPOHO EKPE

5. OBONG OKU AKAMA EKPE

6. OBONG MBOKO EKPE

7. OBONG NYAMKPE EKPE

8. OBONG (M)BAKARA EKPE

9. OBONG MBOKO MBOKO EKPE

10. OBONG MKPE EKPE

11. ISE MONKO EKPE

12. ISUNG EBONKO EKPE

13. ISUNG NKANDA EKPE

14. ISUNG OKPOHO EKPE

15. ISUNG OKU AKAMA EKPE

16. ISUNG NYAMKPE EKPE

17. ISU NKANDA EKPE

18. MURUA NKANDA EKPE

19. MURUA OKPOHO EKPE

20. MURUA OKU AKAMA EKPE

21. MURUA NYAMKPE EKPE

22. EKUNDU OKPOHO EKPE

23. ISU EKPE

Much care is taken on how to site the Temple. There exists the strong belief that the temple should face a natural body of water. despite this belief it has not always been possible to satisfy that condition. Since a river does not, as a rule, flow along a straight channel with parallel banks from source to its mouth, it may be absurd attempting to enforce the rule in every case. Even though the practice of immersing neophyte in water is no longer a regular practice in Efik land, it is still the baptismal practice at USAK EDET (Isangele) after which he emerges purified, this aside of initiation into the BAKUNDI NYAMKPE grade for the initiate to become an adept. It is even suggested that the Pharaohs of old provided baptismal font for that purpose within the Pyramids.[26] Down the ages water had been known as a purifying agent. The Essene used it.[27]

There are also those who by virtue of their interest insist on conditions that suit them. Those who are NDEM worshippers will naturally insist to have the temple properly located and oriented for their needs. Closeness to natural body of water aids evocation and invocation of elemental spirits of water which as earlier stated above are commonly referred to by the generic term 'NDEM' in Efik. The presence of a body of water also facilitates the operation of (M)BAKARA, the hermaphrodite, at home on land and in water. It has to do with change of state from solid fire

(earth) to liquid fire (water).[28] The colour usually assigned to (M)BAKARA is red but this may not be the appropriate colour.

Figure 5 NKANDA Equipment

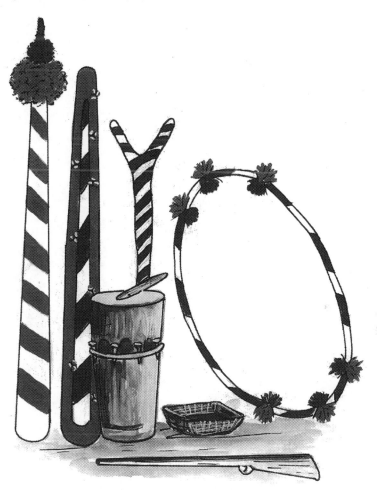

Women and Ekpe

Amongst Efik EKPE legend has it that a well connected woman named MBANG discovered EKPE (MBOKO) floating in a river when she went fishing. Rather than bring it to the notice of her brother MUTAKA whom she met on her way home, she elected instead to reveal the secret to her husband NKUK AFUTA who subsequently brought it to the notice of

elders of the race EYO EMA and ESIEN EKPE. The three males came to the conclusion that the event was unlikely to remain a secret unless MBANG was put away. This may be the origin of the common belief that men wrested EKPE wisdom from women. In comparison, the Osiris (MBOKO) legend of Egypt states that Osiris was slain through the cunning of his brother Typhon (emblematic of the destructive aspect of nature), and his body placed in a box and thrown into River Nile. After a long search Isis (EBONKO) found him and hid him where she felt was safe. Unfortunately, Typhon found him and cut him into pieces, but he was brought back to life through the wisdom and magic of Thoth (NKANDA) who, being enraged by Isis (EBONKO) for the help she surreptitiously extended to Typhon when he waged war against him, killed her.

Figure 6 EKPE and Human Principles

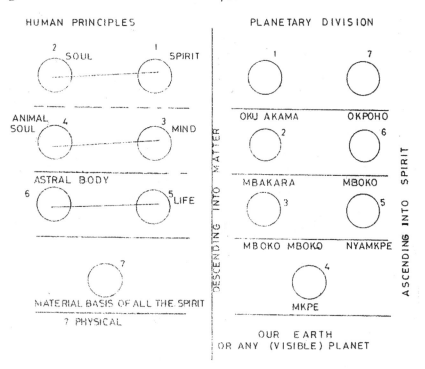

Even though Moses is suspected to have exported Egyptian Theosophy into Israel, the Chief Priests whose job it was to deal with the masses'

discriminated against women. Most probably it was not the practice amongst the Egyptians. The inner teachings of the Egyptian temple were brought to Moses by Queen Batria, Pharaoh's wife who was herself an initiate of the Egyptian temple. Also, Pharaoh Akhenaton was taught by her mother, Queen Tiy, and it is unthinkable that she could have done this effectively without being an initiate herself, especially as it was Akhenaton who attempted to abolish the polytheistic practices of the Egyptians. Most probably since the Egyptians were accepted to be more civilized at the time than the Israelites, their women were more emancipated. The attitude of the prophets of Israel was different. Some women, notably Deborah[29] and Huldah were prophetesses.[30] These prove that God does not discriminate against women.

In sub-Saharan Africa women are considered to be inferior to men and the origin of EKPE is not something found by the river side as some have come to accept. How come it then that the Efik hold the view that women were the original custodians of EKPE knowledge? Of course, if Moses the father of Israelite Theosophy was discovered at the bank of a river by a woman, the daughter of Queen Batria as history tells us, those who trace the origin of their EKPE knowledge to Moses may claim that EKPE was discovered by a woman. It is true that in EKPE terms, Moses may be regarded as EKPE. On the other hand, those who feel happier to trace the root of their EKPE to Egypt and were involved in the dispersion that attended the death of Pharaoh Akhenaton, the founder of Monotheistic Religion in ancient Egypt, may claim that since it was Queen Tiy who passed on the inner teachings on monotheistic worship to her son who attempted to popularise it, she is the root of EKPE.

What is perhaps more likely to be true is that the four appearing behind the veil at EFAMBA are used allegorically to represent what is known in arcane wisdom as the sacred Four, the externally self existent one (external in essence not in manifestation and distinct from the universal one), otherwise known as Tetraktis of Pythagoras.[31] This foursome comprise three males and a female whom if the teachings were correctly followed would have allowed MBANG to secure a berth at the EFAMBA and perhaps MUTAKA to be dropped. This inaccurate representation of the teaching is suspected to be what the profane refers to as woman being tricked out by men. It must be admitted though that the story has been

peddled for so long that it has wrongly been accorded acceptability. If EKPE is taken in macrocosm and in variety, inner teachings hold that the Divine Immaculate Mother-nature preceded human life. In the extended sense, it may be conclude that women are the custodians of EKPE.

Whatever is the origin and status of the claim, it is true that women are residing in what is generally accepted to be a man's world, particularly in tropical Africa. They have been distanced from full EKPE initiations because of male chauvinism and the real fear arising from most women's inability to keep secrets. Talking is one of the pastimes of most women, whereas in EKPE silence is golden and is deliberately cultivated. In real terms, the so called women initiation is a cosmetic gesture designed for social events. It starts with the painting of white rings on hands and legs, and end with the firming of a peacock feather on her head. It has no effect on the psyche. By this restriction, women are not really members of EKPE fraternity. It is against natural justice to deny any self respecting person the right to awaken God's endowment.

Chapter Five

EKPE Initiation

Up to the first quarter of the 19th century, EKPE initiations were reserved for nobility simply because knowledge that was not commonly available was imparted in the temples away from common view. And knowledge, as they say, is power. With it much was accomplished, including keeping the masses on tow. In time, the initiates began to enjoy the spoils of power and this in turn led to blatant abuses against society, particularly women and slaves. As time moved on, selfish interest took a better part of the initiates and brought them to agree on symbolic initiation of slaves, non-indigenes and some women who were members of the blue-blooded class. The nobility having engaged much of their time on feasting, wining and dancing, particularly after materially-rewarding mercantile links were established with England, soon found that male slaves were increasingly being harassed while trading for their masters. Also, there arose the need to motivate an industrious and trusted slave who through hard work had become a pillar of the family within which he was serving. Having rewarded them with the marriage of blue-blooded daughters of the family, room had to be made for them and their male descendants to be free in all respect, including right to initiation.[1] A new policy was designed for that purpose and it states:

Irrespective of the social status of the husband, a blue-blooded women cannot give birth to a slave.

Under the weight of ignorance much of the masses remained docile. Throwing its divine teachings and tenets to the wind, the initiates continued the practice of using their positions to debase the less privileged in society. Such inhumanities saw the birth of a whirlwind that brought no good, and soon, an avalanche put into motion currents of decadence that swallowed up the spirituality of the fraternity. One by one the real adepts were called up to higher octaves of existence and those who were left, on discovering they were deprived of the divine spirit, admitted sorcerers, black magicians and others of their yoke into the fraternity. These upstart powers helped in boosting the image of the fraternity amongst the ignorant and gave the initiates a false sense of power, while the Houses soon became acknowledged Houses of horror. In time, the purveyors of these powers took control of the fraternity and the purity that is EKPE was no more.

The abuse of EKPE power together with the excesses highlighted above under the heading "Law and Politics" caused the loss of the intrinsic value of EKPE and encouraged the growth of alternative value, the conversion of EKPE into a commercial enterprise. It was no longer necessary for a candidate to subscribe to acceptable moral values. All that was necessary was ability to pay what was demanded by both the candidate's sponsor and the fraternity. The procedure did put sever strain on the purse of candidates who had to pay a not previously disclosed amount up front to every initiate of the temple into which admission was sought. The total number of initiates was never disclosed before hand to the candidate. If it happened that the money made available to the sponsor was inadequate to cover the fee fixed as the entitlement of each initiate on the roll on the day appointed to consider the eligibility of the candidate, the examination was brought to an abrupt end and the candidate was deemed to have lost all that had been paid out. He was entitled to other attempts if he so desired. Despite the high-handedness, the prestige that attended initiation and the business gains accruing, guaranteed a continuous flow of candidates and caused a ban to be placed on initiation outside the Efik metropolis where the ETUBOMS, the Heads of Efik Royal families, have their official residences. Even then, it was mandatory for initiation to take place before a minimum of two MBONG EKPE (full adepts) of the relevant temple. Non-compliance was treason

and the penalty was death.

For some time nobility was able to reserve the adept position for themselves. The blue-blooded families who had managed, often through intrigue and trickery, to corner one or more such positions guarded them tenaciously lest they slipped into the custody of expecting and willing hands of another family. A Royal House that has no access to an OBONG EKPE position is not entitled to the Paramount Ruler's seat, for example, that of the OBONG of Calabar. The practice allows a family to hang on to the position for eternity, unless it slips off through carelessness. For this reason, the demise of an OBONG EKPE is a well guarded secret of the family until a blue-blooded member is available to lay claim to the seat in a prescribed manner before death is announced. The claim is filed before the OBONG EYAMBA or an available most senior OBONG EKPE by EKPE ranking. Candidates for OBONG EKPE status were required to be house-owners and married. They were expected to have recognisable and acceptable sources of livelihood, and not be charlatans. These conditions have to do with the need to maintain the honour and dignity of the fraternity, and as prerequisites for teachings on renunciation. Unfortunately, the demands have long been waived resulting in lapses in moral values of initiates and adepts. Neophytes were expected to have been 'born again'. Their character should be impeccable and they should not be flippant. They were placed under observation for some time and must have an OBONG EKPE as sponsor. Not less than a day was required for the neophyte to finally purge himself of unwanted habits and refrain from sex before presenting himself for initiation. He had to learn to regulate his sex life.

According to Rosicrucian Teachings, initiation offers a more direct route to soul awareness which ordinarily would take a much longer time to acquire. The pilgrimage of the soul through life is embodied in the Caduceus or Staff of Mercury (Fig. 7) and indicates the path of initiation open to man since the beginning of the Lemurian and Atlantean times of the Earth Period. It was only after the three and a half rounds of that period that humanity was introduced to the Four Great Initiations. The black serpent of the Caduceus indicates the winding cyclic path of involution comprising Saturn, Sun and Moon Periods, and Mars half of the Earth Period during which the evolving life built its vehicles. The

white serpent represents the path that humanity follow through the Mercury half of the Earth Period and the Jupiter, Venus and Vulcan Periods during which pilgrimage man's consciousness expands into that of omniscient, creative intelligence.[2]

Figure 7 The Caduceus

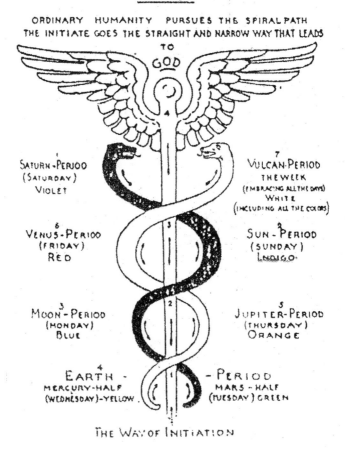

THE SEVEN DAYS OF CREATION
AND
THE FOUR GREAT INITIATIONS

ORDINARY HUMANITY PURSUES THE SPIRAL PATH
THE INITIATE GOES THE STRAIGHT AND NARROW WAY THAT LEADS
TO
GOD

SATURN-PERIOD
(SATURDAY)
VIOLET

VULCAN-PERIOD
THE WEEK
(EMBRACING ALL THE DAYS)
WHITE
(INCLUDING ALL THE COLORS)

VENUS-PERIOD
(FRIDAY)
RED

SUN-PERIOD
(SUNDAY)
INDIGO·

MOON-PERIOD
(MONDAY)
BLUE

JUPITER-PERIOD
(THURSDAY)
ORANGE

EARTH -
MERCURY-HALF
(WEDNESDAY)-YELLOW

- PERIOD
MARS - HALF
(TUESDAY) GREEN

THE WAY OF INITIATION

EKPE subscribes to the concept of septenary cosmos with the seven planes corresponding to the state of consciousness in man. This is another way of saying that man has to tame the lion in himself. In EKPE

the neophyte is expected to meet the basic moral standards set, be of amiable disposition, be trust-worthy and not flippant. Before he is allowed to present himself at the Portal of Initiation, he should have been 'born again,' that is, given up bad habits and be vouched for. The divinities are expected to play their part during initiation by releasing appropriate energies as the relevant colours and symbols are painted on the spots having correspondence with the divinities. Normally, the raising of consciousness is expected to be actualised as the initiation proceeds from past planetary rounds to future rounds. The secret signs and symbols are painted with appropriate colours (after the order of the Caduceus) on designated spots on the bare-bodied neophyte who, because of obscenity, is allowed to barely cover his nakedness. (See Fig. 10 & 11). While this is being done, singing and drumming relevant to the EKPE grade or House into which the neophyte is being admitted, ring out. The exercise is attended by the seven rounds of group drumming and singing relevant to the grade or House in staccato. This is indicative of the septenary globe cycles and rounds undertaken by the monad. The ceremony is punctuated from time to time by the MBOKO roar appropriate to the principles and divinities being invoked/evoked. After the initiation, the new initiate is taken on a tour of the relevant EKPE House where the secrets are revealed and teachings imparted on a person to person basis. The initiate is then considered ready to proceed systematically, but not rushed, up the ladder of initiation. Using this technique ascent is safely made from earth to heaven while the man is still in the flesh. In modern times, the septenary group drumming is reserved for the OKPOHO initiation. Time had become a valuable commodity.

OKPOHO is an important station with a host of **nsibidi** and symbolism. It is where the initiate is expected to stand before the Mighty King, OBONG OKPOHO and his Council of Ministers, to be examined on whether he is worthy of the secrets behind the inner veil. The initiate has to prove he is familiar with the tenets and workings of the lower orders. Aside from being knowledgeable in some aspects of NSIBIDI, he should be familiar with some of the fundamental issues. The initiate must, amongst other things, know that, (i) except for music and MBOKO trumpeting, initiation must proceed in silence; (ii) naked fire is prohibited; (iii) gun shot is prohibited except when occasion demands, and (iv) it is

beneficial to pretend to be ignorant but alert when visiting another temple. The principle of man for which the keys are located in OKPOHO House is spirit. At OKPOHO the adepts and full initiates examine the desirability or otherwise of proceeding with the initiation to the higher grades of pure spirit. Unless one has someone who knows the way, there is the possibility that the whole exercise may be a nullity. It happens when the correct procedure is not followed and this may be deliberately organised.

Figure 8 Caduceus, the basis of EKPE Initiation (Alternative A) after the Order of Gupta-Vidya Cosmogony

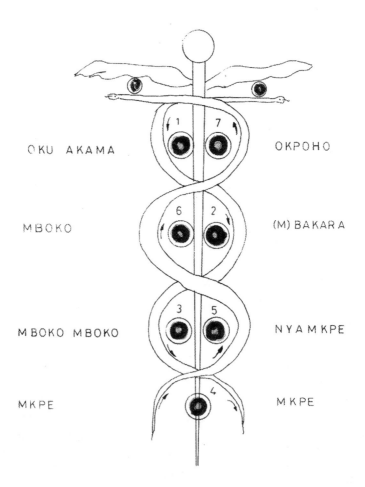

OKU AKAMA OKPOHO

MBOKO (M) BAKARA

MBOKO MBOKO NYAMKPE

MKPE MKPE

Figure 9 Caduceus, the basis of EKPE Initiation (Alternative B) after the Order of Chaldean Kabala

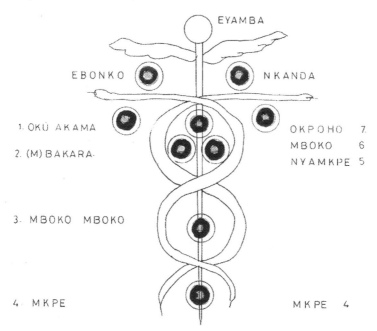

EYAMBA

EBONKO

NKANDA

1. OKU AKAMA

2. (M) BAKARA

OKPOHO 7.

MBOKO 6

NYAMKPE 5

3. MBOKO MBOKO

4. MKPE

MKPE 4

Each OBONG EKPE (Adept) has a corresponding divinity in the outer realm of existence that he should be in conscious rapport with if he knows his onions. An initiate is encouraged to understand the workings of the House (Globe) into which he is initiated. One may enter a House to which he is not an initiate at the pain of grave bodily harm. In the olden days, the price for such an indiscretion was death inflicted by man. It could also be death caused by improper arousing of a divinity. Whilst conducted tours of an appropriate House were encouraged, one could not exceed his limits. The focus is personalised and the initiate should not advance unless he has matured in the preceding House(s). Each time a temple meets in conclave procedural and NSIBIDI tests are set and the initiates are encouraged to respond in the presence of all. Success leads to fame and respect for the individual and his temple. Failure is a disgrace for all. This may be the reason why some temples outside Efik land invest in unorthodox methods though the use of secret processes to enhance memory, perception and manifestations. These are suspected to be black magic practices that are not encouraged in **EKPE** Efik.

Figure 10 Initiation symbol after the Order of Gupta-Vidya
 Cosmogony

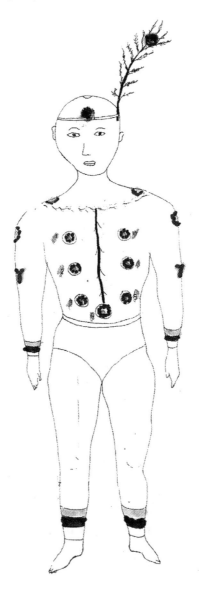

Figure 11 Initiation symbol after the Order of Chaldean Kabala

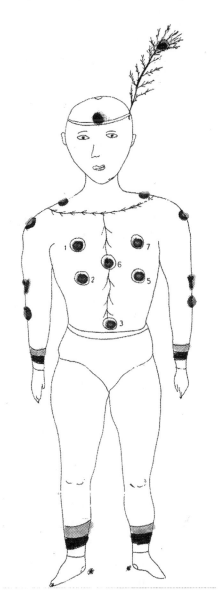

The organised focus of the EKPE House or Globe as they are called in arcane doctrine is the concept of planetary chain and Rounds, and Globe cycles.[3] According to these teachings, of the seven globes in the earth

planetary chain of the Earth Period only our earth is visible and man bearing at this time. EKPE enables man to visualise and appreciate the principles for which each of the seven globes are the key bearers as if all the globes of the chain were visible. This visualisation is an aspect of the re-capitulation exercise which is part of Rosicrucian teaching.

EKPE goes even further to reveal the qualities of incoming human generations. The EKPE Houses (Globes) taken as forming the earth planetary chain are OKU AKAMA (1) (M)BAKARA (2) MBOKO MBOKO (3) MKPE (4) NYAMKPE (5) MBOKO (6) OKPOHO (7).

Ekpe Forms and Imageries

Life, according to esoterists, is cyclically organised. When taken at the individual soul or world soul levels, EKPE may be conceived in the cyclic order after the cosmogony concept of the East and West. The result of this application is given in Fig. 12. Applying the Rosicrucian tenets, the positions of the EKPE Houses in the cycle may be taken as the stages of man's development in relation to God. These positions are embodied in the paraphernalia of the individual forms, imagery or masquerade. They also show that the fall of man will in time lead to the rise of man. For example, the inner man is discernible if some of the forms are closely examined particularly amongst the EKPE at the lower positions. The mesh covering of some forms reveals the inner man within the mesh. The (M)BAKARA position indicates the time before separation into sexes, a change or an impending change of status. Its imagery is Hermaphrodite and its mundane form is crocodile, or another reptile at home on land and in water. (M)BAKARA display is rarely staged because it is supposed to signal the death of an important personality. Its appearance is a public announcement of an impending transition, the separation of the soul from the body. In India, the sign called Makara is connected with the birth of the spiritual microcosm, and death or dissolution of the physical universe (its passage into the realm of the spiritual). Its symbol is the crocodile.[4]

After the separation, that is during the third or Moon Round of the Earth Period, a naked man MBOKO MBOKO known in the Kabala as Adam (ethereal), appears in the scene. The EKPE form carries a fish trap,

ESAK in Efik, an indication that he has to bear his burden. A record says "You will have to work hard and sweat."[5] The treasured companion MKPE (Eve) subsequently took a very low position in relation to God. Her constitution had to be consistent with that of our Earth at the time. She had acquired a full mesh (net) covering over her real form, a coat of flesh as the Bible puts it. Having aged, the status of the soul of the woman improved until the fifth or Jupiter Round is reached when she will take the naked posture again, the body constitution having changed to become less materialistic and physical. This is the NYAMKPE position. In this position she from time to time earns elevation in spirit. By the time MBOKO is reached and that is the sixth or Venus Round, there is no longer any difference between man and woman. All earthly desires are gone. Man and woman become one through life of discipline, sacrifice and purity. This is the Throne of Solomon otherwise known as the Christ centre. It is one of the most guarded secrets of EKPE lest the knowledge be abused. History also has it that the Throne of Solomon was attended by twelve lions, signifying that death awaits an impostor. At this position he begins to open up to the wonderful possibilities that exist for man. At OKPOHO, the seventh or Vulcan Round, the man becomes a Mighty King, correct and right in his words, actions and thought. He is wise, he is exalted to inherit the earth. He is at a higher rung of the spiritual ladder than its correspondence, OKU AKAMA. He has "transfigured." NKANDA as part of the triune delegation of EYAMBA, NKANDA and EBONKO seated in the Region of the three higher planes of septenary Cosmos, is represented by a bearded old man, wise in every respect, submitting only to the will of God with whom he is in near perfect communication. At the EYAMBA level, man is at-one-ment with God. "You are gods" is a well known saying.[6] EBONKO is represented by an old chaperon caring over the weak ones mothered by her. She (EKA EKPE, Mother of EKPE) has lost a measure of spirituality when compared with EYAMBA representing The One, but is still highly spirited and her representative form of its formless status confirms this. The body covering is silky cloth, indicating she is highly ethereal.

The comparative diagram of Fig. 12 demonstrates the Eastern and Kabalistic concepts of World Cosmogony[7] vis-à-vis the EKPE equivalent. Some may hold the view that the EKPE system fits more closely to

the Kabalistic concept when EKPE is considered as unity. It is the position of MBOKO (Tiferet) in relation to the other EKPE Houses or globes described in Western Doctrine that makes the difference. In the case of Kabala the MBOKO (Tiferet) is shown as having easy direct links with the other Houses or Globes of the system, and in a controlling position. These Globes are houses of differentiated divinities that are not self-existing. The three upper globes are located within the three higher planes of consciousness, revealed and explained normally only to initiates of the higher orders (See Fig. 12). The lower ones represent the four lower planes – the lowest being our plane or Globe or MKPE House or the visible universe. The Globes or Houses located within the three higher planes of consciousness are in the realm of pure spirit and are known in EKPE as EYAMBA, NKANDA and EBONKO Houses. These are visualised within, the objective universe as the relevant EKPE forms (masquerades). The symbolisms may be of universal application. The Eastern and Rosicrucian cosmogonies are useful when consideration is evolution. Applying this to EKPE and employing the relevant EKPE forms, the effects of involution and evolution are identifiable, and the contribution of each EKPE House or Globe, as it is called in the East, could be recorded.

Applying the Rosicrucian concept of Recapitulation of Round activities, which states that before the activity of any Period can start there is a recapitulation of all that have gone through before, it may be concluded that during the Earth Period, OKU AKAMA relates to the first or Saturn Round activities; (M)BAKARA relates to the second or Sun Round activities; MBOKO MBOKO – the third or Moon Round; MKPE – the fourth or Earth Round; NYAMKPE – the fifth or Jupiter Round; MBOKO – the sixth or Venus Round; and OKPOHO – the seventh or Vulcan Round. It should be remembered that the names given to the Rounds have no relationship whatsoever with the physical planets bearing these names. If the writer's experience could be relied upon, the concept of recapitulation of Round experience is valid and operational, but one is unable to attribute the experience to EKPE Initiation.

Man in the First Round and First race on our Earth is acknowledged in arcane studies to be spiritual within and ethereal without. He is more or less, like a phantom and not a tangible being. He was non-intelligent,

super-spiritual and sexless. The ethereal body was monstrous but compatible with his coarser surroundings. The First Round First Race man is symbolised in EKPE by OKU AKAMA, the EKPE form or masquerade well equipped for demolition. Its body covering is cloth of dark bluish hue. This signifies the ethereal nature of this man's body. The deformed conical head covering is an indication that although the First Race man was highly spiritual during the First Round, he had nevertheless departed from the realm of pure spirit, part of his spiritual constitution having given way to the growth of ethereal body. The degree of disformation or distortion of the head covering is a measure of man's spirituality. The wing or hat as it is commonly called, located at the back of the head, is fixed and bears small mirrors judiciously place to harness the energy of the Central Spiritual sun. It serves as a sort of disc to absorb the supreme solar energy and is a symbol of power. This proves that the divinity back of form is not independent and the man is non-self existing. It also proves the reality of God. The wing is fixed and non rotatory because the Race is not yet far removed from the energy source. Even though OKU AKAMA is taken to be positioned on the Tree of Life on the column of femininity, he is sexless and without identifiable eyes as we now know them. OKU AKAMA is animalistic in form. The Elephant and her baby represent it.[8] This is aptly demonstrated in its dance form. He is Horus of Egyptian Theosophy.

The Round Two First Race man was still gigantic and ethereal but growing firmer and more condensed in body, more physical and of the Sun Round. He was still less intelligent than spiritual for the mind is less susceptible to change than the physical frame. He may be best described as being of psycho-spiritual mentality with ethero-physical body. The (M)BAKARA EKPE form (masquerade) fits that description. He is an hermaphrodite and has no visible eye but can perceive. It is the EKPE most associated with the physical element, water and is not too far removed from the form we know. The body dress of reddish hue is mainly raffia netting with limited covering of cloth of similar hue as skirt. It may bear two short but permanently fixed reddish ABASONKO on the forehead and at times there may be a similar one at the back of the head. The indication here is that the physical body is taking over fast from the ethereal. In short the (M)BAKARA may be said to have an ethero-physical

body. The androgynous status brought him into the realm of psychology and inner characteristics may be described as psycho-spiritual.

Figure 12 World Cosmogony

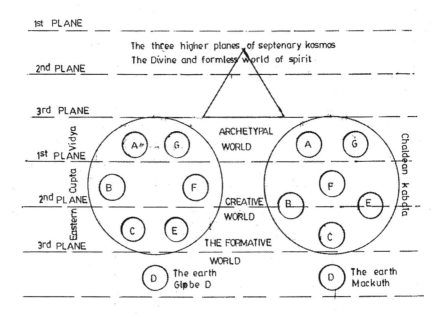

GLOBE	EKPE
A —	OKU AKAMA
B —	MBAKARA
C —	MBOKO MBOKO
D —	MKPE
E —	NYAMKPE
F —	MBOKO
G —	OKPOHO

The Round Three First Race man had acquired a perfectly compacted body and was becoming rather cunning than spiritual. He was three eyed. In EKPE the one at the back of the head is often indicated by a special ABASONKO known as ESAK (fish trap), flexibly attached. This is considered to be adequate identification. The body is raffia netting with a limited cloth skirt. The ESAK represents a trap for man's burden that will

result in the loss of the third eye or spirituality. The Round Three First Race man is aptly presented in EKPE as MBOKO MBOKO. Being on the downward arc of the planetary Round he had reached a point where his primeval spirituality was eclipsed by developing mentality. Eastern doctrine states that his gigantic structure decreased and his body improved in texture with him becoming a more rational being during the last of the Third terrestrial cycle.

In the Fourth Planetary Round the First Race man had his intellect through enormous development, and dumbness gave way to the development of human speech which is perfected during this Fourth Round experience on our planet. In the course of time the third eye was gradually petrified and lost because of his inability to properly bear his burden. Strictly keeping to arcane teachings, it is only from the time of the Atlantean of the Fourth Race of the Fourth Planetary Round that one ought to speak of man even though his physical frame was larger than now. He is represented by MKPE symbolised by a young woman with two eyes, she having lost much of her spirituality signified by the third eye.

EKPE forms or masquerades may be conceived as arch types or models of men appearing from time to time on our earth. These seven types of men are the extended expressions of the cosmic Christ, the second person of the trinity.[9] From this it may be adduced that the NYAMKPE, MBOKO, and OKPOHO types will be appearing. Man's spirituality will be on the rise on our present earth now that more than half the Races have climbed out of the deep of the Fourth Planetary Round. The characteristics, principles and consciousness represented by the EKPE Houses or Globes will become more prominent as the Races transit the relevant EKPE House or Globe. Man's spiritual nature, consciousness and form as seen on our earth will in time approach those embodied within the NYAMKPE House. For the moment the NYAMKPE influence is limited if at all manifesting. Ultimately when monad moves into the NYAMKPE House or Globe, man will ordinarily be able to conquer time and space.

In EKPE practice, a man who puts on a masquerade of an EKPE House is expected to exhibit the principles and consciousness relevant to the House when called into activity through appropriate drumming, sing-

ing, and toning or trumpeting of the MBOKO. This is a process of aligning the higher states of an initiate to the three higher planes in the cosmos. Similarly a monad transiting a Globe is cultured by that Globe and the journeyed planetary rounds it has been exposed to. In the case of NYAMKPE, the position of ABASANKO, the atrophied conical helmet of salvation, when examined in relation to the vertical gives the degree of spirituality at that time. It serves as an adjustable antenna possessing almost all degrees of freedom. The angle the ABASANKO makes with the vertical is a measure of the spirituality of the IDEM NYAMKPE. When it flops over the face, its consciousness is at the mundane level. He has temporarily lost almost if not all the spirituality, but has the potential for regaining it. To regain, he has to desire it, work for it and pay the price up-front. The EKPE (God) responds, the ABASONKO regains its verticality and spirituality. To further strengthen its ability to adjust spiritual focus, bird-type wings studded with mirrors are provided at the back of the head so that they flap, close and open when the IDEM NYAMKPE is in motion. The variable wings function as adjustable solar disc allowing for ease of focusing at the centre of life, the Central spiritual sun, that is the centre from where the spirit of God radiates. The wings are additional symbols of spirituality that enables IDEM NYAMKPE to enjoy flights of consciousness from one state to another. In real life situation, a hand at the back of the head is symbolism for power initiation. With all these facilities, the IDEM NYAMKPE is well equipped to operate on almost if not all the seven planes of consciousness, and so understand what life is all about. He represents a man who is enlightened.

At the IDEM IKWO level, the conical helmet is completely atrophied leaving on the roots. His spirituality is much reduced and limited. He is no longer in possession of the 'antenna,' but a feather on the forehead is indicative of the possibility of redeemed perception if coveted. Additional feather is proof that the particular IDEM IKWO having had her inner nature cultured by MBOKO, perhaps has transfigured.

At the MBOKO stage, the atrophied cone or helmet as it may be called, is shrivelled up, dried and hardened. It detaches itself from the head position to become a powerful tool in the hands of an adept whose will to call with love for his mind good desires may be firmly toned or trumpeted and amplified using the MBOKO vehicle. The MBOKO trum-

pet or vehicle is a powerful communicator with a custom built transmitter and 'amplifier'. It is also a generator of power. The EKPE (God) responds by bringing the communicator's heart desires into manifestation. The adept's prayer is answered because he has sought well through Christ. He knows the way. Being in contact with his soul, and operating from the plane of soul he is also able to create in love.

Figure 13 IDEM NKANDA

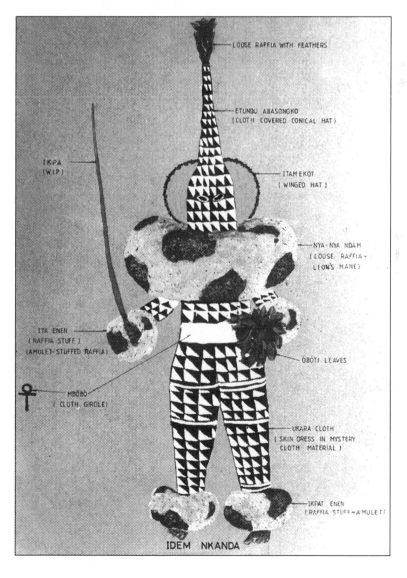

IDEM NKANDA

Variants of the conical helmet exist at levels below NKANDA and EBONKO. The shapes shown in Fig. 15 represent some of the possibilities. In terms of the physical body of man the principles contributed by these Houses of our earth planetary chain are as in Fig. 6. Each House (Globe) has a ruling self existing divinity or spiritual intermediary or mediator in the service of God, and an appropriate call signal of the MBOKO vehicle. An Adept's initiation has to do with the candidate acknowledging the call each time a signal relevant to the divinity he is representing is released. He is for all intent and purposes being 'married' to the divinity which the candidate represents on our earth.

Despite elaborate EKPE initiation rites, a lift in consciousness does not now come easily if at all. Experience has shown that it should not be expected unless serious effort is made by the initiate to covet EKPE, and if time at the temple or during exoteric displays is not wasted on drinking and eating orgies but on learning. With some luck, lift may come to the one who perseveres, but the experience is likely to be left-handed. This is because the focus had for generations gone sour. The temple had become a place where evil has continuously been perpetuated and ancient powers concentrated. Even now, the existence of purity of thought cannot be vouched for. This is perhaps why some temples outside Efik land recourse to the use of unorthodox methods to obtain elevation, howbeit of the left-handed path. Under normal circumstances, pure divine spirits are unlikely to easily find accommodation in such run down temples. To further complicate matters, there are spirits that are worse and inferior to the lowest savage. Such spirits are readily available for work on our earth. The close proximity of our respective abodes and planes of perception are in favour of such inter-communication unfortunately, as they are ever ready to interfere with our affairs for weal or woe.[4]

Some initiates, because of orientation and ancestral links, may find it easier than others to experience elevation. In any case, it is doubtful if full recapitulation of experiences envisaged under the Rosicrucian tenets could now be experienced by EKPE initiates in Efik land unless induced. Alice Bailey defines initiation as: "A gradual and realised series of expansion of consciousness, a steadily increasing awareness of divinity and of all its implications."[5] She refers to it as a living experience, implying that all should endeavour to have that experience. However, to gain the expe-

rience, she warned that reliance should not be placed on modern esoteric groups. This is because they are not the custodians of the teaching of initiation nor is it their prerogative to prepare man for this unfoldment. In the light of the false claims made by some occult teachers and psychic seers, she recommends the Christ path involving five initiations capable of being administered by pure divine spirit during full waking consciousness as man becomes ready. There is a spate of organisations claiming to be custodians of Truth. While it is true that from time to time teachings on truth are released through some organisations, such releases are time related, well-purposed and well-intentioned. It is not for all time and for everything as are being claimed. The five initiations of Jesus all form part of EKPE teachings but are not presented as such.

Initiation is one of those words Efik Christians would rather not use unless they are as initiates of EKPE or other secret organisations of the land. The objection stems from the common belief that initiations are attended by rites which the Christian masses associate with black magic. For many, ritual has to do with church and rite with magic. In reality, ritual means a system of rites, and some rites of magic have found respectable accommodation in Churches as rituals. There are those who having accepted Christianity are consciously rejecting their own culture. Such people are unlikely to accept or submit to the painting of their bodies and the attendant music and sounds for whatever purpose. These people have rightly dug in and are unlikely to be uprooted from their new beliefs if they have found the Christ.

In some customs appropriate write-ups are handed out to the candidate for initiation to recite. But, in EKPE these are replaced with signs and symbols painted on predetermined spots of the body to serve various purposes including being a reminder to the initiate for life. Together the signs and symbols tell stories that would have called for extensive writings. A mature person who has passed through full initiation rites together with teachings of purity, sacrifice and endowment is unlikely to easily forget it. The care and pains invested by the officiant to make sure that all is right is not without risk. He will be expected to pay a substantial fine levied by the adepts were he to falter on the job he freely opted to perform on behalf of the EYAMBA, the traditional initiator.

The many who are in love with EKPE may continue with the initia-

tion procedure even though the initiation performed after the order of Christ is a spiritual affair and takes place during full waking consciousness. If men were Christ-centred, EKPE initiation and the initiation of Jesus should occur at the same time. As it is, there are gaps between them as there are in man's relationship with Christ, especially now that EKPE practice is, probably, no longer age and time-related.

It may be asked, is it mandatory to have the body painted with symbols before a lift in consciousness could be experienced? Obviously not. There are many different faiths and paths who being non-subscribers to EKPE have earned elevation in spirit, and there are also some EKPE initiates who are strangers to awareness. These are adequate proofs. The root of the matter lies in believing and having faith in what one professes, and being able to pay the price up-front for what is required. Having been involved ancestrally and, perhaps personally in EKPE, and the environment had contributed its quota, many may be mentally, psychologically and emotionally committed to the point of loving, believing and having faith in the system or religion they subscribe to. Those who have been privileged to occupy or inherit positions of power within the system hardly find anything wrong with it; whereas those with grouse see nothing good in it. This later group are the ones who quickly embraced the early Christian Church for the much-needed protection against the then prevalent human right abuses. This is, perhaps, the reason why the adepts make poor church Christians and are rarely attracted to priesthood. Outwardly, they profess to be church Christians and may even be occupying positions of honour within the church but hold on to what the forefathers and society had handed down. The reason for this is not far-fetched. They are not yet convinced of the new faith's claim to superior merit over what the ancestors had bequeathed and, therefore, are in support of the stand of King Eyo II who believed that church Christianity did not bring anything new. A church Christian is he who believes that the path to Christ is through the Christian Church alone. He belongs to the emotional many who approach and benefit through faith. Contrary to church teachings, there are other Christians, although not members of the church, who are also approaching Christ as part of the emotional many through faith. Finally, there are the few who approach Christ successfully from the plane of mentation.

In the context of needed change, EKPE initiates may be grouped into about five classes. The first are those who have been deeply rooted and are unwilling to accept any change from what they know to be EKPE. They see nothing wrong in it even though they may outwardly profess commonly accepted religious faiths. The second class accommodates those who are prepared to accept only minor changes of what was handed down. Such changes may include the use of additional colours to improve the efficacy of initiation, and correlate the exoteric colours of the divinities. They will not go far from the old trodden path or practices. The third class may move a step further to accept a re-arrangement of body symbols. The fourth may be willing to contribute towards the improvement of the quality of temple music. Amongst the final class are those who having understood the meaning of actions and accepted that during this age when Christ role is active, the important temple activities are:

i) Appropriate temple music and songs

ii) Trumpeting (praying to God through Christ Centre.)

This fifth class will no longer invest in body symbols and signs. To them the way to truth had been opened by Christ at Golgotha. Human nature being what it is, the desired changes need to be worked and brought to be in stages if success is to be earned. The matter should not be rushed. The initiates have to be educated to understand the religion they are clinging to, the meaning back of its workings, and the need to change. The Christian experience should convince the fair-minded that it may be wasted effort attempting to uproot the initiates without educating them to fully understand the weakness of their current practices before bringing them to grasp the import of the superior alternative teachings they are expected to cultivate.

The Caduceus

The Caduceus with its double serpents is one of the symbologies the ancients employed to conceal a secret lesson on Truth from the uninitiated. A soul encircled by the double serpent must learn to conquer them if he is to break the chains that anchor him to the earth, otherwise he will be forever condemned to the eternal fire. The serpent is symbology for the devil or tempter of the Bible. The way of release from the chains is

the main focus of religion and organisations of Truth. This is organised through the auspices of the Christ Spirit without which the soul finds no peace.

Figure 14 IDEM EBONKO

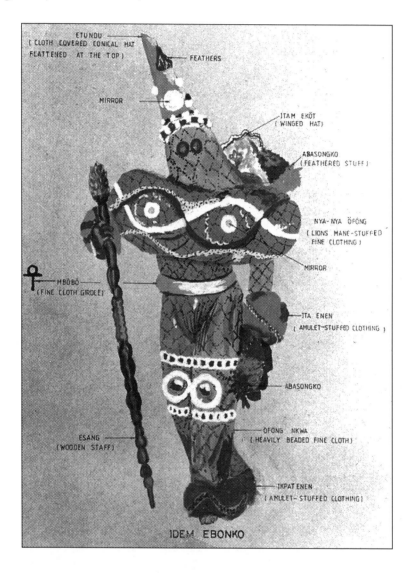

The Caduceus is probably the root of EKPE symbolism of handing over a headed staff as a final initiation rite of an adept. Usually, a piece of

cloth of appropriate colour, not black, tied close to the head of the staff may represent the wings of the Caduceus. The colour correlates the representative colour of the House into which the initiate is being installed an adept.

Figure 15 Heads of EKPE Forms

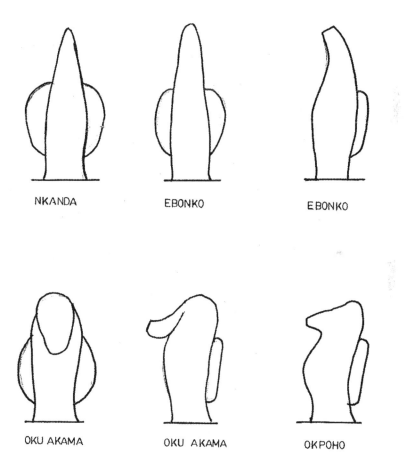

| NKANDA | EBONKO | EBONKO |

| OKU AKAMA | OKU AKAMA | OKPOHO |

Initiation commences with painting of rings in white, red and yellow-orange on the hands and legs of the neophyte. By this procedure the soul of the initiate is expected to be activated to recapitulate its experiences during the first three and a half rounds of its pilgrimage of the Earth

Period when so described, but this is now hardly the case in Efik land. At USAK EDET the machinery for recapitulation is planted on the soul after the initiate had been served with a secret root meal or received a second water initiation. The MBOKO roar together with the attendant music and songs should normally cause the soul to play back its experiences and enhance the evocation and invocation of the divinities, but now this seldom occurs in the Efik Temples. For all intents and purposes the initiation rites for initiates and adepts are now cosmetic affair for most. The benefits are accepted by many as social. The method used at USAK EDET for enhancing perception is unorthodox in that the process should occur naturally and not forced. The method is suspected to be in the realm of black magic.

Fig. 16C provides a linkage between EKPE and Caduceus. It depicts an EKPE adept dressed as was the case amongst the affluent and well connected initiates during the period up to the fourth decade of the twentieth century A.D. The man is shown as bearing an extended sash that runs from the right shoulder round the left hip to a position halfway between the right hip and the knee, before tailing into a Caduceus (OKPOMKPOM) that sweeps the ground. The tailing Caduceus gives meaning to the sash. The man is no ordinary commander but an EKPE adept. The extended sash signifies the evolutionary path of the Caduceus which the man is treading during his ascent from matter to spirit. The staff is a symbol of authority, an indication that truly the man is an adept, an OBONG EKPE according to Efik tradition.

Fig. 16D shows a man adorned with an extended sash terminating in a trailing Caduceus (OKPOMKPOM) that hangs from the first knot by his left side. It portrays a man on the evolutionary path from earth to spirit who has almost succeeded in freeing himself from the serpent of illusion if he is to successfully accomplish his mission on earth. The Caduceus and staff give meaning to the sash. They are not ordinary symbols or common adornment. They confirm the status of the man. He is a high EKPE adept.

Okpomkpom Ekpe

OKPOMKPOM is a cloth necklace worn by males during traditional ceremonies. It is adornment. There are different types, and the design of the more common ones depends on the resourcefulness of the wearer. The design and use of OKPOMKPOM EKPE is restricted and controlled. It is NSIBIDI of man, a reminder to him to know himself. The OKPOMKPOM EKPE bears either three or four knots and each knot represents an acknowledged EKPE House, principle, power or energy. The knots represent some key stations on the path of awareness. A piece of suitably sized cloth of one colour tied above a knot indicates the House over which the adept has authority.

When man is conceived as being subdivided into three parts, namely:

i) the Head, analogous to the Spirit aspect;

ii) the Upper Torso or part above the diaphragm analogous to the soul aspect;

iii) the Lower Torso or part below the diaphragm analogous to:

(a) the sex organs, the creative aspect,

(b) the stomach; and,

(c) the spleen or the receiver of energy,

and the initiation rites are after the order of Chaldean Kabala (See Figs. 9 and 11). The lowest knot is MKPE, the starting point on the way to awareness. It signifies a man resolved to push forward to matter the difficulties. He has belted himself adequately with a winged girdle which may also be taken to represent the creative female organ. The tails that hang between the wings of the bow may be taken to represent the creative male organ. This is NOT phallicism. Both creative organs must cooperate for the re-generative energy to commence refining the man. More meaningfully, they together represent the straight path from matter to spirit available only to initiates. The next station or second-knot upwards is MBOKO MBOKO. Here the man acquires endurance which enables him to accommodate burdens. As the Bible puts it:

> ... we know that trouble produces endurance, endurance brings God's approval, and his approval creates hope.[6]

For this reason the relevant EKPE form or masquerade bears a fish trap (ESAK), burden collector. The third and final knot, the MBOKO, represents a man perfected through suffering and glorified through trial. More often than not Figs. 8 and 16B are relevant during initiation in which case position (6) MBOKO replaces position (4) MBOKO MBOKO which moves to a position between the thighs, and the MKPE positions are marked on the legs.

Figures 16a,b OKPOMKPOM EKPE

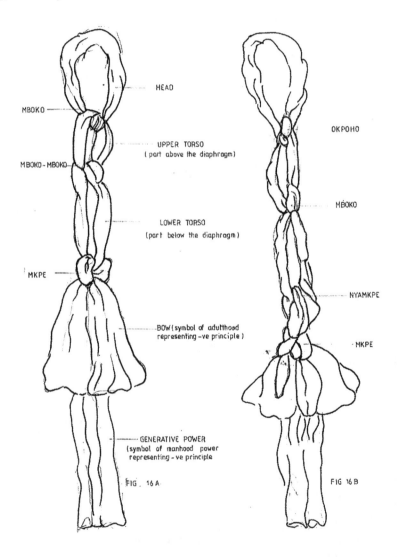

HEAD

MBOKO

UPPER TORSO
(part above the diaphragm)

MBOKO-MBOKO

OKPOHO

MBOKO

LOWER TORSO
(part below the diaphragm)

MKPE

NYAMKPE

BOW (symbol of adulthood
representing -ve principle)

MKPE

GENERATIVE POWER
(symbol of manhood power
representing -ve principle

FIG. 16A

FIG 16B

Figure 16c(left) OBONG MBOKO
Without Colour Correspondence

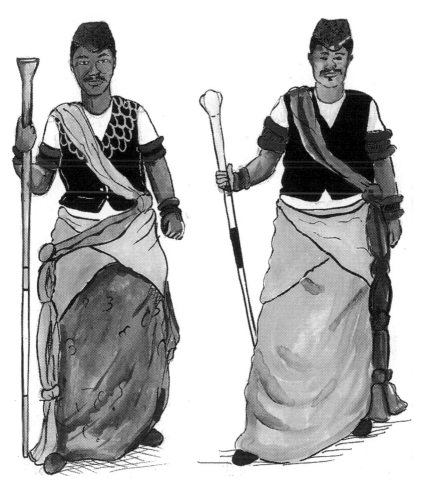

Figure 16d (right) OBONG OKPOHO
Without Colour Correspondence

Figs. 8 and 9 show the body arrangement of initiation symbols as organised, after the order of Gupta – Vidya cosmogony. The 4-knot OKPOMKPOM EKPE relates to them, and the knots are named; MKPE (1); NYAMKPE (2); MBOKO (3) and OKPOHO (4) in an ascending order. NYAMKPE signifies victory. Here the initiate begins to have the

feeling of freedom and the attendant joy and delight. He commences to experience the beautiful things of this life which he never knew existed. The principle housed in OKPOHO is spirit, and a man who has attained that state has acquired the disposition of a king with considerable authority. Beyond this the man is in the realm of pure divine spirit away from the planes of manifestation. An extended sash tailing into OKPOMKPOM EKPE of Fig. 16D and F normally identify MBONG EKPE on the evolutionary path of OKU AKAMA, EBONKO or EYAMBA respectively.

The two columns of the OKPOMKPOM EKPE bring into focus the not so obvious downward involutionary path from spirit into matter and the evolutionary path outward from matter into spirit.

Ntang Nkanda

NTANG NKANDA or peacock feather is a symbol of EKPE initiation. Its use is not accidental. Ordinarily, a feather in EKPE connotes a purity, power and soul knowledge. The peacock is a rare bird of great beauty treasured by the ancients in possession of esoteric knowledge. The Pharaohs of Egypt treasured it. The hind-feathers in particular bear the colours of the rainbow, and since each EKPE House has a colour of the rainbow by which it may be identified, the feather was acknowledged by the ancients as having special meaning and place in EKPE. It was adopted as a symbol by which an EKPE initiate could easily be identified. Considering that the NKANDA grade is the highest but one grade available to initiates who have traversed the seven colours of the rainbow at the portals of initiation, the NKANDA feather should have been reserved for those who have scaled the OKPOHO grade and attained the NKANDA grade. In the Egyptian system Maat the goddess attributed to the sphere Chesed (OKPOHO) always had her headdress adorned with a peacock feather. This is not the case in EKPE practice. Its use is now confined to women and others who are young and inexperienced in the workings of the fraternity. Mature initiates have no need for exoteric identification, but should be equipped and ready to prove their mettle when challenged. In distant past, the use of NTANG NKANDA was restricted to EKPE initiates. There was a time when penalty for infringement meant death to the offender.

Initiation of an Adept

The path to adept status is tortuous. An initiate with interest first has to be an acknowledged candidate. He will do well to undertake a self examination to determine if he is *prima facie* qualified before moving forward. The fundamental pre-requisites are:

i) be a long standing initiate;

ii) be well behaved;

iii) be literate in NSIBIDI EKPE and conversant with EKPE (MOBOKO) language (These conditions are no longer mandatory);

iv) be married;

v) be a house owner;

vi) have a visible and respectable means of livelihood and;

vii) be of a birth acknowledged by the EFE (lodge) into which entry is sought as being relevant and adequate.

Should the self examination lead to positive results, the interested initiate will then seek the assistance of an OBONG EKPE of the lodge of his choice who, acting as the sponsor, approaches the EYAMBA with customary drinks to intimate him of the desire of the initiate. Then EYAMBA after consulting the EBONKO, summons a meeting of adepts to confirm if a vacancy exist and at what level. The meeting is sponsored by the one seeking to be a candidate. On declaration of a vacancy, the sponsor is directed to present specified MIN NTOT (complimentary drinks) to every adept on the *roll*. The quality and quantity of the drinks are in accordance with the rank of each adept. That done, the initiate now termed a candidate, is invited to a meeting of adepts where his credentials are critically examined. The financial cost of all meetings of adepts connected with his candidature are to his account. Should he be successful, he is invited to yet another meeting where the entrance fee and other costs are disclosed. As an old and experienced initiate, he should be aware that EKPE could not be kept waiting. It is in the candidates interest to promptly pay the fees demanded. A delay may result in the fee being raised or confiscated when paid thus causing the initiate to recommence

the process, if allowed. At times an unqualified initiate is allowed to go through the process only to be subsequently declared unqualified after payment of the fee demanded. This is why it is important to have an honest assessment of one's eligibility before moving forward. Unless one is gunning for a hereditary position, a candidate is rarely informed of the grade to be assigned to him. He has to throw his fishing line into the river and be grateful for what ever fish is caught.

If all work well, the EFE acting in consultation with the candidate fixes a date and time for the elevation. The attendant entertainment of initiates take place firstly at the EFE and thereafter at the new adept's home. Both are important and unless they are perfected the whole exercise is inconclusive, and the man will have to start afresh.

Often the candidate is required to present himself at the EFE the night preceding the day appointed to publicly elevate him. The purposes of the meeting are threefold, namely:

> i) to put final touches to next day's arrangements;

> ii) to seek the cooperation of EKPE; and,

> iii) to perform secret rituals relating to the initiation.

It is customary for the candidate to provide refreshment at such meetings, and advisable to identify the musicians and their supporters; the MBOKO trumpeters; the NYAMKPE and the relevant IDEM EKPE for special treatment if the impending ceremony is to have a guaranteed accolade.

Some adepts may advise the candidate to avoid investing in two groups of musicians, namely; those to accompany him to and from the EFE, and the other whose business should rightly be confined to the EFE. Initiation is an expensive business and it would be wise to take control of the budget otherwise it may run out of gear. Under normal circumstance, the advice to have only one group of musicians is a good one, but this is not necessarily so in EKPE. As a rule the musicians for the EFE are arranged by the EFE. They are often the resident temple musicians who are under the control of the EFE. It is not unusual for them to refuse to serve the candidate unless a firm arrangement could be struck beforehand. Even then, the adepts may slip away to the EFE with the musicians from the home of the newly installed adept. Should this happen the

newly installed adept is deemed to have been dispossessed of his newly earned status.

An impressive fellowship (sacramental) meal and drink offering are mandatory aspects of the entertainment at the EFE. A follow-up entertainment of a limited nature awaits those who may choose to accompany the newly installed adept home where initiates and adepts may publicly demonstrate their prowess to the accompaniment of music. At each venue all in attendance are expected to partake of the meal and have a share of the drinks that will have to be taken on the spot. The fellowship meal of UKANG EKPE is the meal of the day. An affluent candidate may provide a variety of meals but they do not count. Unless the UKANG is served at the EFE, the initiation ceremony is not complete. The man remains a candidate until he can provide the UKANG EKPE. There are different types of UKANG, but that of EKPE is a special meal of large chunks of yam or plantain (unripe), dried scale fish and OKOYO (deer) meat seasoned with spices and fresh green leaves, and cooked in fresh palm oil. The meal make-up are in such generous sizes that a portion of the meal served to an initiate is usually more than he could conveniently handle, but he must make his way through if he is not to dishonour EKPE. The meal is served to all from a container placed before all to see. This is to avoid contamination.

On the day appointed for the initiation, the musicians and some initiates arrive early at the home of the candidate to begin warming it up and to inform all and sundry that something great is about to happen. Their services are rewarded with entertainment. Naturally, the singing, drumming and entertainment attract other initiates who according to EKPE rule are entitled to be entertained. In EKPE, music is an open invitation to initiates to attend a party. While that goes on, some adepts are busy dressing the candidate for the occasion as if he was for a traditional wedding. He is wrapped in his best loin cloth, preferably a matching UKARA, with the knot to his right. Very often a T-shirt, over which are laid a beaded cloth vest and beaded knitted necklace in matching colour, is tucked into the loin cloth. Beaded biceps and wrist amulets adorn the hands. Waist bands of silk scarfs that tail left and right over the loin cloth are secured to the waist, and a matching cloth necklace, OKPOMKPOM, of generous length extends beyond the knee (Figs. 16A – D). Usually, the

shoes are beaded in colours matching the amulets and the beaded fez if that is the preferred head covering. Alternative head wears are available and they vary from knitted skull cap known as BIDAK to top hat.

When all is ready, the candidate is handed a staff bearing a generous bow tied close to its head. He is instructed to remain silent until ordered by the EYAMBA, and also not to allow the staff to touch the ground before handing it over at the EFE. Libation is poured before the procession moves out led by an initiate of adequate stature bearing an IDEK EDEM. IDEM EKPE (EKPE masquerade) may also be in attendance. Preferably, two adepts flank the candidate while the musicians and initiates bring up the rear. The necessary protection of the candidate is provided by the initiate with IDEK EDEM and the two adepts whose specific responsibilities include accepting on behalf of the candidate the challenges of EKPE initiates and adepts who may wish to test the candidate's eligibility as he moves to and from the EFE. Cross road rituals are performed and mandatory EKPE stations recognised on the way to and from EFE. A ceremonial umbrella may attend the candidate.

The employment of two musical groups is an advantage. The resident musicians start early charging the EFE in readiness for the arrival of the candidate. This facilitates the initiation process. The alternative is to allow sufficient time for the musical group attending the candidate to arrive and settle in at the EFE before attempting the work of raising the lodge. Such a procedure leads to delay.

On arrival at the EFE, the candidate is received at the entrance and every one brought to silence in a ritualistic manner after which the candidate is led to his seat. The temple musicians recommence the process of charging the EFE and at the sound of the MBOKO the music stops for all to listen. The MBOKO calls three times and after each call the EYAMBA responds first on behalf of the divinity to the South: then on behalf of the divinity to the East; and finally on behalf of God. After this the process of raising the lodge continues and as the musicians move from one EKPE grade to another, the MBOKO intervenes from time to time with appropriate calls to which the corresponding adept responds. Finally, the initiation proper begins. The candidate is invited to stand between two adepts one of whom is the sponsor. The staff having been powered by EYAMBA becomes the ROD OF INITIATION[7] and is

handed over to the candidate who holds it in both hands with the head towards himself. He points to activate the MBOKO who then calls the candidate by his EKPE rank to which the candidate responds. This is repeated. After the candidate has responded the third time, the MBOKO confirms the elevation and the initiate is immediately transformed to an adept. In Efik tradition he is an OBONG EKPE.

The EFE then moves into a period of sustained merriment with the musicians hard at work and the initiates demonstrating their knowledge. A time comes when a break is allowed for refreshments to be served. Drumming and dancing resume after refreshment until silence is again ordered by the EYAMBA to enable the MBOKO to formally round up the performance with an appropriate ritual. The newly installed adept then withdraws for home with the musical accompaniment that had brought him. At home he receives his guests and entertains them for hours. When he withdraws from the EFE most of the adepts of his lodge including the EYAMBA and EBONKO, remain to formally and ritually close the EFE before taking their positions at the home of the new adept.

Chapter Six

Some Reserved Teachings

The House of Adepts

All the inhabitants of the four kingdoms of nature of the terrestrial earth are aspects of EKPE. So also are the celestial and cosmic populations. These together do not adequately define EKPE for the simple reason that thoughts of men cannot encompass Him. If these were possible EKPE would not have been EKPE, the only ONE. In the context of oneness and unity, the word EKPE is a pseudonym of Him whose name is sacred, blessed be His name. He is what is commonly or exoterically referred to as God, but whom the ancient rarely mentioned. The name God is very much revered and therefore should not be of common usage.

Each EKPE House (Globe) has responsibility for the invisible life principle(s) and the associated lives assigned to it by the ruling divinity. In the physical sense and when the need arises, the invisible principle(s) and associated lives are displayed in the houses in symbology as physical display by initiates. NSIBIDI is employed and the initiate has to be tutored to understand and appreciate. The death of an adept affords the opportunity for the display to be organised. Such a display should normally relate to the House over which the adept was ruler. In practice, there is hardly any distinction particularly in Efik land. Fig. 18 is an

example of such a representative display. A reddish abasanko, an indication that EKPE is always present, is carried on a wheel of life threaded on a beam representing the life track. In reality the life track is not straight but cyclic. A second wheel to which a bell and buntings are attached is suspended from the wheel of life. These represent influences that work against the proper run of the wheel of life. The bell is the built-in alarm within man. The position of the wheel is an indication that the man has reached the end of his time. He is shown sitting in the shed in complete control of the leopard within and without. He had attained the rank of an adept before answering the call to depart this life. He is victorious.

An initiate is not rushed into burial. A ritual is performed to return the deceased initiate to mother earth the way he came. Initiation was performed to open the neophyte to the path of truth and bring home to him God's (EKPE) endowment to people world wide, also to remind him of the need and way to work and gain awareness and freedom from the confinement of ignorance and wrong living. Initiation is for the living and not for the dead. Before burial, he is relieved of the initiation, the soul having acquired its lesson and floated off.

UFOK NKANDA (NKANDA House) is the residence of all that has to do with death. It is also involved in birth. As part of the funeral obsequies of an OBONG EKPE, a display of the House of adepts may be arranged in his honour. Rather than being involved in an elaborate and expensive display, the deceased family may request the ruling fraternity to organise a frugal display which will have to run for four days or longer depending on their ability to bear the attendant cost. An empty room is set aside for this purpose. The artifacts consist of a bird symbolising a spirited dove which from time to time let loose the divine creative spirits of God, symbolised by strips of white cloth, to pregnate matter and cause it to differentiate into a multitude of lives. The descent is signalled each time by the sound of the bell which remains silent until the moment of release of the creative fire or expressions of the cosmic Christ. The differentiated lives below correspond with lives associated with the divinity which the deceased was a correspondent when alive. In this instance, the circle in Fig. 19A is divided into seven compartments instead of the twelve shown. When the compartments are twelve in number, the focus is the Zodiac with the signs and symbols in place. The signs and symbols of

zodiac relating to the birth and death of the adept may be highlighted. Should OKPO EKPE, model of a deceased adept ritually dressed for burial replace the circle, the focus is the power of resurrection. A suitable UKARA, the EKPE secret cloth, screens off the door to the room thus restricting entry. To gain entry a test is set and on scaling it, an oath of secrecy is administered. When all is set, libation is offered and the trumpet sounds signalling opening. The inverse ritual takes place at the end of the exhibition.

Evolution in EKPE

The word evolution is repugnant to most Christians for the simple reason that it is taken to mean Darwin Theory of Evolution which postulates that the evolving life saw man through progressive changes in status from mineral, vegetable, animal to man lives in that order. The objection stems from the Bible account which states clearly that man was created from the dust of the earth, meaning minerals of the earth, and that God breathed the breath of life into him.

On its part, EKPE does not subscribe to Darwin Theory. Although it concerns itself with the happenings on the earth of the Earth Period, it believes in the existence of separate evolutionary paths for minerals, vegetable, animal and man. It teaches that as man moved on earth from a more spiritual and less ethereal than physical constitution, changes occurred in man such that a reduction in the spiritual was attended by growth of the physical and vice versa. This concept is brought home to man through the EKPE forms or masquerades. EKPE in accepting the Bible account of the creation of man is aware that a transition period was essential for man to be a man even if the Bible account of a day is accepted. A day in this context is used figuratively. It is not the time duration man defines as a day. EKPE goes further to teach that man in the form known appeared on our earth during the third or fourth rounds of the Earth Planetary chain and subsequently separation into sexes occurred and women came into being. This is the Bible story detailed. It is in this context that the word evolution is used hereafter.

To avoid misunderstanding and to facilitate appreciation of the import, it is essential to first appreciate what is meant by evolution in EKPE.

In this regard, it could be said that Man takes a lot for granted. For example, he watches his grandchildren grow but often fails to view this against the growth of his children. If he did he might realise that even though his grandchildren are acknowledged humans looking every inch chips off the old block as far as the outer form is concerned, they are different. They are more inquisitive and independent than their parents at the same age. It is not uncommon to hear a parent boast about the level of intelligence of his grandchildren yet he is incapable of correcting some of what he considers their most disturbing pastime. This is because the unfolding time has its effects particularly on children of the time. The earth is ageing and in the process releases energies that grow and die. This dance of energies as it may be called, affect lives on earth. It affects much more than the outward form. Consequently, even though the word "growth" may adequately express the totality of happenings in a man during his sojourn on earth, it does not relate very well with the changes that occur when men of one age are compared with those of another. In such cases the word evolution is preferred.

A common belief of Efik is that the soul of man has an animal as his double. This does not imply support for Darwin Theory. The belief arises from a misconception of occult doctrine which acknowledges the existence of soul and animal soul as parts of human principles (Fig. 6). Also the belief is a natural consequence of the misunderstood teaching and practice in magic and EKPE bearing on man's ability to change form provided he is a master of the elements and is in rapport with powers correlating with his inner focus.

EKPE Account of Creation

EKPE recognises the involvement of the realm of pure spirit in the creation process of man. Since EKPE does not encourage voiced language, reliance is on dance forms, NSIBIDI, colours and sounds for the dissemination of information and training. At the demise of either an hierophant (EYAMBA) or a High Ruler who was a title holder (only title holders were allowed to be Rulers), the final rites are rounded up with a "dance of life or dance of creation." This dance is a mundane show of the activities involving the EYAMBA, NKANDA, and EBONKO spirits in the realm of pure spirits of the three higher planes of consciousness of the

cosmos. This dance of life is perhaps better described as a demonstration of the cooperation that exists between these pure spirits. NKANDA represents the male principle and EBONKO, the female principle. Creation is effected in EBONKO. Following the death of an EYAMBA or high grade Ruler, someone has to step into the position vacated. In practice there is never a vacancy. It is the EYAMBA or Ruler-designate that oversees the prosecution of the funeral rites. At that level, EKPE demands continuity. Symbolically, it is taken that there is a vacancy and it is mandatory for a new hierophant (Chief Priest) or Ruler to be born.

The symbolism involves dummied beautifully-adorned 'damsels' (male) from the EBONKO stable dressed in white skirts and sleeveless blouse over which may be laid designed beaded necklaces and symbolic beaded vest. The arms and legs are dressed with or without beaded amulets. Each 'damsel' holding with both hands a short locally made drum (womb) with the open end facing her, starts a rolling dance involving her body and hands, the legs moving right foot first in a rather slow movement as if she has all the time in the world for it. As she dances, the face of the drum is directed at a male partner (fiery spirit) in an inviting manner signifying she is ready to create, or is in heat. Similarly dressed dummied male bearing a peacock-like tail and holding a bow and arrow responds with a similar dance form but aims his arrow (fiery spirit) at the face of the drum (womb). Both are dummied because they are spirits and do not speak the language of men. The arrow is never released. It is a sort of mating dance that some birds involve themselves in during season. The arrow signifies the creative fiery spirit of NKANDA whilst that of EBONKO is the drum (womb). The dance team usually involves three arrow bearers and four drum bearers. The EYAMBA spirit intervenes later to impart spirituality to the new born enabling him to become aware. EYAMBA the man, is the one who directs the training of neophytes and supervises their growth along the path of adept. (See Fig. 17). At the mundane level the dance maybe likened to the movement of human male spermatozoa and the female counterpart, the ovum, towards fusion.

Figure 17 Dance of Creation
(Note the dancers with drums and those with tails.)

A spermatozoa bears a tail but the ovum does not. It is perhaps relevant in this context, to briefly consider the Indian philosophical concept of creation. The first Root-Race is the first man on earth and these were the progenies of the "Celestial men" or the "Lunar Pitris or Ancestors" of which there are seven classes or hierarchies. These are made up of some who agreed to create and others that refused. Those that created gave form to man, but, the solar Devas or Pitris were responsible for imparting intelligence and consciousness to man. The Lunar Pitris created the physical man and solar Pitris fashion the inner man, but spirituality is imparted by other intelligence.[1] Similarity with the EKPE account should be noted.

Resurrection

In EKPE, action speaks louder than words, the exception being singing that attends drumming and dancing. Inner teachings of arcane wisdom encourage the cultivation of silence. A long period of non-speaking existence was a pre-condition for admission into the Pythagorean school of old. Jesus the Christ said, "Let your speech be yea-yea and No No," meaning silence is golden. Where inner teachings are allowed in public symbolism is employed.

These public displays take some time for the tempo to build up. When the air is sufficiently charged, an initiate of adequate stature floats into the arena. He dances for a short while showing himself up and daring anyone who considers himself knowledgeable in the art of NSIBIDI EKPE to step forward to challenge him. For a while the spectators remain in studied silence. Suddenly there is response. Someone floats into the arena. A challenger has appeared. As the two dance, they also busy themselves in silent communication using NSIBIDI EKPE. The idea is to show that the other person is not sufficiently literate in NSIBIDI EKPE. Tension mounts. Without warning, one of the dancers drops flat on his back with hands and legs open and eyes shut. Esoterically, he is presumed dead, but the other dancer does not really understand what had gone wrong. As the spectators watch, drummers and singers continue working hard at their jobs. The dancer on his legs rushes to the assistance of the one fallen. He examines the eyes and checks the heart beat of his fallen compatriot, and obtaining no favourable response, floats around in search of

help. On finding none he pours drops of water or gin whichever is at hand on the ground besides the fallen one before turning to EKPE (God) for help and is advised on the procedure –"Hand to Hand, Foot to Foot, Cheek to Cheek, Knee to Knee, and hand at the back."[2] He pulls the body towards himself and to a standing posture. The man stands his grounds. The man had shed his blood and died but resurrected to life eternal. This may also be taken to signify the laying of one's life for others in order to gain it again. The watching initiates who are also the judges at the contest indicate their approval. The EKPE ritual is similar to the performance of the Adeptus Minor of the Hermatic Order of the Golden Dawn, and Third Degree of Free Masonry and a ritual of a renown Christian church. A brief description of the ritual of the organisations mentioned other than EKPE is as follows:

> *The life of an enlightened Adept is rehearsed in full ceremonial form; that is to say, the history of being whose consciousness has been made divine is magically celebrated. The method of enactment portrays a man who dies actually or mystically, and accomplishes his own resurrection as a God radiating forth divine wisdom and Power.*[3]

Reincarnation in EKPE

The funeral obsequies of an EYAMBA or a highly ranked ruler provide a rare opportunity for some of the reserved teachings to be imparted to initiates who are inquisitive. More often than not the drama leaves no special imprint on the minds of witnessing initiates. After the adepts have certified that death had occurred and the public is to be formerly informed, selected adepts and initiates are summoned to the EFE for the rites to begin. The conclave assembles and is raised by MBOKO. When convenient, MBOKO is seduced out by ISIM, an EKPE form adorned as a peacock but handling a bow and arrow. On realising that the seducer is an agent of death, he flees. He is aware that death will mean judgement, taking of embodiment and return to earth. Not finding these attractive, he elects to flee from the EFE bent on arresting him. Following his flight, a hunt is organised and as he roars (wails) per chance a friendly power could offer him sanctuary. The hunt closes in but each time he manages to elude the dragnet. After a long hunt MBOKO is

finally tracked to the EKPE bush, a mystery school in the etheric region of the world, where he is caught, caged in a special UKARA, judged and sentenced to take another embodiment as an EYAMBA or Ruler as the case may be. For this to take place, an appropriate body is prepared. This is represented by a dummied EYAMBA or Ruler-elect ritually dressed in UKARA. When all is ready, a procession of initiates in the etheric region leaves the EKPE bush led by the dummied EYAMBA holding in both hands an MMOYO, an adorned special sceptre symbolising supreme spiritual authority. The EYAMBA is dummied because he is devoid of life principle.

As the procession is on its way toward the temple of embodiment, the MBOKO continues to roar. Without warning EBA (a symbol of death), an IDEM NYAMKPE that had lost much of its freedom suddenly re-gains it and strikes. The MBOKO (soul) is presumed dead as the procession breaks up in confusion. Instantaneously, the MBOKO roars in the EFE and is deemed to have taken embodiment as the new EYAMBA. To prevent the IDEM running wild, he is enticed into the EFE through the irresistible urge to pounce on a wailing old woman and a bleating goat provided for that purpose. Once within the EFE, the Idem transforms back into an IDEM NYAMKPE with full honours and control. This ritual display is meant to present important lessons about life, namely:

i) Judgement after death is imperative.

ii) The soul is indestructible.

iii) The decision on embodiment is beyond the authority of a soul.

iv) The body to be taken by a soul is prepared for it by higher spiritual authorities.

A burial ritual of EKPE involves drum toning of the words "AKPA AKPA ODU, AKPA AKPA ODU, AKPA AKPA ODU" meaning life comes after death.

Efamba

EFAMBA is an EKPE display of manifested cosmos staged in a confined space. It employs artifacts and symbolism such that as much as possible of whatever existed is given recognition and a place. The aim is to present a near life situation as could possibly be managed, and to plant the usual obstacles to spiritual growth of man perchance he realises the need to enquire and not go through life as if he were blind and a deaf mute. The setting of the display is an artificial tropical mystery forest carefully crafted by adepts and initiates. It is a painstaking assignment.

The crafted forest houses elements, minerals, plants animals, human and spirits of all types, and the ten divinities of our earth planetary system known in EKPE as EYAMBA, NKANDA, EBONKO, OKPOHO, OKU AKAMA, MBOKO, NYAMKPE, (M)BAKARA, MBOKO MBOKO and MKPE, amongst other conceived creations of God in representative capacities. Employing symbolism, these creations are discretely positioned at secret locations and carefully camouflaged within the forest. MBOKO, the jewel in the forest, is hidden deep and jealously guarded by a giant python expertly crafted or NDEM as some would wish to call it. A secret bird, USARI (crow) perched on a tall tree provides additional security against intruders to the prohibited zone. The USARI serves as an early warning system. Any one in possession of the MBOKO has direct access to the divinities and God, and could create his heart's desires. This may be the reason why the urge to possess MBOKO, is inherent in man.

The journey to possess the MBOKO is dangerous and tortuous. Both the living and the dead are represented in the forest, so also are spirits and powers of every description whose main tasks, depending on character, are to either obstruct or assist the hunt for the jewel. The quantum of work to be done, the degree of alertness in demand together with the sacrifice to be made, make it mandatory to seek the assistance of one who knows the way thoroughly. For the hunt to be successful, the spiritual powers of darkness known in EKPE as EKPO NKANDA will first have to be firmly attended to as the hunt progresses. Challenges come up almost at every turn, and greater challenges emerge as the hunt comes close to target. The hunt must be repeated until the man is able to hunt on his own and register success. This implies reincarnation. It is only

then that the full value of success is earned. A fleeting visit is unlikely to lead to success. The import is that several incarnations are necessary if Christ is to be adequately formed in man.

EKPE mythology credits MBANG as the first human being to have the knowledge of MBOKO, who because of love of her husband, NKUK AFUTA, refused to reveal the secret to her brother MUTAKA who accosted her on her way from the mystery forest of 'IKOT EKPE' as it is known in EKPE Efik. NKUK AFUTA thought it wise to involve the elders of the race EYO EMA, ESIEN EKPE and MUTAKA who make up the four seated at the podium behind the veil to watch and judge the hunt. Since principles form the bed rock of EKPE, it does not disturb much if in exoteric (open) displays MUTAKA takes the place of MBANG. Displaying the foursome behind the veil in the EFAMBA is an indication that they are used in allegory to represent principles whose names are much revered or unknown. Most probably they represent the 'Sacred Four,' the second logos otherwise known as Tetraktis of Pythagoras.

The mystery forest may be taken to represent the world with all the influences, some positive others negative; some good, others bad. Bad in the sense that they work against man realising his full endowment and also because they obstruct the soul from gaining release from the confinement of the flesh. EKPE teaches that assistance of Elders of the Race, those who are spiritually enlightened, is absolutely necessary if any meaningful progress is to be made. While possession of MBOKO is essential it is necessary to understand the language of communication with the divinities and God. From the lessons of EFAMBA, success will hardly come but not impossible at the end of the first tour. Several re-births are necessary. The human body does represent the mystery forests in which much of value is hidden. The divinities have latent correspondences in man (woman) which EKPE initiations are meant to activate.

Figure 18 House of Adept

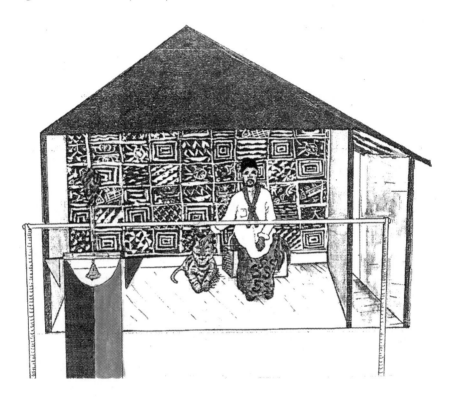

IKOT EKPE

The literary meaning of IKOT EKPE is EKPE forest or bush, but in reality it is the world of action and reaction, of joy and pain, of mountains and valleys, of war and peace, of night and day amongst others, through which the pilgrim must make his way. Some refer to it as a mystery school where the lessons of life are learnt. IKOT EKPE is a grand EFAMBA organised in a natural setting and free from the confinement suffered by EFAMBA. Also, as much as possible, living things are used instead of artifacts and more secret lessons taught. Here the thrust is different. It has to do with how it was at the beginning. Arising from the

much larger space in use, there is the real danger of one losing his way being harmed by EKPO NKANDA (evil powers). For this reason, it is advisable to secure the services of a respected able guide who should be an initiate. Only initiates may attempt to pass through IKOT EKPE and EFAMBA. There are usually several obstacles on the way which have to be overcome.

Man in his wisdom and desire to be like God felt that the ingredients and secrets of creation are buried under a stone (ITIAT EKPE) in the deep of the forest, the world of ideas and creation. She he invested in a search for the origin of life and God. After many tedious and dangerous challenges he came across a stone which looked every inch respectable and relevant. His desire was further inflamed as he settled to dig out the stone. As he toiled at the work on hand he looked around to make sure no one was watching. He was determined to share the secret with no one. At the end of the digging, he struggles to roll off the stone only to discover that what is under the stone is no different from what had been with him from the out-set, **nothing** other than manifestations(s) of the uncreated God. A popular saying in EKPE is:

'ESIO EKPE KE ITIAT'

meaning EKPE is born from a rock. This is perhaps the strongest indication that EKPE may be linked to Mithraism. Mithra was believed to have been born from a rock.

ITIAT EKPE (EKPE Stone)

ITIAT EKPE and EKPE are inseparables. It is the store house of EKPE and it secret abode. Without it EKPE is barren and sedentary. EKPE which is barren is unable to reproduce itself. Consequently, a community is unable to share its teachings with another community, neither could initiation of individuals be successfully performed. To being a community to the knowledge of EKPE wisdom the divinities have to be evoked from the ITIAT EKPE of the giver to that of the receiver, using the MBOKO vehicle without loss of potency either way. It is the responsibility of the giver in consultation with the guardians at the inner realm to obtain the relevant specifications, and locate, move and plant the ITIAT EKPE within the environs of the EFE of the receiver. The exercises call

Figure 19 House of Adept

for substantial investment in time, finance and manpower which in distant past invariable often resulted in loss of life. It was designed that way to discourage frivolous request, adventure and the cheapening of EKPE. In the sight of the untutored, ITIAT EKPE is a weather beaten oval shaped naturally occurring igneous rock, the source of which is a well guarded secret.

Sacrifice (UWA) is offered to EKPE after the planting procedures have been completed and thereafter, as and when necessary. Howbeit, the mandatory UWA of expiation for sins of the community is performed once a year under the supervision or delegated authority of the EYAMBA. In ancient time, it involved the slaughtering of a Zodiac relevant bovine animal, e.g. bull, on the ITIAT EKPE over which blood was allowed to flow. Current practice encourages the use of goat. This generous outpouring of fresh blood on the ITIAT is symbolism for the cleansing process offered by renunciation. The exercise performed at the end of each year places the community on a redeemed path towards Christhood. Sin must be given up for God's spiritual endowment to blossom. Thus it is written that the soul of man must place himself upon the rock of Christ willingly ere the rock descends upon him and grind him to powder.[4]

Sacrificing to EKPE begins with symbolic return of the spirits, some good some bad, that had taken residence within the EFE during the period in review, including the thought forms of all those who had been to the EFE, to the ITIAT for rejuvenation. At the end of the sacrifice, EKPE divinities are evoked from the ITIAT to the EFE in full glory and without loss of potency. These transfers are accomplished either by individual calls or composite call using the MBOKO.

Fig. 23 symbolises the responsibility of the Hierophant (EYAMBA) as the bearer of community sins. The man wears a knitted black and white check skull cap adorned with a red floss, the symbolism for blood and service. He is obliged to shed his blood from the head down if the sins are to be off. The black and white check part of the OKPMKPOM (cloth necklace) confirms his bondage to the world of duality, of good and evil. The red that entwines the black and white check shows that his release and that of the community are obtained through service and sacrifice. The yellow tailing of the OKPOMKPOM signifies endowment (spiritual gifts of God) revealed only through renunciation (service/sacri-

fice). The man has to give up undeserving pursuits to gain what is spiritually rewarding. Ordinarily, yellow colour indicates the beginning of evolutionary journey known in EKPE as MKPE but the difficulty the ancients had in maintaining white made them at times to employ yellow in place of white when the focus is OKPOHO, the seat of spirit principle.

IDEM IKWO

To fully understand the role of IDEM IKWO in EKPE, it may be useful to reproduce with the writer's incepts in brackets a well known legend from the British Museum Brochure on the Egyptian Book of the Dead as recorded by Israel Regardie.

> Isis [EBONKO] was, besides all things, the highest type of faithful and loving wife and mother. It was in this capacity that the Egyptians honoured and worshipped her most. According to the now familiar legend, Osiris [MBOKO] her husband was slain through the cunning of his brother Typhon or Set [emblematic of the destructive aspects of Nature, e.g. Satan, EKPO NKANDA] and his body thrust into a box which, after being thrown into the Nile, was carried out to sea. After a long wearisome search [by messengers of EBONKO – IDEM IKWO] Isis found it, and set is as the thought in a safe place [the central column within EKPE House] where it was found however by Typhon [Satan, EKPO NKANDA] who maliciously cut the corpse into a number of pieces. The incidents of her search for the mutilated body, and of the conception and birth of child Horus [OKU AKAMA] powerfully impressed the imaginations of the Egyptians. Particularly so, when legend narrates her seeking the help from Thoth [NKANDA] the God of Wisdom and Magic, and he by consummate skill in Theurgic Arts was able to tell her of the process and words of power which temporarily restored Osiris [MBOKO] to life, and enabled him begat her god-child Horus [OKU AKAMA].[5]

The arcane wisdom passed on to Isis (EBONKO) by Thoth (NKANDA) is the L.V.X. sign. It is the sign employed by IDEM IKWO when he meets an EKPE initiate so that what befell Osiris (MBOKO) remains ever-green in the memory of initiates and to reassure initiates that resurrection power is real. The IDEM looks the initiate straight, eye ball to eye ball, to make sure the fellow is an initiate. He then throws the right foot behind and resting it while the weight is borne by the slightly bent left leg and the staff on the right hand held close to its head. He brings the fresh leaves (purifying spirit) on his left hand stretched to the left (L-sign) to slowly and gently sweep the left side of the initiate from shoulder to the foot and to the left of the foot. This procedure is repeated on the initiate's right column. The ritual continues with IDEM IKWO facing the initiate frontally and quickly raising the leaves up towards the temple of the initiate (V-sign) and bringing it down quickly. As both face one another and with elbows bent so that the palms are towards the owner's chest, the shoulders and hands are suddenly raised (X-sign) and lowered, signifying that Osiris (MBOKO) has risen from death. IDEM IKWO are emissaries of EBONKO. The key to the L.V.X. sign is to be found in Fig. 21.[6] In EKPE the L.V.X. ritual is a way to activate the latent powers of the active, passive and neutral columns of the man. An initiate blessed with the spirit of discernment may experience the flow of electrons out of the -ve hand to the +ve hand, an indication that the powers have been activated. EKPE grades above NYAMKPE hardly involve themselves in this ritual.

Many now interpret the letters, L.V.X. to mean 'Light of the Cross'. They came to that conclusion because the letters INRI were initially found on the crucifix, and L.V.X. means light in Latin. Considering that EKPE religion probably came to be active during the period of Egyptian and Mithraic Mystery Religions, the origin of L.V.X. sign could not have had it origin at Golgotha. Going backwards in time, it is found that the initials of the names Isis, Apophis, and Osiris represent IAO, the supreme God of the Gnostics, a cult group of pre-Christian centuries. Since the sun is the giver of life and light, IAO was taken to represent light as the redeemer. The letters LVX are portions of one type or another of the cross.

L. V. X.

L sign means: The sign of the Mourning of Isis. It expresses the sorrow of Isis (EBONKO) on learning that Osiris (MBOKO) had been slain by Typhon (EKPO NKANDA).

V Sign is: The sign of Apophis and Typhon (EKPO NKANDA). Typhon murdered and mutilated Osiris, and this prompted Isis (EBONKO) to search over creation for him. It is: The sign of Osiris slain.

The X sign is: 'The sign of Osiris risen'. These signs are evocative gestures which have similar effect and purpose as the Third Degree Masonic drama of the slaying and raising of the Master, Hiram Abiff; and the Catholic Mass bearing on the life, crucifixion, resurrection in glory and ascension into heaven of Jesus the Christ.[7] Hiram Abiff is probably the same person or principle known to Christians as Huram-abi, and Ebrambi in EKPE.

The claim that IDEM IKWO, a lowly placed EKPE which many fraternities outside Efik land do not recognise as EKPE, is the visible sign of EKPE cult in NDEM world is questionable.[8] If by this is meant that EKPE in NDEM kingdom is clothed in the paraphernalia of IDEM IKWO, the concept is faulted by the fact that EKPE forms resemble nothing in creation. They are all teaching aids. In any case, if Prophet's claim that occasionally on the invitation of God of the Earth the hierarchs of the four elemental kingdoms of fire, air, water and earth move from the four quadrants of the earth to meet in conclave is anything to go by, attendance at such an elevated conclave would require the initiate to arrange for the quickening of the physical elements through the auspices of the hierarchs and the Holy Spirit, to bring himself and the form into rapport with the conclave environment. Such an elevation is certainly beyond the capability of an ordinary initiate, and it is unlikely that an adept worth his salt will allow himself to be adorned as an IDEM IKWO. Also IDEM IKWO being of too low a status precludes it from appearing when a conclave holds within one elemental kingdom, an activity that is not strange to EKPE. Even at the mundane level, IDEM IKWO may not present himself when the fraternity meets in conclave.

Figure 20 IDEM IKWO

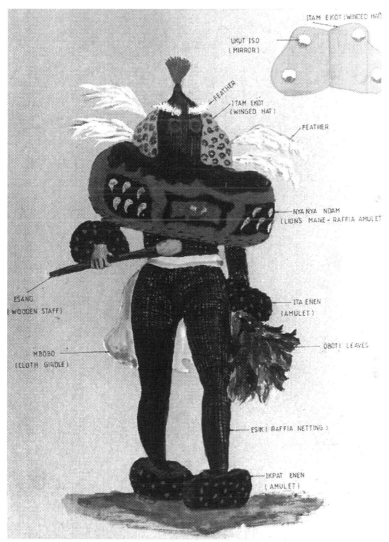

IDEM IKWO is a lowly placed EKPE that has lost almost all its spirituality and has become earth bound. Aside of the inner man being confined within the mesh body covering; the conical helmet, the antenna that should bring him into conscious rapport with God had become atrophied leaving only the roots. The situation is further compounded because he had lost the status that allowed him to wear a fixed hat meant

to indicate closeness to God but had instead acquired a winged hat which calls for greater effort to be invested to facilitate acquisition of power from God. This further confirms the low status of the IDEM. This EKPE form is usually girdled into colours, yellow and green representing mercury and Mars halves of the Earth period respectively. The other EKPE forms have single colour girdles as a rule.

Figure 21 The portal and L.V.X. signs

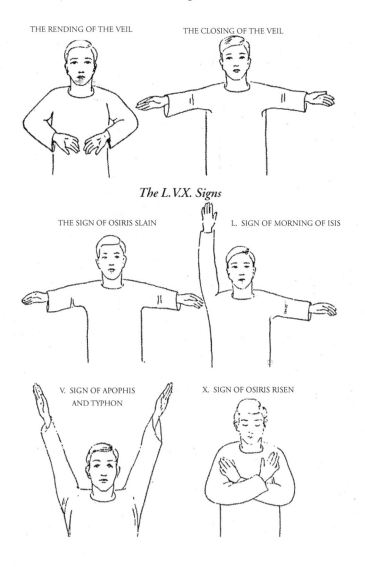

THE RENDING OF THE VEIL THE CLOSING OF THE VEIL

The L.V.X. Signs

THE SIGN OF OSIRIS SLAIN L. SIGN OF MORNING OF ISIS

V. SIGN OF APOPHIS X. SIGN OF OSIRIS RISEN
AND TYPHON

Chapter Seven

Temple Works

Mboko Sound

The MBOKO vehicle is for all intents and purposes a trumpet, a wind instrument. It works like a mouth-piece transmitting the message of the heart. Out of the fullness of the heart the mouth speaketh. Its child is sound and sound is power in EKPE. It is common knowledge that the prayer of a righteous man has great power in its effects. A righteous man is one with clear conscience and is dedicated to the service of God in a way pleasing to him. He is therefore able to call and pray to God with success. In addition to using the mouth, God had at the beginning shown to man how to magnify and transmit his heart desire and his prayers so that the family of God may bear witness and respond. Here sound means the roar of MBOKO, the sounding of the MBOKO trumpet or sound produced by the MBOKO vehicle. The MBOKO House occupies an important position on the Tree of Life in relation to the other EKPE Houses (Globes). It is at the central position, a commanding position. From there activities of other Houses could be regulated or monitored.

The MBOKO position is known as the seat of Solomon or the Christ Centre.[1] The heart of any thing is the life of that thing. From its vantage position, evocative/invocation and banishing commands are directed at

other Houses. There will be favourable response provided appropriate language and call signals recognisable by the intelligences or divinities residing in the House addressed are employed. Each House is under a ruling divinity recognised in some systems as god. Successful evocation, invocation and dismissals depend on the application of unadulterated pointed will within the MBOKO House. Such a will is Christ-centred. It is essential to engage a capable trumpeter, an expert on MBOKO vehicle, that is one with a pure heart, if he is to communicate successfully. Seekers of the way to soul freedom know that the pure in heart are the ones who will make conscious contact with God, provided each is able to work with his mind and hand well positioned. According to Bailey correct timing will enable man to create his various needs including the nourishing of his body with requisite spiritual food.[2]

The MBOKO trumpet comprises a portable native drum and a variety of tongues. There are a variety of trumpets in use by Efik. NKANDA has a trumpet that correlates with the elements. Some EKPE grades have their own trumpet, but the trumpet of the sanctuary is resident in the MBOKO House, the Christ Centre. These trumpets are routinely and methodically lubricated with gin or water while in use to vary the tone and pitch of the sound and facilitate coding of messages in a discriminating manner. The whole exercise involves working in the mental plane and synchronising the energies of love, mind, hand and the drum. Love unifies and attracts, but the mind is the main creative power and employer of the energies of the cosmos. Love attracts but the mind attracts, repels and coordinates. The hand codifies while the drum magnifies and transmits. It is the mind that creates but love intelligently applied is the mould. It is necessary for the mind to hold a position beyond and detached from the creative process if it is not to be sucked by evil desire into destruction. For good and safe results, the purpose of the exercise must be God. This is where the difference between good and evil lies. Any programme that is not God-centred or purposed is evil.

The main functions of MBOKO trumpet include: –

i) The alignment of the principles in man with higher divine spirits

ii) Participation in God's plan by involving in God's centred creative work.

The exercise of trumpeting involves synchronous sounding of the personality and soul notes of the trumpeter with his mind stilled but properly focused. Should the trumpeter cultivate silence, he may sense an inner response or sound, the fused echoes of notes trumpeted. This resultant echo helps in the development of the sensitivity of the inner ear noticed only in stillness and quiet. When sounded forth with intent thought behind it, it acts as a disturber, a loosener of the coarse matter of the body of thought, of emotion, and of the physical body. When sounded forth with intense spiritual aspiration behind it, it acts as an attractive medium and gathers in particles of pure matter to fill the places of those earlier thrown out.[3] The reader may wish to compare the Bible account which states:

> ... so short blasts are to be sounded to break camp, but in order to call the community together long blasts are to be sounded.[4]

The MBOKO sound is of value in that it results in the building of bodies for the use of the soul, and also serves to indicate to others with similar spiritual interest that someone or a group is available for God's work. During the process of raising the fraternity each OBONG EKPE responds as he is called through the auspices of the MBOKO. By this the personality and soul notes of each are gathered and registered ready for release to the divine spirits in the cosmos. To be effective, the trumpeter has to train himself to do at least five things.

i) To communicate with the divinity in the language it understands;

ii) To be receptive to the mind of the divinity being addressed;

iii) To cultivate a right intuitive understanding of communications released by the divinity;

iv) To develop the communications received into suitable forms for use;

v) Through sound, vibrations and other relevant equipment, make his thought form and those of others, active so that other minds may be reached.

MBOKO sound is potent when the trumpeter has learnt to subordinate the lesser sounds. For efficacy, the sound should be sparingly used

and investment in noise, a common feature of the temple, withdrawn. An initiate on this path must learn to be frugal with his words, cultivate silence, spend less time on spiritually unrewarding pastimes, and also cultivate a life of purity. Failure to adequately address oneself on these matters invariably result in him encountering untold difficulties that may lead subsequently to untimely demise. These conditionalities and the cost of failure have caused many to shun the position. A wrong language from the MBOKO may

i) cause the chosen divinity to be out of step with what was intended,

ii) bring no response because the language is unrecognisable by the divinities, and,

iii) generate unexpected response from an undesired divinity.

Love in the heart of the trumpeter guarantees good results. In EKPE Efik sanctuary practice, two trumpets are in use, namely, (a) the MBOKO vehicle and (b) pure, clear well-purposed and directed thought and aspiration. These are used for long and short blasts but the pitch could be altered to some degree. The quality of thought of the trumpeter could not be guaranteed. Consequently, favourable results from trumpeting could not always be guaranteed.

In the context of sound produced by the MBOKO trumpet, a deep or heavy, sharp and abrupt "WOOB" sound is a call to order, it means be attentive, expectant and be alert. It is an alarm. A second "WOOB" is a confirmation of the first. A third "WOOB" of similar constitution means move out quickly but expect further instructions. When this is followed by a flowing "Wooing" sound, initiates are invited to assemble, and non-initiates are warned to keep off. Subsequent instructions may take the form of medianly pitched sharp and abrupt or flowing and pouring sounds depending on the nature of tasks or actions to be undertaken.

There was a time when the use of musical instruments except the organ during church worship was not allowed in Efik land. Time has changed to the extent that local drums (tom-tom) are now used extensively. Objection to MBOKO arise from the fact that not many know it to be a local trumpet. Also the sound is frightening, especially as the

initiates have a habit of bringing it on at a godforsaken hour of the night to cause maximum disturbance and fear. The MBOKO trumpet has to be redesigned to raise the pitch of the sound. It is a thought magnifier with effects similar to that of group prayer and what is popularly referred to as chain prayer, particularly when the people are of one mind. These are techniques for the powering of prayer and sustaining its momentum.

Unity of Life

EKPE believes in unity of life. It conceives the existence of a mysterious something which for want of words may be called substance that links all lives. The word substance implies some degree of condensation, materiality and to some extent tangibility. This mysterious substance is really not substance at all. It is certainly not what we know as substance in this side of existence. With this mysterious substance other lives maybe contacted. It is mesh covering of all lives. The ESIK mesh of some of the Ekpe forms (masquerade) is a good example of what the mysterious substance is like. As the ESIK covers the man and every movement of the man activates the ESIK, so also it is with the mysterious substance that surrounds every life linking them one with the other, except that on the latter, integrated electronic circuit chip-like units are installed at the nodal points to produce a super communication highway. This facilitates discrimination.

Experience over the ages has shown that matter, intelligence, consciousness and spirit respond to vibration. Adopting a deliberate policy of discrimination, these lives could be put into communication with man. Thought causes vibration and the power behind thought depends to a large extent on the quality of love within the heart and the mind stuff of the man. In the case of MBOKO, and provided the mind is firmly focused on the work at hand, the trumpet amplifies thousand-fold the thought of the trumpeter or communicator as he may be called, so that lives in distant cosmos may be touched through the agitation of the mysterious mesh. It is a matter of causing the strands of the mysterious substance to vibrate in a controlled manner and in response to a coded language recognised by these divinities.

Over the ages nations had fashioned out their own peculiar way of contacting these divinities that some elect to worship. The origin of these ways is God through inspired revelation to those he had chosen and prepared for the purpose. Every group has had for long their way to God who is not parochial. In the context of EKPE, God went further to teach and he did so by addressing all throughout the earth. The instructions on the use of the trumpet handed over to Moses[5] were perceived by EKPE initiates who acted upon them, howbeit in a different way but satisfying the directives given to Moses and Israelites. The practice is handed down from generation to generation. In Israel it is the Kabala, amongst Efik it is EKPE. The difference is that in Israel it is recorded but in Efik land it is locked up in the heads of men most of whom have passed on. The result is that those now in charge of EKPE temples see dimly hence the temple teachings are no longer worth the candle. The modern man hardly has time, discipline, patience, devotion, clarity and purity of purpose that success demands. The ancestors saw the need to pay the price of success up-front by studying and observing gifted trumpeters sound the trumpet.

Though the MBOKO vehicle is known, the art of trumpeting is not that simple and involves some risk. Most of those who had taken over the job of trumpeting are known to have had it rough in life. They invariably die as paupers. Inexperience does create problems some of which may be difficult to contain. Also since tone is known to build forms in the physical world, tone can also destroy. This power could be employed for good or for bad depending on the competence and disposition of the trumpeter. The destruction of the walls of Jericho by the Israelite army under Joshua, son of Nun, is an example of what is possible. To avoid unwanted results, care was taken by the ancient in choosing the trumpeter and his aides. Despite the seriousness of God's instructions which earned an implied warning against abuse, man proceeded to abuse the equipment with corrupt intentions and as a result pay the price for disobedience.

Raising the Fraternity

After the pouring of libation the process of bringing the assembly into session begins. Applying the Cupta Vidya cosmogony the trumpet sounds the first time the EYAMBA calls the divinity on the South by

name. At the second sound of the trumpet, the EYAMBA calls the divinity on the East by name. Finally, there is a third sounding of the trumpet, then the EYAMBA responds as the representative of God. Raising of the lodge is preceded by the charging of the environment with songs and drumming. The singing and drumming are interrupted intermittently as the trumpeter calls the divinities and receives the responses of the MBONG EKPE (Adepts) representing them. The raising of the fraternity follows an established order identifiable by singing and drumming, and the related trumpeting of the MBOKO vehicle. After the fraternity had been fully raised, a divinity may be encouraged to become active, often within some initiates and EKPE's representative form (masquerade). This is the invocative activity that enables those visited to perform beyond their natural capabilities, including going through concrete walls and moving in and out of a large naturally occurring body of water without being wet. An initiate may take a form of his choice. This is perhaps why Efik military commanders were expected to be EKPE adepts, and Mithraism was popular amongst the military of the Roman Empire up to the third century A.D.

Music

Music is a very useful esoteric tool. Rhythm and grace are characteristics of nature. EKPE is one of the beneficiaries of these treasures that are brought into activity as sound, music, song and dance. Tone is the originator of colour so that when a certain note is struck, a corresponding colour appears.[6]

Each EKPE House has its own music, song, dance, form, tone, and, consequently, colour. These colours are employed on designated spots of the body that are aligned with corresponding divinities. At the same time the songs and music create tones which in turn create colours that are beneficial to the psyche of the initiate.[7]

The main musical instruments presently in use in EKPE on the terrestrial region of life are a family of tom-tome, a local percussion instrument called NSAK (rattle), and the single metal gong, (NOT TWIN). These instruments are commonly and readily available. Music employed by the fraternity is overburdened by heavy sounds of a variety

of tom-toms. It is not balanced. This considerably reduces the efficacy of the music and may be responsible for the delayed and often inappropriate responses of the divinities and the initiates themselves. It takes a good part of a day for the temple to be adequately raised. The quality of music available in EKPE temple falls short of what is evident in most other esoteric temples.

In ancient Egypt before Islam took root, the secret music of the temple utilized strings, percussion and wind instruments in their variety to create effects for raising consciousness and managing nervous disorders.[8] King Saul who had a nervous disorder was comforted each time David was at his harp.[9] Ancient Egyptians were great musicians and they are known to have used a great variety of instruments. Considering their excellence in other areas of endeavour, it will be surprising if they were not familiar with music therapy applicable to a variety of disorders. Modern men have made a profession of Music Therapy.[10]

EKPE as part of arcane wisdom is closely related to the wisdom teachings and activities of ancient Egypt and Israel. It is not surprising that music is one of the areas of interest to EKPE, particularly as much of the fruits of invocation and evocation depend on it. In Israel and Egypt, instrumental music involving harps, drums, flutes and lyres were used as invocative aids during religious dancing to the extent that on an occasion even King Saul was personally involved in ecstatic dancing and shouting.[11] On another occasion, King David stripped to the waist, unashamedly danced and jumped in public in a sacred dance to honour the Lord, an exercise which some modern Christian zealots will term satanic. Music and dancing have been with man for a long time and both have been used in the temple to advance awareness. They were both taken seriously in the temple. The situation of EKPE Temple in Efik land is now different. The temple has become a place of enjoyment and no longer meant for the worship of God.

Dance

In EKPE, dance is a serious affair. The dance forms relate to the dance and characteristic of the divinities. They are the unvoiced language or coded communications which the divinity recognises and understands.

Dance is a medium of communication between man and man, man and the divinities and vice versa. To be meaningful those involved should speak the same language especially as each EKPE House or Globe has its music and dance forms. These dances may be categorized, but three groups will now be discussed;

i) Hunting Dance

The dance recalls the experiences of a hunter in the forest in search of game. It may more appropriately be described as a display by two initiates one acting the part of a hunter and the other a game, a sort of pantomime devoid of jesting. It is a dance drama in which great effort is made by the initiates to present a near-natural situation as possible. At times an initiate goes solo playing the part of hunter and animal. The dance embodies the hunters patience; alertness; fleeting feet; the electrifying presence of a game; the pincer-like movement in search of a vantage position; perhaps, the realisation that the game is not worth his effort or is too dangerous for him to take on; the decision to continue to lay in wait; the resumption of the hunt; the discovery of a suitable game well positioned for him to strike; the instinctive reaction of the game in the face of danger; the firing of the gun and the falling of the game (symbolically); the attendant silence; the cautious manner in which the fallen game is approached with the gun reloaded and on the ready; the game is certified dead; the joy that attends it; the movement back to the village and the joyous reception that follows. The dance tells the story of a man going through the forest that is this world, to kill the animal in him. It is usually staged as part of NYAMKPE display.

ii) Animal Dance

The earth is a world of lives and forms. It is where a man cannot afford to move as if nothing else exists. He must learn to be observant, attentive, alert and yet patient. The dance is designed to bring home these qualities to initiates and the need for them to have interest but no jesting and involves at most two initiates.

EKPE does not tolerate an all comers display. The dancers must be closely watched by the judges and learners alike. For this purpose, the grounds must be cleared by all except the two on the job. The dance may

proceed in batches of two and run for a long period, perhaps, a good part of the day or night. The dancers mimic animals of their choice in a meaningful yet not easily understood manner. Each dancer is expected to be quick in understanding the movements of the other, and so respond in an appropriate but slightly delayed manner to enhance the expectation of the spectators.

Figure 22 IDEM NYAMKPE

The dance is stopped when one fails to respond appropriately or willingly withdraws or is compelled to do so by the adepts who serve as judges. Those who go dancing must first understand the drum language and the sounds. The drums do communicate with the dancer, and is some way control his movement. The talking drum represents the Christ in man and a successful race of life is run only and only if the man allows the drum (Christ) to guide.

EKPE Houses or Globes do have forms by which they may be identified. The masquerade is a form but its common use as artifact is not convenient. At times they are spiritually directed. For these reasons, simple but handy forms are preferred. They allow for handy artifacts to be prepared for use. Usually these are of universal application. For this purpose an elephant represents OKU AKAMA; leopard – NYAMKPE; Crocodile – (M)BAKARA and a local trumpet – MBOKO. The dancer may choose to represent any life of his choice and this may vary as the dance progresses provided it relates to the attendant music. The exception allows the dancer to borrow from the dance forms of other EKPE Houses to enrich his NYAMKPE display. NYAMKPE has this privilege because its inherent consciousness allows temporary visits to be made to other EKPE Houses or Globes.

iii) Dance of Adepts

The unspoiled environment provides an opportunity for understanding the balance and conquest of barriers. It brings home to the modern man the realisation that there may be many things he may have to learn from those he dismisses as villagers, bushmen and uneducated. Somehow, some of the bushmen have managed to understand nature much more than most educated people. Perfect examples are found in the lives of the Pigmies of Africa and the Talapoin of Siam who move about in the jungle without fear or harm. The Bible stories about Shadrach, Meshach and Abednego[12] and Daniel[13] are relevant. The Fakirs of India are known to be able to control the wildest of animals. These go to prove that man should know himself and be able to live in peace and harmony with himself and the environment. The Bible confirms that God had given that power to man.[14] The dance is a secret dance performed in the sacred room of the temple or in a secluded place where only the privileged ini-

tiates may be allowed to witness. It is a demonstration by adepts of what is possible in EKPE. The demonstration may include (i) trumpeting of the MBOKO by the spirit when ordered; (ii) the spirit activating and putting on an 'IDEM' paraphernalia and performing; (iii) causing IDEM NYAMKPE to gain entry into locked rooms (iv) having the IDEM (masquerade) and some attendants to take a plunge into water in a completely dry state; creating where none had existed before; and others. On such occasions, an adept may wish to demonstrate the hidden processes behind inner realm changes and initiations, and their resultant effects on the objective universe including man. He points his walking stick, an essential item of his paraphernalia, at an object of his choice, and by the application of pointed will charges the stick with power enabling the object to either respond as a MBOKO TRUMPET or bring about a desired change. The walking stick functions as a ROD OF POWER, which, according to Bailey are of four types in discriminate employment of the Cosmic Logos, Solar Logos, Planetary Logos, and that group of spiritual beings on the inner planes of the solar system who are intelligent forces of nature in control of the evolutionary processes known as the Occult Hierarchy.[15] Although these wonders no longer occur in Efik Temples except when visiting adepts and initiates of distant temples are received, they show the possibility that exist. Some may ascribe such demonstrations to black magic, but is it not an eye opener to the fact that God is capable of bringing man to greater heights when he is ready? The devil cannot be a more wonderful worker than God to whom all glory belongs.

Song

'Out of the fullness of the heart the mouth speaketh' is an old saying of truth. Songs are the outward pouring of the heart's intent. They reveal the hidden letters, petitions, prayers, wishes and desires of the man. These involve the cooperation of the heart, tongue and mouth, the three inseparable triplets required for effective results. The tongue is recognised as a little member of the group that can make and unmake. With the heart properly aligned and the mouth in discriminating attendance, the tongue could assist to produce music that is beneficial. Aside of the effect of the words of voiced language, the attended orchestration resulting

from the proper use of the 'triplets' could have far-reaching effect on the divinities and the psyche of man. The mouth and tongue could be made to function as wind instrument. They also may be made to perform as percussion and string instruments, so that if group singing is employed as is done in EKPE Temple, the initiates' hearts' intent may be realised when they are of one mind.

Chapter Eight

Religion, Magic and Ekpe

Religion and Magic

EKPE involves religion and white magic, but there are many who hold the view that EKPE is black magic and that it has nothing to do with religion. Unless this conflict of thought is removed, it may be difficult to understand what EKPE is all about, much less appreciate how to release the majority of EKPE initiates from their present wrong-living and not abandon them as many would wish.

Contact with the psyche (human soul) provides the key to reaching the power sources of the universe after the physical and soul senses have become full grown or as St. Paul puts it – "Until the Christ be formed in you."[1] The way to God has been a subject of discussion throughout the ages. There are those who say two ways exist for bringing man to the power sources of the universe, and list religion as one of the ways. E. Bolaji Idowu opines that in religion reliance is placed on communion, communication, submission and appeal as against command; this they do irrespective of the quality of the source. By the second method man seeks alignment with the powers, energies and forces he identifies as being relevant to his needs and organises them to yield to his heart desire. To him that is magic.[2] Idowu believes that the basic premise of magic is that all that exist are forces or energies that may or may not be perceived.

It all depends on the orientation of the operation. Fortune limits herself to worship. According to her, there are two ways in which God could be worshipped. The first has to do with worshipping in unmanifested essence, and the second worshipping him in his manifested form. She advised that in worshipping the manifested form, care must be taken not to forget the essence, and worshipping the essence should not be confused with the manifested form, otherwise the devotee will be guilty of the sin of idolatry. According to her, worshipping God in his manifested form is the way of fulfilment, the aim being to obtain complete mastery over every aspect of created life.[3] To some degree, white magic involves worship of God. The difference between Idowu and Fortune lies in the definition of magic. The former implies that worship is not involved in magic whereas Fortune thinks otherwise.

Fortune went further to describe the way of religion or devotion as the way of renunciation of the mystic in a milder form. In her opinion, worshipping God in essence is a difficult undertaking because of the essence being unmanifest. It eludes the consciousness of most devotees except the special few. To overcome the impediment, a mystic applies ascetic discipline to free his consciousness from its habitual bondage to form. Continuing on the way will ultimately result in breaking through the limitations of his lower nature and entry into his freedom.[4] Fortune considers the mystic way to be unsafe in that it may cause irreparable damage on those not cut out for it. At the end, both Idowu and Fortune do not seem to agree. Each prefers the method he (she) is familiar with. This has always been the problem with opinions. They are hardly untinted with bias.

Going by the pastimes of men, it may be concluded that there are, perhaps, as many groups of men as there are ways to God. Fortunately, the soul knows which way is best for it and will not find rest until it is on the path it acknowledges. Howbeit, God in his infinite mercy and wisdom has made it possible for the honest and truthful on the path of religion or devotion to progress to a point where a true spiritual teacher makes his debut. There are many who will not accept him. To them the devil is trying out his tricks on them. It is true the spiritual teacher unfolds the inner teachings according to the degree of devotion and aptitude of the devotee. The way allows for personalised teaching. To deserve the

attention of a spiritual teacher it is mandatory to covet the spirit and endeavour to practice charity. Success will not come without the use of mind and will. Submission to the mind and will of God will come later. It serves no useful purpose to harass new converts with treatise and preachings on will and mind. Some do-gooders go to the extent of advising adherents to urgently do away with their minds and will if they are to make any meaningful progress, thus attempting, howbeit without knowing, to turn the people into zombies. Patience and consistency are necessary if progress is to be made. The way to contacting the soul is slow and tedious, but as soon as contact is registered the soul's inherent goodness takes over allowing the mind and will of God to rule. This is a natural reward of the growth of soul qualities.[5] This, it seems to me, is the correct position.

Often there is hardly any difference between religion and magic. Both rise from the same root, worship. Religion and magic have been very closely connected from earliest times. So close that it has not been possible to establish without doubt which predated the other. According to Idowu, even though both recognise the transcendental power, the supernatural, a power beyond man, religion is the primordial or elemental basis of belief and therefore predates magic.[6]

The difference between religion and magic may be found in their individual attitudes and techniques. The approach in religion is one of submission and appeal. There is the belief that there exists an infinitely higher power to whom supplication is made. This is also true of magic. In all cases of magic, success depends on the acceptance of and submission to the existence of prevailing higher powers. What is often not acknowledged is that at some stage in man's spiritual ascent through religion, he receives direct instructions and teachings which application brings his practice or actions into the realm of what an uniformed observer may term magic. Should the man be fortunate to be an accepted messenger of God, and this is not as rare as some would wish others to believe, he is often ordered on a mission without lodging an appeal. Lord Jesus once spat on the ground and made mud with the spittle. He rubbed the mud on a blind man's eyes and directed him to wash his face in a pool. The man did and was healed.[7] It is obvious that some people concluded he was a magician. On another occasion, the Bible acknowledged that the

power of the Lord was present for Jesus to heal the sick.[8] At the material time he was a messenger of God. Also Paul "saw that the man believed and could be healed so he looked straight at him and commanded him to stand on his feet."[9] Both Jesus and Paul were obviously working as messengers of God. What the ignorant does not understand and is incapable of carrying out he condemns as magic. This was true of Daniel the honoured man of God. He was called the chief of magicians and wizards.[10] Much ignorance and, to some extent, jealousy permeating humanity is responsible for the parochialism evident in religious and magical practices.

There is dirty religion and dirty magic. Dirty religion has to do with worship of powers in rebellion to God. Magic is a word that has been misused by many who do not even bother to enquire what it means. Its meaning is wide. It extends from theatrical display of tricks for entertainment of spectators by performers better known as impressionists, to what is rightly described as white, grey and black magic. Although the technique in white and black magic do not differ much, the little difference that there is lies in the attitude of the operator, the symbolism employed and the powers contacted. According to Fortune, should a real magical exhibition be held for the benefit of an audience it may be safely concluded it is black. This is because it will sooner or later arouse the baser instincts of the spectators present. Techniques involving sex and blood relate to Black Magic and involve deliberate evocation of evil very often for revenge. The invocation of certain primitive types of natural forces though not intrinsically black, is likely to go sour and should be avoided. Fortune, who seems to have had considerable experience with magic, is of the opinion that here is no clear dividing line between white and black magic. The transition is known as grey magic. She advises that while white is white and black is black, grey does shade into black making it difficult to adequately distinguish the two. Fortunately, all white magic operations are designed and carried out in conformity with God's universal law, not different from the Christ law of love. Any operation that does not conform with the Christ law is grey, whereas those which deliberately proceed in defiance of the Christ law is classified as Black Magic.[11] Involvement in seance, fortune-telling, psychism and such like activities is grey magic because the aim is sense-gratification or satisfaction or

personal desires as against gains in spiritual quality. These seemingly innocent activities do in time cause noticeable deterioration in the quality of the mind. For this reason, any form of indulgence in forced psychic activity should be avoided. The way of magic has inherent risks that the wise will do well to avoid unless under the guidance of an acknowledged teacher, and they are few. The problem lies in how to recognise them.

The difference in technique between religion and magic is not as clear cut as some would wish. The existence of the classes of magic differently purposed compound matters. It is the habit of generalizing the status of magic that is responsible for the confusion in people's minds. The "use of spells and enchantments consisting of secret or archaic language or cryptic terminology and expressions that are often unintelligible"[12] relate to black magic and, to a lesser extent grey magic. Very often an observer ignorant of the way is not in a position to give any value judgement on the workings of the spirit. The spoken word may not be in use and the symbology if employed, may be pregnant with meaning but simple. Ponder over the saying "action speaks louder than words." Worship is the foundation of white magic, the aim being to establish communion between God and man or perhaps between the divinities and man. Once the communion is established and God's will becomes the will of man, he could be expected to create by the power of the will of God. No word uttered and no movement made yet things happen. Perhaps, it is not commonly realised that most of the important rituals of the orthodox churches have their equivalence in magic. One such example is the consecration of the Eucharist, and, in this particular instance, it predates Christian practice.[13] The advice of Fortune should be heeded. She says:

> *If we understand the psychology of ritual we shall be released from the bondage of superstition, ignorance, wrong judgement and not be in rebellion against empty forms. It will then be realised that a form is the channel for a force, but it is not only the material substance used which is the physical channel for a force, but also the vivid pictorial image created in the mind of the worshipper by its ritual use.*[14]

Let it be remembered that a white magician is also a worshipper who may employ rituals in his approach to God. There is language and spiritual force behind forms, symbols, dance, colours and words used by all

engaged in true worship of God irrespective of where the worshipper may choose to be. This is true for both religion and magic. Lack of understanding of the language is no proof that its purpose is evil or irreligious. A Christian may unconsciously be involved in movements that have spiritual significance but which an ignorant bystander promptly dismisses as stupid, obscene or even satanic. In this regard, there is the example of Michal, the wife of King David, who thought the King had made a fool of himself when she found him involved in dancing and jumping around in a sacred dance.[15] Man may even speak in 'tongues,' now popular among Pentecostals. The power behind the form is what to go for. The outward visible sign is but the focusing point of attention which enables the worshipper to come into soul touch with the form of spiritual force which is the animating life of that form. For this reason forms used in religion and white magic are not necessarily graven images. Undoubtedly, many may be irredeemably rooted in their conviction one way or the other about these matters. Could it be said their conviction rises from experience gained as an insider or by spiritual revelation or reading? Witnessing is not a matter of reading, it is of experience. Prophet Ezekiel had proven that it is not necessary to be an insider to witness. Witnessing could be spirit sponsored.[16]

Ekpe and Magic

A black magician does not as a rule operate outside the plane of mind. Although his effort may be attended by quick results, a false sense of security and power that are ephemeral, he is invariable propelled by evil desire into self-destruction. In contrast, EKPE is founded on pure motives and initiates are encouraged to invest in soul-rewarding activities. These pursuits are now more of intentions than practice. This is so because human organisations down the ages have often introduced undeserving concepts, thought and procedures to corrupt pure intentions of various groups. In that way black magical practices, sorcery, and the worship of gnomes and undines known in Efik as NDEM were introduced. Ordinarily, common practices in EKPE expose its workings to exploitation by some powers of the cosmos. Invocative and evocative practices belong to this category. When the soul and personality are not ready they tend to have the mind improperly focused, and do influence

the man to wrongly assess his capabilities. He tends to have an inflated opinion of himself, and before he realises it, he is on the way to self-destruction having slipped unconsciously into the realm of black magic. This is perhaps the reason why trumpeting of MBOKO is shun by the majority of initiates. The price paid for these infringements include:

i) Poor trumpeting of MBOKO;

ii) Flirtation with ancient powers in alliance with poor thought-forms generated within the temple;

iii) Contrasting focus of the initiates; and,

iv) Corruption or displacement of weak souls resulting in mental problems or death.

These have led many to conclude that EKPE fraternity is of the left hand path; it is black. A few, including initiates recognising neither good nor bad in it, wrongly conclude it is a social organisation.

The word 'invoke' creates a problem for many. It is anathema to them who think of it in terms of black magic. The word means to bring forth, not necessarily evil spirits, ghosts and demons. Contrary to popular belief, spirits are not necessarily actualised only by incantations. Prayer is an evocatory tool, and the result may crystalise in many ways including personification. Words need not be uttered, ceremonies may not be brought into play, and actions, if present at all, maybe limited, yet the environment is alight. The consecration of the Eucharist involves invocation but how many are against it? Fortunately, the inner teachings of some of the churches recognise and acknowledge it for what it is, if other Christian congregations deny that there had been acculturate and inculturate actions by the church. This does not imply that invocation as practised in EKPE is acceptable. EKPE could not be without blame but its position is not irredeemable.

On the basis of its original motives and workings, EKPE is a monotheistic religion. Sacrifices are offered to EKPE (God) and never to its constituent units that are worshipped in some systems. Sacrificing to EKPE implies worshipping of God. White magic, the closest form of magic to EKPE properly focused, accepts pantheism whereas EKPE does not. White magicians may be classified under two groups, and they are:

i) those who indulge in worship;

ii) others who do not, but employ other methods to bring themselves into conscious alignment with their souls.

Those involved in worship and accept initiation as bench marks of spiritual attainment are the esoterists. Classical EKPE initiates are esoterists, and MBOKO sound is engaged on the building of good bodies for the soul as part of God's plan for humanity. Under this condition the soul is all seeing and knowing through safe contact with God and His agents, such that the soul is not soiled by the ensuing activities.

Black magic and sorcery practices are no longer deliberate activities of Efik Temples. NDEM has been a problem to both EKPE and the Christian Church because Efik believe in it, welcome it and worship it. The fight against NDEM is not only for EKPE but also for the church to take on. Should EKPE be dismissed because the man whom the Christian and other faiths are attempting to salvage brought it to where it is now? Would it be right to abandon it when there are indications of divine light penetrating it?

The difference between Efik fraternity and others in the out-lying areas should be obvious to an impartial observer. When Christ visited the temple in Jerusalem and found it defiled and misused, he did not cause the place to be closed down, but he took action to clean it up. Does it mean EKPE fraternity could not be cleansed? Let attempts be made to identify and uproot the obnoxious practices. There are many within it who need to be re-trained. Fortunately, the way of Jesus the Christ is already embodied within EKPE as part of its treasures even though veiled to most. Consequently, the process of acculturation and inculturation that had enriched the Church of Rome[17] may be examined in relation to some aspects of EKPE teachings. Efik have kept their EKPE culture away from non-indigenes for too long and as a result deny the world a source of wisdom. They themselves have lost much from that wholesome practice.

Ekpe and Religion

In the material world there is mostly conflict between persons, interest groups or organisations. Some may think of it as competition which

more often than not is unhealthy. Subscribers to the true religion rise above such unhealthy competitions. They accept and endeavour to love their neighbours as themselves. The illusion of quick rewards led many including EKPE initiates to abandon pious activities and the path to invest in oppression, parochialism and evil desire. Much attention and resources continue to be invested in orgies of drinking, feasting and dancing, raids to plunder, immorality and sharing of booties. These led to the derailment EKPE from the path mapped out by good motives. This should not be the end of EKPE if man invests to redeem what is redeemable, and in the process help himself to remember his past.

The acceptance of the divinities does not in any way abrogate EKPE claim to be a monotheistic religion in its original form. These divinities have no self-existing status and are not worshipped. The EKPE heads and wings are proofs that the divinities are not independent of God. Their primary aim is to bring the higher planes of consciousness of pure spirit of the cosmos into alignment with man. This is also true of the Christian Church, other faiths and organisations when properly focused. The position is now different even though the purpose of EKPE has remained the same for those who are well intentioned. In the course of time, men with varying interests elected to harness the potentials of the various EKPE Houses or Globes. Some held the view that to seek after at-one-ment is an unattainable goal. The idea is too far-fetched and removed from real life situation. They elect instead to flirt with subsidiary powers of the EKPE Houses that are not far removed from man. In their opinion, the demands of these powers are easily within their reach and the benefits quick in coming. They become involved in activities that frutify their desires. Others elect instead to worship the overlords of the principles that each EKPE House represents (demigods in Eastern terminology). By this they unwittingly transform EKPE into polytheistic and pantheistic organisation in addition to it being monotheistic. It all depends on the interest of the adherent or initiate. EKPE is the world of interest, and a system that meets the needs of Christianity, Judaism, Hinduism, Buddhism and others. The benefits of EKPE are born out of practice. The system encourages the initiate to harness his God-sponsored experience in resolving the conflict of paths for himself and to come to the conclusion that monotheism offers a more permanent and

beneficial reward. Let the lone God be the only one worshipped, adored and prayed to with Christ as the way. That is EKPE in practice.

EKPE is open to all religious faiths. Religion is not a barrier to EKPE initiation. In the early days, it boasted that its long-tested system guaranteed the attainment of oneness with EKPE (God) through the Christ. EKPE teaches that MBOKO is the Christ centre and there is no way the trumpeter could have good results from his effort if his position at the Christ centre is incorrect. There was a time when the experience gained as the initiate moved up the ladder of initiation was taken as proof that the system was no less efficacious than some of those then under popular cultivation. In order that initiates may not slip off into the path of least resistance and continue to be lead astray, it is necessary for the adepts and initiates to be well grounded in the teachings of Christ so that evil desires may not continue to consume them. This is what is now lacking since mercenaries, sorcerers, and others of their yolk took over control of the fraternity.

Unfolding time has brought in new ways for reaching out to God and man modified his approach according to his needs. This does not invalidate earlier methods to God. Despite the self-righteous position taken by most professed Christians, the Jews are still approaching and receiving God's Grace through Judaism. Christ said he did not come to break the Law. His was to reveal greater understanding of the way and prove to man his inherent original right to God. Obviously the old method must give way to the new when the new is more soul-rewarding. As John the Baptist puts it: "He must increase but I must decrease."[18]

Each tradition had a method whereby every type of person was taught the language of his own particular nature so that a man of action grew to become acquainted with his psyche (soul) through deeds; a man of heart through devotion; and an intellectual through the contemplation of ideas.[19] Even though this system worked and continues to work for some, it is cumbersome. Sorting out by man for man has to be effected and may fail to produce the desired result. But through the advent of Jesus the Christ, humanity is made to appreciate and accept the path of devotion as the key to sustainable enlightenment for most during this age, as man believes and surrenders for the spirit to teach and direct. Those who humble and purge themselves of bias, prejudice, complex and holier-

than-though attitude will discover that the spirit teaches the beautiful things of this life. This promise of God is being fulfilled every second of life. Most critics contravene the rule requiring man not to judge those who do not belong to their group. It is the spirit that should judge. Unfortunately, most of those who judge do so from a position of weakness. They have forgotten that God's love in them is not yet perfect so they now see dimly. The unfolding drama of the spirit of God reveals the emptiness of man and humbles the enlightened.

The occultists and magicians consider the way of religion to be circumlocutous. They rather take what they call the straight path. Man certainly knows how to convince himself to do what he sets out to do. Many erroneously believe that practitioners of black magic possess more power than either white magicians or christed devotees of a religious faith. Even though they can quickly achieve results that are temporarily more potent, the results are ephemeral. Black magicians work from and in the plane of mind and are unable to function outside their field of play as does the soul. Black magic carries destruction and disaster in its wake, and the practitioner is eventually submerged in the resulting cataclysm. There is the case of two cousins, one of whom is a subscriber to a popular fraternity on truth and a Christian. His advice to his cousin who was seeking along the Christian way was that it was wasted effort relying on that alone. The cousin advised persevered against the advice offered, but after a short while the adviser recognised to his amazement that the cousin had made some progress. Man is always seeking after quick results which may inadvertently lead to black magic and self destruction.

In the past, spiritually beneficial ideas reached humanity in two ways. "One was through the teaching of a teacher who founded a school of thought, and working through the minds of the chosen few, finally succeeded in colouring or influencing the thoughts of men of the time. This was the way of great minds who although working from the mental plane may not necessarily be occultist or magicians. Plato, Aristotle, Socrates are some of those whose teachings have influenced man down the ages either thru acquiescence in their theories or rejection of them."[20]

The other method involves the pouring out of the inner wishes of the masses to advance towards greater awareness. This movement is based on some voiced idea embodied in an ideal life. This is how the work of

Saviours of the world came to be, and which finally found expression in a world religion. This method is emotional and for that reason easily affect mass consciousness. Christ is a product of this mass desire for goodness and his message of love is relevant. In these ways the mental few and the emotional many have been meeting the needs of humanity, and man had always been the laboratory for processing the forces emanating from these techniques of activity which have roots in the consciousness of God. Unfortunately, there are many who, not knowing where they rightly belong, choose to invest in the path not cut out for them.[21]

For the good of all it is necessary for the few to become the many and that no man should be denied an opportunity to full mastery of his spiritual endowment. This calls for culturing in love of the few who may be operating at the mental level and the raising of consciousness of masses operating on the emotional platform to become conversant with the power of mentation. Already there are those who have made the religious and mental approaches to truth, and having established enough soul contact may now be poised to contribute to world ideas and work as a group.[22] EKPE fraternity is the meeting place of the many of the religious and the few of the mental groups. Wherever two forces meet there is activity.

EKPE initiates were esoterists but many have turned black magicians and sorcerers. The rest are neither polytheists nor pantheists, but worshippers of the lone God, esoterically named EKPE. A natural follow up question is, why is it that the organisation strikes much fear in people? Ignorance is a root of fear. The experience gained from the abuse to which EKPE has been subjected to over the centuries is also relevant. Ordinarily, human organisations are influenced by human thoughts and actions. If not God-directed, they decay and die leaving no root. Man's continuous involvement in sinful act have polluted the original concept, teachings and purpose of EKPE. Men with impure thoughts hijacked it for their material and societal benefits. Evil men introduced their weird activities into it. Similar practices brought about the spirit of Reformation that gave birth to Protestantism and the world is now better off.

Fortunately, God has his time and his way for working out his plans. He has been intervening, but his way came into the open in Calabar, Nigeria, in 1846 when the Protestant missionaries arrived Calabar Town and Creek Town, Nigeria, at the invitation of King Eyamba V, the

OBONG EYAMBA EKPE and King Eyo II, the OBONG EBONKO EKPE, of Efik Prime EKPE fraternity. Both occupied the highest positions in EKPE Efik. The arrival of the missionaries marked the submission of EKPE to Christ, and the lighting up of Efik land by Christ spirit. Subsequently, the full weight of EKPE was brought to enforce attendance during Sunday worship at the church. Esoterically, it marked the commencement of the process of transformation of the masses into Christ culture period. It was the rending of the veil of ignorance and wrong living. The light had been amongst the people but they recognised it not. The Christ centre, MBOKO, had been with EKPE for centuries but the people recognised not its import. Finally, the king-makers acting without prompting, accepted to have the final crowning ceremonies of a new king performed in the Presbyterian Church. By this all aspects of Efik cultural heritage and people accepted the supremacy of Christ and the related new teaching. Since then the cleansing process by light has been progressing to the extent that the cloud within the EKPE Temples in the Calabar and Creek Town areas are lighter than what is experienced in upcountry areas. Certain practices have been discontinued, particularly those that have to do with black magic and witchcraft. Already some temples no longer offer animals as sacrifices to EKPE and there is no noticeable sign that they are worse off by it. Old ways are certainly giving way to new. This suggests that the hearts of men are being lighted up and good thoughts born.

The changes that are now being noticed came from organisations outside EKPE itself. These are the results of the effort of the Christian churches, amongst others, working from without. The pace of change may be quickened if the battle is fought from within EKPE organisation. Over the centuries wrong thoughts have pervaded the psyche of EKPE. Considerable concerted effort is required to rend the veil of ignorance and wrong living and put the vehicle meant for group emancipation and deliverance to proper use. Let it be remembered that the secret of God is to bring all creations in heaven and on earth under the headship of the Christ. Instead of running away and saying "not I: it is not possible: it is evil," let man rededicate himself to becoming a worthy channel by which evil may be defeated. Christ should be invited to clean up the place as he did in Jerusalem and remove the unwelcomed aspects of EKPE religion.

There is room for the improvement of the psyche of EKPE. As was said earlier, there are some temples that no longer offer sacrifices of animals to EKPE whereas in the olden days offerings of humans were, perhaps, not unknown. The wind of change is already blowing. What is required is the exercise at quickening the pace of change. There is room for improvement of the quality of music that has found accommodation in EKPE over the years. Heavy sounds in their own are known to encourage evocation and invocation of agents of darkness. They are at variance with the requirements of the centre of being. It is essential for human consciousness to be at-one-ment with the higher consciousness that is Christ. That is the goal of worship and should be the goal of music. One of the early steps of the initiates will be to improve the quality of music emanating from EKPE Temple. The globes provide excellent examples. They are models for the temple and gifted musicians. Introduction of instruments that are not now known in EKPE is necessary. To improve the quality and spirituality of the temple music, a balance of the sounds of percussion, string and wind instruments are necessary. These sounds will approximate the music that is food for the soul only if the quality of thought is adequate. The music is no better than the man generating it. Voice may attend the music. Although singing is very much part of African culture, the lyrics of EKPE songs, are designed for sense enjoyment and are inappropriate vehicles for contacting God. Songs of adoration and praise of God (the EKPE) will further facilitate the cleansing of mind, body and soul of the initiates, people and the environment, and bring home to many the import in EKPE that had been hidden from the people for generations past. The EKPE Temple, if properly organised, is where God may be experienced by those who are Christ-centred but not necessarily church-goers. EKPE Temple is where the many of the emotional (religious) group and the few of the mental group sacrifice sense enjoyment so that Christ at the centre of being is revealed.

There are those who routinely object to changes. They take pride in saying they are traditionalists. Many are pushed by fear of the unknown to object. Others object for selfish motives. The truth is that such people are afraid of losing their exalted positions to others during the process of adjustment to new ideas and practices. Not too long ago many worshippers at the so called orthodox churches were shocked to their bones when clapping of hands was allowed. Greater revulsion was experienced when

music of the land and the attendant dance forms gained admission. It will be hypocritical to deny that the new musical entrants have had no profound influence on worship and worshippers. Yet the things that now bring joy were dismissed in years past as evil. This wind of change has continued to blow with increased strength such that temple music of individual EKPE Houses are gaining acceptability in some churches. The changes will continue to occur until people come to the knowledge that what matters is the quality of love radiating from the heart and the status of the mind-stuff. For the same reason, EKPE zealots will raise a lot of dust against the introduction of 'strange' living, and musical instruments into EKPE. They will rise in ignorant defence of what they wrongly conceive as the tradition of the forebears.

Many will find it difficult to accept that the MBOKO roar may be valuable. It has for generations been the tool for intimidation, oppression and other ignoble acts. When toned, the sound is difficult to ignore. It may build or destroy. When properly toned the dormant fire in man is brought to life by it. As the communicator issues out the call signal, he is at the same time bringing his personality and individuality, and that of the group into focus. It is all a matter of thought, spiritual aspiration, association, vibration and colour. The MBOKO vehicle will transmit and amplify what it is given by the communicator. The vehicle is simply an instrument for transferring or projecting thought and aspirations. If the thoughts are good and well stationed or attended by pointed concentration on the object and subject for goodness sake, every unit of life in macrocosm and microcosm will be awakened by the call and the wish will prevail. This wish is prayer.

Mithraism, Ekpe and Christianity

Mithraic Religion was a mystery religion of Vedic India named after Mithra, an ancient mythical God of the Aryans. It was introduced to India when the Aryans invaded the Upper Indus Basin around 1500 B.C., and by about 68 B.C. it went West into the Roman Empire where it found favour with the military and those involved in business. During the monotheistic reforms of Zoroaster it shredded its polytheistic structure for non-strict monotheism. It was made subordinate only to the Supreme god Ormizd, but was subsequently accepted as the god of heav-

enly light, all seeing; protector of the righteous in this world and the next. He was the archenemy of the powers of evil and darkness. As the creator and mediator between man and the higher gods, it was the chief god of the cult whose practice was taken to be not strictly monotheistic. It will not be surprising if the true position of the practice was wrongly assessed by those who were not members of the cult and therefore not well informed. It was a mystery religion because it heavily depended on rituals, rites, symbolism and the Zodiac. Killing of a bull was probably an indication that the practice came to be when the sun was in the zodiacal sign of Taurus. The sacrifice constituted a solemn rite in worship of the god, and the other rites included a sacramental meal which some Christian writers likened to the Eucharist and a sort of Baptism. Seven degrees of initiation were available to a Mithraic adept compared to a minimum of nine or ten in EKPE Efik; and these were;

> Corax, Raven; Nymph (i) us, Bridegroom; Miles, Soldier; Leo, Lion; Perses, Persian; Heliodrom, Courier of the Sun; Pater, Father.

If the three grades of EKPE that reside in the region of unmanifested cosmos of pure divine spirits, that is EYAMBA, NKANDA and EBONKO, are brought into contention when the grades of EKPE and Mithraism are compared, the Father position is probably NKANDA EKPE. This may lead to the conclusion that NKANDA is perhaps equivalent to Pater in Mithraism. When the intention is soldiering NYAMKPE is perhaps akin to Miles of Mithraism. Considering that MBOKO is the roar, seat and heart centre of EKPE, it is probably equivalent to Leo of Mithraism.

In Mithraism initiation was open to all irrespective of social status but women were barred, whereas Christianity admits all. In contrast, EKPE holds that creed, social status and womanhood constitute legitimate barriers to admission and initiation. Christianity does not subscribe to initiation. Baptism is important in Mithraism, EKPE and Christianity where it is held as an important pre-requisite for spiritual growth. Limited body branding or marking was used in Mithraism. For the Miles grade, a mark on the forehead was proof that the neophyte had been recruited into the army of Mithra and sworn to combat evil. The head of a chapter of Mithraism was commonly referred to as either a Pater or

Priest, but called a Bishop when the chapter was large. In EKPE a mark on the forehead of a male initiate signifies admission into the NKANDA grade. A woman receives a cosmetic initiation when a peacock feather is planted on her or held in position with a ribbon. The EYAMBA EKPE may be referred to as the Bishop. He is the chief initiator.

Mithraic Religion was a cult, a private association supported by private contributions administered by non-clerical officials. Christianity is supported by private donations and contributions administered by approved persons. EKPE depends largely on what it can wrest from the people in terms of initiation fees, fines and, to a limited extent, donations. The simplicity of the Mithraic sanctuaries attest the fervid piety of the worshippers. One will be hard put to claim such a high level of piety for EKPE initiates at this time. Ignoring the artifacts, the EKPE Temple may be described as simple. Despite the presence of artifacts that many may find disturbing, the things that matter in EKPE Temple are: (1) the initiates; (2) the MBOKO vehicle; (3) the musical instruments; and (4) songs. Like Christianity, Mithraism and EKPE profess to explain the origin of the universe and also to predict its end. Mithraism and EKPE offered teachings about ancient wisdom.

Mithraism owed its diffusion in the West to the military but it was brought to an abrupt end in 394 A.D. by Theodosius who outlawed it when it appeared as it was emerging to be a chief rival and opponent of Christianity. According to Encyclopaedia Britannica (1968), Mithraism and Christianity had much in common and this led some to conclude that if Christianity had been stopped early in its history, the world would have been Mithraic. To some extent, EKPE and Mithraism may be said to have areas of similarity, but major differences may have existed between them as was the case between Mithraism and Christianity.

Some of the similarities between Mithraism, EKPE and Christianity are:

i) A divine Lord by whose deeds, performed once (unlike the annual passions of an Osiris), man was assured of salvation;

ii) A sacramental meal;

iii) A ritual of baptism;

iv) A concept of religion that could liken the religious life to enlistment and service under a divine commander;

v) Not dissimilar ideas of heaven and judgement;

vi) Mithraism and Christianity did not subscribe to social prejudices;

vii) A moral code considerably higher and more rigid than that found in contemporary society of the time;

viii) Mithraism and EKPE believed that spiritual attainment comes through initiation on the physical realm.

Noticeable differences existed between the three religions, namely:

a) Mithraism was not strictly monotheistic even in its hey days whereas Christianity remains strictly monotheistic. EKPE was originally monotheistic.

b) The redeemer in Mithraism and EKPE were mythical figures as compared with the Christian Jesus who lived on earth as God incarnate.

c) Mithraism and EKPE discriminate against women whereas in Christianity the role of women has remained a subject of intense discussion and argument.

d) EKPE alone encourages creed and social prejudices.

e) The family is a source of strength of Christianity and the guarantor of its growth. Even though the family was a source of strength of EKPE, the abuse to which it had been put has now made it the source of its weakness. Mithraism depended on the military and the business people. As soon as the power base was removed, it collapsed.

f) Sacrifice of bull was common in Mithraism and EKPE whereas Christians believe in the sacrifice offered once at Golgotha for propitiation of sins.

A major similarity between Mithraism and EKPE is their claimed birth from a rock. In EKPE the rock birth is the exoteric teaching released to the masses. It implies that difficulties await those who wish to discover the origin of EKPE (God).

Figure 23 Propitiation of Community Sins by the EYAMBA

One of the major differences between EKPE and Christianity is mem-
bers' attitude towards the devil. To the average Christian, the devil is
responsible for the wrong living that brings in the many and varied prob-

lems of life. The man is seldom held responsible for his actions. It is the devil that is made the scapegoat. For this reason, prayers of the faithful frequently incorporates rebukes directed at the devil. EKPE's attitude is different. The devil is conceived as an agent of God charged with responsibility for keeping man in check. The man is encouraged to hold himself responsible for the problems he encounters. He cannot rightly blame them on others. Rather than being conceived as working against man and God, the devil is looked upon in EKPE as an important worker in the vineyard of God charged with responsibility for testing man's resolve to continue investing in soul-rewarding enterprises, and for making sure the man pays for his transgressions. The Bible is supportive in the following words.

> *Simon! Simon! Listen! Satan has received permission to test all of you to separate the good from the bad, as a farmer separates the wheat from the chaff.*[24]

The saying "For everything give thanks" is an important teaching in both EKPE and Christianity, but the approach by each organisation is different. EKPE tends to be more demonstrative. Mere words are offensive. To have any meaning word must be attended by actions symbolised by material presentations to the EFE (the lodge). Action involves gratitude, repentance, and sacrifice as may be appropriate. This, a man does whether he is happy or sad. Whatever the situation he must remain ever grateful to EKPE (God). In Christianity, words are acceptable. Appreciation may be unvoiced, an expression of the mind.

Similarities between EKPE and Christianity provide the reason for the use of Biblical references in this publication. It may also be responsible for the relative ease with which Christianity continues to permeate the societal fabric of EKPE zones of Africa as compared with the other world religions. In these areas, EKPE and Christianity contest for the hearts of the people. Sign abound as proofs that Christianity is winning the battle against EKPE as it did against Mithraism of the Roman Empire. Unless EKPE succeeds in eliminating its dehumanising and discriminatory practices, and be cultured in charity, it will die as others before it.

Evolving civilisation must bring its changes whether man likes it or not. This is because culture, even though a child of God, is really not a static phenomenon. Its field of play is the plane of manifestation, the

Table No. 2 Comparison of Gods, Powers and Intelligence of Various Religious System

No.	Sephirah	Planet	god (Egyptian)	Ekpe	ArchAngel	Choir of Angels	Intelligence of Planet	Spirit of Planet
1.	Keser		Ptah, Amoun	Eyamba	Metraton	Chaos HaQuadosh		
2.	Choknah			Nkanda	Ratziel	Ophanim		
3.	Binah	Saturn	Isis	Ebonko	Tsafkiel	Arilim	Agiel	Zaziel
4.	Chesed	Jupiter	Maat	Okpoho	Tsadkiel	Chas-Malim	Isophiel	Hasmiel
5.	Gevurah	Mars	Horus	Oku-Akama	Kamael	Seraphim	Graphiel	Bartzbael
6.	Tipharas orTipharet	Sol	Ra, Osiris	Mboko	Raphiel	Malachim	Nachiel	Soras
7.	Netsach	Venus	Hathor	Nyamkpe	Haniel	Elohim	Hagiel	Kadmiel
8.	Hod	Mercury	Anubis	Mbakara	Michael	Beni-Elohim	Tiriel	Taphtar-tharath
9.	Yesod	Luna	Shu, pasht	Mboko- Mboko	Gabriel	Cherubim	Tarshish-im	Hamodai
10.	Malkus		Seb	Mkpe	Zaziel	Ishim	Ad Ruach AxhwxhLIM	

physical earth. Consequently, it is time and age-related. Every age is attended by a period of recapitulation of ideas and actions; of giving up or gaining of spirituality; and a transition that fits the purpose and plan of the incoming age; yet there is continuity. These activities have to be adequately cultured in and within the discriminating power of God for the results to be relevant and adequate. In the dynamic sense, culture is essentially an expression of the state of consciousness of the mentally polarised people of the race, of the intelligentsia or those who constitute the link between the inner world of soul life (those whom Christ has formed in them) and the outer world of tangible phenomena (materialists). The intelligentsia are positive and their positive mental orientation give birth to the culture of their time, or race or community. Civilisation is an expression of mass consciousness at the physical plane level, that is on our earth, and involves adjustments in relationship, method of living and awareness. The masses are negative and responsive to desire. It is through the interplay of these opposite poles that progress and development is generated and carried forward.[25]

Efik and Christian Faith

The primary subjects of religion are pious activities, economic development, sense enjoyment and liberation from material bondage. Eating, sleeping, drinking, fearing and mating are the principles of animal life and these are present also in man. But religion is reserved for man. Without it, man is no better than is an animal. It is for this reason that man possesses a built-in appetite for religion in one form or the other. For those in the lower stages of civilisation, the main pastime is competition to conquer material nature and satisfy the senses. Many are attracted by the illusion of quick returns to invest in alternatives to true religion and worship of the LONE GOD. This proves that religion is performed by most for economic gains needed for sense enjoyment. It is to this level that EKPE has sunk.

God was not unknown to Efik. He was seen as the creator of all things. Alexander Gammie remarked that "the people of Calabar acknowledged a creator and a supreme governor of all things."[26] King Eyo II made a similar remark to Rev. Hope Waddell when he said that "every man knows that God lives and that he made all things."[27] While it is true that some

Efik, finding it difficult to worship in abstract terms, have had to rely on representative forms to concretize their belief, the spiritually enlightened few, the initiates of EKPE fraternity, did not have to perceive to worship. This is because spirit is very much part of their workings. Such a dichotomy in beliefs and worship was not uncommon. It existed in ancient Egypt, Babylonia, Greece and India, to name but a few.[28] The masses were led into common beliefs while teachings of substance different from those dished to the masses were imparted in the sanctuaries. Amongst Efik such teachings were imparted in accommodation recognised, acknowledged and revered by the people. Because Efik had known about God they were not initially enthusiastic about what the Christian Missionaries brought. They recognised nothing new in it. To them the Christian religion was full of mysteries which were not different from what they already knew about religion. This is important. It is proof that God had revealed Himself not only to the Israelites and that EKPE is a religion. Those who saw it that way were not the masses, but the ones at the helm of affairs; the EKPE initiates and adepts. Any one who has gained entry into an active EKPE Temple meeting in conclave will appreciate what John Leighton Wilson had in mind when he said:

> *Whenever you enter the precincts of the unknown and the mysterious, the realm where the imagination alone can travel, there is no other area where the African feels more at home and would even demonstrate that he has no rival.*[29]

Contrary to popular belief, the main barrier against Efik meaningful involvement in the teaching of Christ is not EKPE but NDEM. Many more Efik are involved in NDEM for the simple reason that it is available to male and female, young and old. The majority of Efik see nothing wrong in the worship of NDEM.

Ekpe and the Initiations of Jesus

The occultist has been a declared enemy of the Christian Church for centuries for reasons that will not be treated in this book. It is enough to state that at times the Church had over-reacted and caused many to lose their lives. Present day Christians, though not involved in any shedding of blood, nevertheless, kill with tongues, often in ignorance, those they

call occultists and magicians. For the avoidance of doubt, it may be ben-eficial to briefly describe an occultist. He is one who studies the secrets of the Kabala, astrology, alchemy, and all arcane sciences including psycho-logical, physiological, cosmical, physical and spiritual phenomena.

It is unthinkable to attempt to discuss initiation during this age with-out reference to Jesus Christ. Doctrinal arguments exist between the popular Christian faiths on the one hand, and other faiths and fraterni-ties of Truth on the other due primarily to the early attitudes of the Christian Church. Initiation is not as bad as some would wish others to believe. One may be initiated into a good or bad order. For this reason, general condemnation of the practice may not be encouraged. It may not be appreciated that rites and ceremonies that precede admission into the various hierarchical priestly orders of the Christian Church commonly referred to as ordination are acts of initiation when attended by spiritual affirmations during full waking consciousness. The affirmation may take different forms that should be witnessed by the conscious few. The in-formed accepts the important and unassailable status and role of Jesus vis-a-vis humanity. His life and mission as expounded in the Gospels reveal five sequential stations of truth unfoldment which all men must visit sequentially to receive the blessings of each of these stations as it was with Jesus the Christ. There is a portal of initiation through which one must pass to become an initiate of that station. It needs not be a physical station. The confusion in the minds of men is caused by the song about Jesus being the only Son of God and which completely over-whelms his humanity meant to bring into the open what is expected to be the start-ing point of experience in Truth. Not that the song is bad *per se*, not that Jesus' life that revealed the love aspect of God could be equalled, but the over-indulgence in it has caused many to say – 'I am different. He is God. I cannot be expected to be like Him." As a result of this, many have elected to deny his humanity and in effect refuse to be disciples and initiates. St. Paul confirmed the importance of Jesus' humanity in the words – *"For the full content of divine nature lives in Christ, in his human-ity and you have been given full life in union with him."*[30] The people who deny his humanity may be grouped with those St. Peter described as not having the spirit from God.[31] Be it as it may, his life reveals to humanity five sequential stations of truth which esoterists and EKPE fraternity rec-

ognise as stations for initiation, namely:

i) Birth at Bethlehem

ii) Baptism at Jordan

iii) Transfiguration on Mount Carmel

iv) Crucifixion on Mount Golgotha

v) Resurrection and Ascension.[32]

God has always revealed the secrets to life as he thought necessary to those who are worthy, and there is continuity in revelation. To them he had revealed the pre-eminent status of Christ spirit before Christ became manifest as Jesus. It is not unusual. It is the way the advent of Christ on earth was revealed to the Prophets.[33] Jesus' sojourn on earth opened the door to truth for those willing to go through. It brought into the open some of the basic teachings reserved before then for the privileged. Hitherto, complicated teachings on initiation meant to serve as short cuts to soul freedom were confined to the temples. Very few benefited even though many had received the temple teachings. Those who were not cut out for it made no progress and they were many. Christ presence on earth unveiled a new surer and easier way for the many. He proved that there is no need consuming volumes of written material, no need putting oneself through ascetic discipline and investing in body symbols, but that spiritual upliftment is possible for many including the uneducated during the normal march of events. As man proceeds to play his role in life honestly and properly, then will the spiritual teacher appear to lead him aright and reveal to him the beautiful things of this life, things he never knew existed. The initiations must take place during full waking consciousness as it was with Christ. It is remarkable that it is in EKPE that there seem to be the marrying of aspects of the old teaching with the new that Jesus brought. These may be summarised under two headings:

i) The way to contact God is by regular trumpeting of the MBOKO vehicle which in modern parlance means coveting the Christ spirit through well-purposed prayer, and

ii) The old procedure of initiation veiled Jesus' programmed experience of spiritually arranged visits to the portals of initiation at the five sequential stations of truth. Although Jesus

was not yet on earth, revelation had established the pro-
grammed initiations in the minds of those worthy.

Continuity of Inspired Religions

Many hold the view that new ways and beliefs must totally eclipse the
old, and that a total break is mandatory as humanity moves from one age
to the other. In Bailey's view:

> *The old order changeth, but primarily it is a change of dimen-
> sion and of aspect, and not of material or foundation. The
> fundamentals have always been true. To each generation is given
> the part of conserving the essential features of the old and be-
> loved form, but also of wisely expanding and enriching it. Each
> cycle must add the gain of further research and scientific en-
> deavour, and subtract that which is worn out and of no value.
> Each age must build in the product and triumphs of its period,
> and abstract the accretions of the past that would dim and blur
> the outline. Above all to each generation is given the joy of dem-
> onstrating the strength of the old foundations, and the opportunity
> to build upon these foundations of structure that will meet the
> needs of the inner evolving life.*[34]

God is never known to be in error, hence his teachings and revelations
show continuity as one moves from an inspired religion of one age to
another in a long line of succeeding religions that establish the fact of
God amongst chosen group of people or nation(s). Experience down the
ages has it that God-sponsored religion of a preceding age invariable in-
corporates within it a veiled reference to intrinsic teachings of the
succeeding religion. In this way the religion of the Jewish Revelation
brought into the open the hitherto veiled teachings on Christ and sacri-
fice from the Mithraic Religion which EKPE probably relates, and which
preceded the Jewish Revelation. Also the refinement and subsequent clari-
fication of the teachings by Christianity were developed from Judaism.
Thus the fact of Christ is now well established in the consciousness of
men. There could not be any discontinuity in the teachings and proph-
esies if God is not to be a God of confusion. Christ acknowledged the
principle when he said:

Do not think I have come to do away with the law of Moses and the teachings of the prophets. I have not come to do away with them, but to make their teachings come true.[35]

Continuity implies succession if conflict is to be limited and subsequently eliminated. Success carries progress in its wake. Progression is not necessarily born because an earlier religion had anything sinister in it. As the age and time unfold their blessing on humanity, life and quality are adjusted by the ruling and the unfolding religions. Usually, there is a period of withdrawal for the old to bow out. It may take several centuries for the old to retire completely, and until then it will continue to have adherents. As the old wanes, the new waxes strong, but there comes a time when the old will unsuccessfully attempt to hold its own against the new. It was in this way that Mithraic Religion which is believed to be akin to EKPE spread from Persia to the Roman Empire in 68 B.C.[36]

EKPE correspondences of the initiations of Jesus are as given in Table 3.

Table No. 3 EKPE correspondences of the initiations of Jesus

Initiations of Jesus	EKPE Equivalent
New Birth or First Initiation	Neophytes adopt ascetic type discipline to turn over a new leaf and become worthy of the secrets of the Kingdom through initiation. This is the first initiation.
Water and Fire Baptism or Second Initiation	The painting of white on designated spots of the body of the neophyte up to the EBONKO and NKANDA grades connote water and fire purification of the neophyte. The second EKPE Initiation is effected after the initiate has received an EKPE bath in water. This is not commonly available to all.
Transfiguration or Third Initiation	Initiation as OBONG EPKE is the third initiation in EKPE during which the candidate responds to the call of MBOKO and is ritually married to the new way.
Crucifixion or Renunciation or Fourth Initiation	The red colour used in EKPE initiation connotes sacrifice. The colour is used over and over again to firmly plant the importance of renunciation on the psyche of the neophyte. The actual time of the renunciation initiation is unknown but dramatic plays are available as lessons. Most probably humanity is far removed from this initiation.
Resurrection and Ascension or Fifth Initiation	EKPE equivalent not known. Most probably humanity is far removed from this initiation, but dramatic plays are available as lessons on the subjects.

Chapter Nine

Discomforting EKPE Practices

The weight of evidence against EKPE is frightening. To many it is not just a matter of non acceptance, but that of total rejection. Some of these objections are well founded, but many more rise from lack of knowledge, misconceptions and, perhaps, fear of the unknown. These will now be discussed under selected headings that may not be all inclusive.

Classification as a Secret Society

EKPE is a secret society. The MBONG EKPE and initiates openly admit it. Throughout history secret societies had existed in almost every land. People have always looked on the members with suspicion and had ignorantly assigned to them powers they often did not possess, but which they promptly accepted. It was good for their image. The Freemasons were perhaps one of such groups which enjoyed the image painted of them by the public. The fact that they wear black, meet more often at night in a temple that may be located in the neighborhood of a cemetery, enhanced their image, and these attracted candidates most of whom could not go through the ballot. From the ordinary man's point of view the members were in easy communication with spirits and no power could affect them.

All societies could not rise from the platform of evil nor possess the inner desire to be in rebellion to God. The Nazarene was a recognised

secret holy group that existed before the days of Jesus. Not many could become members because the code of conduct was demanding. Jesus himself had this to say:

> *To you has been given the secret of the kingdom of God, but for those outside everything is in parables.*[1]

Where are secrets to be imparted if not in secret to those who meet in secret and are worthy? Being worthy may mean those who are able to understand and keep secrets. Jesus confirmed that in the statement:

> *So that they may indeed see but not perceive, and may indeed hear but not understand; lest they should turn again, and be forgiven.*[2]

He went further to warn:

> *Do not give dogs what is holy, and do not throw pearls before the swine, lest they trample them underfoot and turn to attack you.*[3]

It is also on record that after the fall of man, God:

> *Drove out the man; and at the east of the garden of Eden he placed the Cherubim and a flaming sword which turned every way, to guard the way to the tree of life.*[4]

to prevent man from obtaining the secrets prematurely. The practice of having secret groups is not new to the Christian Church where conclaves are held regularly to which no laity is allowed entry. There is nothing sinistral at such meetings. The culture of operating in secret could not on its own be a pointer to unwholesome, irregular and unholy practices. Christ had approved of it. Man is invariably suspicious of the goings-on at meetings he is not part of. This arises from lack of trust and a feeling of insecurity and to some extent, inferiority. It may even be a complex problem. In reality, the existence of secret groups is a human problem. It is a manifestation of lack of awareness, a measure of the gap between humanity and the Christ. To them whose soul sense are full grown there are no more secrets. They are led into the heart of things when necessary.

Administration of Oath

The oath issue is another sour point. The practice is an old one indeed. It was common practice amongst the ancients of many lands. Some

of these oaths were meant to prevent disclosure of the so called secrets to unauthorised persons and the cheapening of the fraternity. They were designed and administered in a way to create maximum fear in the man taking it. The Church could not be absolved of blame over this matter, but could anyone justly blame it? How could anyone prevent another from divulging the so called secrets, particularly when honourable people are hard to come by, and much less centuries ago when the mind was not much developed. It is not uncommon for oaths to be administered as cover for non-existent secrets. Many are lured by it to believe that the organisation into which they are seeking admission is worth the candle. The ignorant must pay some price for being ignorant, and EKPE is not ashamed of it. The action encourages one to learn to avoid the pitfalls of ignorance. Some of these oaths mean nothing, have no power and can harm no one. According to Blavatsky:

> Oaths will never be binding till each man wilfully understands that humanity is the highest manifestation on earth of the unseen supreme Deity, and each man an incarnation of his God; and when the sense of personal responsibility will be so developed in him that he will consider foreswearing the greatest possible insult to himself, as well as to humanity. No oath is now binding; unless taken by one, without any oath at all, would solemnly keep his simple promise of honour.[5]

On many occasions Christ did require those healed by him not to inform anyone. On such occasions, the one cured was required to keep the event secret. Although no oaths were administered, the person was expected to abide by the instruction on his honour. As Blavatsky has pointed out, the taking of oath is an indication of the failings of the man who is not a man of honour. In EKPE oaths of secrecy are prerequisites of initiation, but the practice is no longer rampant in Efik land. This proves it is not a matter of life and death for a fraternity of honourable initiates.

Connection with Ancient Powers

Over the centuries EKPE fraternity had moved away from the purpose that brought it to life, which, simply put was to bring man into

conscious alignment with the higher divine spirits and God. Instead, it allowed evil desire to overwhelm it and lead it into sin and greater sin. EKPE went from abuse of human rights to black magic and sorcery. The unbecoming activities and thoughts attracted powers of similar constitution to take over the temple and all in it. Having been in occupation for a long time, the adoption of the old procedure that some may claim to be time-tested do excite ancient powers in residence and attract still greater power of darkness and those in rebellion to God. That is a problem that could not be ignored. As if these were not bad enough, the situation is complicated by:

a) The MBOKO trumpeters who are not experienced and possess thoughts that are soiled, consequently, mostly unwanted spirits may be attracted.

b) The MBOKO vehicle that is deficient in sound quality.

c) The heavy sound of tom-tom. Such sounds attract earth bound spirits. Introduction of strings, trumpets and other light instruments should improve the sound quality.

d) Lyrics of temple songs that lack spiritual value.

Sacrificing to Ekpe

The offering of sacrifice is an act that many now find detestable. The offering of sacrifices to what man conceives as his god is not new. It is inborn and what is offered varies in accordance with the weight of sin to be expiated, the quantum of grace sought, and the supplicant's assessment of the status of the god. Sacrifices do not always involve the shedding of blood. The scape goat offering of the Israelites of old is a good example. It was believed to be instituted by God in the following words:

> ... he shall present the life goat, and Aaron shall lay both his hands upon the head of the live goat, and confess over him all the iniquities of the people of Israel and all their transgressions, all their sins; and he shall put them upon the head of the goat, and send him away into the wilderness by the hand of a man who is in readiness. The goat shall bear all their iniquities upon him to a solitary land; and he shall let the goat go in the wilderness.[6]

E.A. Adegbola agrees that what is offered differs, but the idea of offering a sacrifice is in-born and natural to man. He is of the opinion that as man progresses in his religious practices and beliefs, he develops the urge to give things of greater value to his gods.[7]

The import behind EKPE fraternity's indulgence in sacrifice are two fold. Firstly, it has to do with the offering selected food items to EKPE as a sign of adoration and worship. The second is performed as a rite of purification and involves the shedding of blood only as was the practice when Mithraic religion was in vogue. Then the type of animal offered was zodiacally determined. When the sun was in the zodiacal sign of Taurus the Bull, Bull was offered a forecast of that which Christ came later to reveal. There was a time when sacrificing of special cows were mandatory in EKPE. When the sun passed into the sign of Aries the Ram, the lamb was sacrificed and the scape goat sent into the wilderness. In EKPE, goat was used in place of ram because ram was not commonly available in the tropical forests. The practice is being maintained by those who cared even though the sun had moved into the sign of Pisces the Fishes, the Christ zodiacal sign, and is probably now in the sign of Aquarius, the Water Bearer. EKPE sacrificial practice is no longer determined by the zodiac. This may indicate that EKPE practice is now out of time and may be swallowed up sooner or later by the religion of this age.

The Israelites did at a time indulge in rather detestable sacrificial practices. Jephtah felt happy offering his daughter to the Lord God of Israel[8] and the Lord had cause to instruct the Israelites against the offering of sacrifices to goat-demons in the open and in the fields but to him only at a place appointed by him where blood should be poured out on the alter to take away the people's sins.[9] All these may look strange but it will be inconsiderate and a mistrial to condemn the ancient without examining their mental capacity and consciousness level. Even at the present level of education and concern for things spiritual, messages are often misunderstood. How much more when the mind was not as developed as it is now? Later prophets of Israel never approved sacrificial worship. Samuel denied that the Lord had any delight in burnt offerings and sacrifices.[10] Jeremiah said emphatically that the Lord never approved anything of the sort,[11] yet the high priest continued with the practice.

Before the Israelites got involved in offering sacrifices, the hierophants of ancient Egypt were involved with Blood Baptism. An hierophant was left to decide whether to offer himself or an animal for expiation for the past, present and future sins of the people.[12] In the light of all these, it is not surprising that initially humans were offered but these have been replaced by animals when sacrifices are offered to EKPE (God).

Already, some EKPE fraternities are no longer involved in any form of sacrifice. This is a signal that a shift from the past is already taking place. Where the practice is maintained, NYAMKPE and OKU AKAMA are usually in attendance.

Sacrificial worship has been with man for a long time. That was how the ancients conceived the way of coming to terms with their gods. It was an acceptable and an honourable thing to do at the time. Some went as far as to offer themselves for expiation of the sins of their community. It was the way the unfolding minds of the time interpreted the teachings on sacrifice or renunciation. Through Christ man is beginning to understand and appreciate what is meant by sacrifice. Even then it is still a far fetched concept. Man needs time to understand it and since the fraternity must learn from man, more time is needed for the change to overwhelm it. Nevertheless, there are indications that some temples in Efik land no longer indulge in sacrificing to EKPE. Doing away with animal sacrifice is therefore not a problem.

The Use of Graven Images

If some people are allowed to have their way, most works of art would be destroyed, and the world would have lost most of its valued treasures. For ease of reference, the Bible passage suspected to be at the root of the objection by Christians to the use of EKPE forms (masquerades) is given below, and it states:

> *Beware lest you act corruptly by making a graven image for yourselves, in the form of any figure, the likeness of male of female, the likeness of beast that is on earth, the likeness of any winged bird that flies in the air, the likeness of any thing that creeps on the ground, the likeness of any fish that is in the water under the earth.*[13]

A graven image is an object of worship, an idol. There is no idol in EKPE and the forms (masquerades) have no likeness to anything created by God that is found in heaven, on earth, the air and in the water. They are neither like man nor angel. None of the EKPE forms is worshipped. The Bible passage does not apply to EKPE forms, and those who raise their eyebrows against them do so from lack of knowledge. The masquerades are teaching aids. They tell stories.

The Aphorism – Abasi Ikpaha Afo Ukpaha

The terse statement–"ABASI IKPAHA AFO UKPAHA" meaning "God and you are immortal" is blasphemous when taken on its face value. It is a customary concluding response of an EKPE initiate at a Meeting Ritual performed when an EKPE masquerade meets an initiate. The "man" in the form is taken to represent a soul that had been or is in the process of regaining his freedom in accordance with the plan of God. Commonly, the African conceives masquerades to be outward forms of indwelling spirits, good or bad depending on circumstance, whereas in EKPE the indwelling spirit is the soul. The statement is an admission that the soul is indestructible by powers, and more so when transformed by the Christ spirit. The teaching is in concert with arcane wisdom teachings East and West. The Christian teaching is believed to be supportive.

Some Mandatory Rules for Idem Ekpe

1. Control of EKPE forms (IDEM)

To enhance the respectability of EKPE the ancients made sure that the IDEM was dressed in the temple and nowhere else. By so doing they guaranteed the quality of the displays and made sure that non-entitled persons had no access. It is not often for the EFE to have an initiate who is an all-round expert, consequently, choice had to be made. Permission for an IDEM to appear is always given by the EYAMBA-in-Council, but the actual release was effected through the relevant OBONG EKPE. It was a treasonable offence to organise an unauthorised release of an IDEM, even in the case of an IDEM in as low a status as IDEM IKWO (Fig. 20). Nowadays, the fraternity in Efik land are finding it more and more difficult to exercise control over IDEM IKWO and IDEM EBONKO displays.

More and more initiates and non-initiates alike have made it a habit to organise displays outside the ambit of authority of the fraternities. Strict control continues to be the rule in outlying areas where the offending persons could be seized and sanctions placed. Although execution is no longer the penalty, the offending persons will receive severe lashing with "IDEK EDEM," the secret whip, and pay heavy fines to serve as deterrent to others from indulging in such acts of indiscretion.

2. Visiting EKPE Form

Should an IDEM move into an area of jurisdiction of another fraternity, it is mandatory for him to head straight to the ruling temple to report his arrival, explain his mission, prove himself and request permission to move within the area according to the rules of that fraternity. Usually test are conducted to determine the capabilities of the form. If found wanting, the IDEM is defrocked and the paraphernalia including the drum(s) detained until such a time that the matter is cleared up. This will necessitate the fraternity sponsoring the offending IDEM to have the matter resolved according to EKPE tenets. Sanctions for wrong-doings are usually heavy. That is why it is in the interest of the IDEM to have prior approval of his fraternity before venturing out.

3. Recognition of Deceased MBONG EKPE

EKPE may forgive but never forgets. It does not forget the past masters. They are revered but not worshipped. They are respected the way serious groups take their patriarchs. It is a serious offence for an IDEM to pass by the residence of a deceased OBONG and not show respect. Respect takes the form of a minor ritual involving the use of the bell and leaves or a plume at the entrance to the residence of the deceased OBONG. The IDEM is precluded from entering the premises unless he is certain that an acknowledged initiate of standing is in residence. Should the IDEM be attended by a full compliment of drummers and singers, a major ritual is performed. This involves the minor ritual and evocation of the divinities in a prescribed manner. An IDEM is bared from calling on women and acknowledging them as initiates. Major rituals are also performed at the entrance to an EKPE Temple.

4. Cross Road Ritual

More often than not man finds himself at cross roads. Experience shows that at such times reliance on human powers may prove to be unbeneficial. There are the deceiving spirits and their human agents whose stock-in-trade as their name signifies, is to misdirect and be mischievous. There are also those who not knowing they do not know offer advice that compound issues when applied. Put your trust not on men but on God is a well known advice. EKPE in subscribing to that rule requires the IDEM to perform a major or minor ritual at cross roads depending on whether the IDEM is attended by a full compliment of drummers and singers or not. A major ritual involves the evocation of the divinities. The ritual is a call on God who is the only reliable guide, to direct and guide the IDEM and initiates aright, and protect them from the forces of error that abound at cross roads. These rituals are fast dying out. Initiates are no longer obliged to honour the rules. Some of the rules rose from superstitious beliefs that have long been abandoned.

Chapter Ten

Personal Encounters With EKPE

Inner Realm Trumpeting

Until recently, tradition required a father to initiate his loved ones into EKPE, and this irrespective of sex, provided the conditionalities of the fraternity could be met. Women were flattered with cosmetic initiation. Parents seldom stop to think about the effect of initiation. For them they were taking a sort of social insurance policy for the loved ones. The writer's father did his best to fulfil what was expected of him, but the son would have nothing of it. He was shy and skinny and could not bear to show his bones in public. It was mandatory in those days to move bare-bodied in town after initiation for people to know about the new status earned. For this reason, the proposed initiation of the writer had to wait until he could earn some flesh. The writer was initiated as an adult and introduced to the MBOKO by two of the then most renowned EKPE adepts of Efik land, one of whom was the EYAMBA. He was subsequently put through a more thorough initiation rites in accordance with original Efut custom and later took EKPE titles as OBONG EKPE. He enjoyed these position but had realised right from the time of his initial meeting with MBOKO that EKPE was no ordinary affair. Like every thing that has to do with sense enjoyment, the pleasure from EKPE wore off fast. It is impossible to recall fully and benefit. Looking back the conclusion is that precious time and resources were wasted. While the orgies lasted the writer enjoyed it but also invested in searching for what

he thought was hidden in EKPE. As it turned out most of those he accepted as teachers and who claimed to be the custodians of the secret teachings turned out to be at best poor copies of adepts. What was gathered were fragments of what was left of NSIBIDI, the sign language that does not seem to matter much these days in Efik land. The lesson came clearly to the writer – blame no one but yourself for being ignorant. This is one of the early lessons in EKPE, and it also serves to spur one to go on seeking after the truth, should he so desire.

Not very long after taking initiation as OBONG EKPE, a relation opted to become a candidate for an OBONG EKPE position and it became the writer's responsibility to lead him on ritual visits to the EKPE Temples of the land. On the appointed day and with him fully dressed in accordance with EKPE custom, the procession which included drummers and singers went from temple to temple presenting the candidate and pouring libation. At the end of the ritual performed at the last port of call, it drizzled. Suddenly the MBOKO became active and the trumpet came on. Even though the train was startled, it had to maintain its pace in accordance with custom and by the time it arrived at the temple of origin from where the train had moved out, some of the initiates were already on their way to fetch the custodian of the MBOKO House who had locked up the place and gone to church with the key. The trumpeting continued until the room was unlocked and an appropriate ritual performed to silence it. The spiritual activation of the MBOKO proved that there is much in EKPE.

Ekpe Objection to Disunity

Within a couple of weeks of the writer's previous experience he was again to be involved with the spiritual realm activity of EKPE. A family dispute developed and all effort invested to resolve the misunderstanding failed and this included the taking of EKPE oath administered by a renowned EKPE fraternity in Calabar. After Party A to the dispute had hosted a celebration dinner signalling that the matter could thereafter be left with those in the spiritual realm to conclude, he turned round barely four hours after the dinner to repudiate the understanding. The writer was summoned by Party A and invited to join his group. The offer was rejected on principle, but having failed to convince Party A to allow time

to play on the matter in accordance with custom, he had no alternative but to tackle the matter from the platform of EKPE on the side of Party B. He hoped that the misunderstanding could subsequently be resolved to allow the family to move forward together. Unfolding events proved that the writer did not fully take human nature into contention when making his projections.

Be it as it may, Temple B was the first to be consecrated for worship, and the spirit activation of the MBOKO convinced the writer that he had acted properly. Having had that experience, he was emboldened to inform a candidate for adept position at Temple A that they were about to experience something unusual when their temple is opened for consecration. Initially, it was a bluff but evolving awareness grew as the appointed day for Temple A consecration approached. To the surprise of the initiates, both visiting and local, who had gathered at Temple A, the rituals could not progress satisfactorily because all attempts to get the MBOKO to trumpet failed. In EKPE terms, it was a catastrophe, a major embarrassment and a great EKPE teaching. This was another proof of EKPE power.

The Fruit of Desire

The unusual happening succeeded in sharpening the interest of the writer, but without knowing he was being sucked deep into EKPE. After a period of resumed sense enjoyment he had another strange experience that contributed to a change in his orientation. The writer's father had a residence harbouring a rather large table with side chairs and other items of furniture in the living room that was located between two bedrooms. One of the rooms was used by the writer whose modern bungalow had replaced his father's. The writer had been in the new building for over eight years without anything unusual occurring. Then, one day, without warning, he suddenly discovered that his vision became blurred, but when cleared he found himself to be a youth in the father's old house. Soon he heard NYMAKPE music and as he looked out of the window, he discovered his father leading IDEM NYAMKPE (NYAMKPE Masquerade) and a full compliment of initiates into the premises. The writer rushed to lock them out, but before he could get to the door, they were already in and his father already seated at the table. The IDEM NYAMKPE took a

standing position at the other end of the table. The writer went into the room to fetch a fresh bottle of gin for libation following the usual practice. As he came out of the room, the man in IDEM (masquerade) having defrocked and taken the size of a child of about two or three years of age, ran under a settee which was a prominent feature of the old house and when the writer looked under to find out what was happening, the child ran out of the house. Suddenly, the scene changed, the new house was brought back and the writer was also back to his size and age. While pondering what the whole thing was about, he discovered that he had acquired higher sense of perception of EKPE affairs. As time went, he became clairaudient and clairvoyant, and regularly had flights of consciousness which brought him into contact with EKPE of the inner realm. He was a regular spectator at their ceremonies. These things occurred during full waking consciousness always at his residence. Following upon this uncommon development, the urge to visit his ancestral home in the coastal region of Bakassi grew to the point he sent emissaries to USAK EDET. After all had been arranged, he thought it wise to state clearly his intentions namely; (a) to pay a day's visit to know the village and (b) the visit will in no way involve EKPE. The events were rolling on fast and the writer became apprehensive. The response was terse—

> *It has to do with EKPE and it will last seven days. Do not come if you have no time to spare.*

The writer was taken aback by the response and concluded it was time to have a rethinking about involvement in EKPE.

The decision to have time for reflection of the experience was not well received by local EKPE initiates even though it was a personal and private decision taken without consultation. The writer was at times openly insulted. The reasons for these attacks were never disclosed. No one could claim to have invested on the writer to the point of conjecturing a loss of his investment if he were to give up EKPE. These reactions were nothing compared to what the underworld unleashed. For seven days the writer was whipped twice a day with IDEK EDEM, the EKPE special whip. Except for the whip marks that were clearly evident, no other person except the writer visualized those creating the havoc. The writer refused to submit to their wish and after seven days the ordeal suddenly stopped the way it started, and the beauty that is God commenced his unfolding grace.

Chapter Eleven

Conclusion:
A Future Defined by Compromise

The originator of lasting culture is God. It came into being at the time the spoken word had not yet developed to guide man along the path of goodness so that he may be in conscious rapport with God. Forms, sign, symbols, drama, dance and sound were the teaching aids available and these were employed. The practice is akin to the preachings that go on in modern times. Even though signs and symbols may be universally similar (God is not parochial), environment does influence form, dram, dance and sound. This had to be so if the teachings were to have meaning. Knowledge is power and selfish motives soon introduced dichotomy into the teachings, and the true way to God was often denied the masses until the physical appearance of Jesus the Christ.

Man not wishing to be outdone also created culture for material benefits. These have not been time-tested but as experience has shown, may not last. God-sponsored culture last even though it may be veiled by centuries of impure motives shoved upon it by man. Some of these cultures are all embracing in that they are embodied within the intrinsic teachings about life, creation, the path to spiritual growth, and the consequences of wrong living. Thus a drop in spirituality is shown to be attended by a rise in physical constitution of man in a cyclic order with God graciously providing a way of return to spirituality for those who may so wish. A culture that embodies universally accepted and time-

tested teachings of life and the related organisations of the old way and the new path played out by Jesus the Christ for the spiritual growth of man is termed a christed culture. A christed culture comprises other sub-cultures that are themselves christed. It will be beneficial putting all cultures to test for the purpose of sorting out the bones from the meat. EKPE is believed to be christed culture and the tests are, hopefully, available within this publication.

EKPE is a pseudonym of God and his creations. It is also a course of study or teachings that are similar to the ancient Egyptian temple teachings, the Kabala, the Eastern Gupta – Vidya teachings and, in some respect, to the teachings of Jesus. It is a monotheistic religion, the concept of non-self existing divinities that others call gods, notwithstanding. The origin of EKPE wisdom is not known despite the claims that because NSIBIDI resembles Ancient Egyptian hieroglyphs and lion, the EKPE totem, is an animal of the savannah. EKPE has its root in Ancient Egypt.[1] This opinion is opposed by those who say that the characters of NSIBIDI are different from the hieroglyphs of Ancient Egypt, and that there is no proof of existence of EKPE form (masquerades) in Ancient Egyptian Theosophy. Considering the contacts that had existed between Egypt and Africa, some have come to believe that Negro culture diffused into ancient Egypt through mercenaries, magicians and others. Studying the zodiac led to the conclusion that EKPE is probably akin to the Mithraic Mystery Religion which was popular amongst merchants and the military in Persia and the Roman Empire before 4th century A.D.

EKPE wisdom has its roots in the seven divinities of the Septenary cosmos and the three within the higher planes of pure divine spirits that are gods in some systems. The relevant MBONG EKPE serve as their earthly human correspondents charged with the responsibility for assisting man to activate the latent divinity related powers in man. Its workings accommodate the way of faith of the emotional many and the path of cultured will of the few on the mental plane. To succeed both the OBONG EKPE and the neophyte must cultivate pure motives. The vehicle for reaching out to God is the heart of EKPE, the MBOKO, also called the Christ centre, the birth place of the Christ in man. EKPE has shown that God could be more quickly contacted by trumpeting the MBOKO vehicle if experienced men with clear conscience are engaged on the job. In

other words, the efficacy of the system depends on how spirited the trumpeter is. He who trumpets should be one who is christed. Fortunately, EKPE also subscribes to the way of Jesus. It is an improvement on the old system which needed to be played down while the new way is highlighted without offending EKPE and religious zealots of other faiths. EKPE provides lessons on man's spiritual growth and embraces most of the past and the future. Through comparative study with arcane wisdom teachings of Egypt, Israel and India, it was possible to identify the anomalies that had risen from non-existing records and material deprivations like essential initiation colours, music and the MBOKO SOUND. When pure motives are added the cloud within the temple is likely to thin out resulting in beneficial manifestations of the principles housed within the divinities.

The concept of divinities will disturb most Christians who have been drilled in unexplained monotheism even though the attendant confusion in their minds are evident at times. For ages men had always tried to deceive others into accepting what they know to be not absolutely correct in order to keep the knowledge of truth to themselves and those they approve. Fortunately, truth could not be denied a true seeker for all time because the spiritual teacher will make his debut at the appointed time and place to assist, and direct the seeker. For this reason, those who have already found Christ should continue to remain where they were called but others who are EKPE initiates CAN ALSO FIND Christ where they are through the application of right Aspiration, Right Attitude and Right Action.

There are a number of discomforting practices in EKPE. These were not originally part of EKPE but were introduced by man in the course of time. The incursion is not unusual considering its age and happenings in other parts of the earth. Egypt, once a cradle of civilization, teachings and activities, is unable to boast of much now because of the excesses of the past. Even the Christian Church, an organisation of the present age, has its tale of woes brought about by men, some of whom have been at the helm of affairs. Fortunately for EKPE, most of the objections rise from inadequate knowledge and the fear it projects. The other objectionable practices are already giving way to beneficial activities. Human sacrifices have long been stopped and the sacrifice of animals, black magic

and sorcery are no longer routine practices at most temples in Efik land. Hence this discussion has attempted to educate and enlighten the initiates of the need to adhere to the Christ teaching within EKPE.

There is a large body of men involved in EKPE practice. It is easier to get them to change from the nuisance occasioned by wrong practices that obstruct the initiates from realising the benefits of the system they are in love with, than attempt moving them to abandon something that had become part of their lives. The temple is where they could be easily reached and worked upon. This work can best be carried out by the initiates, who will have to engage themselves in learning, teaching, and living by example. There is need to retrain initiates and neophytes.

The wrong thoughts and practices accumulated over the centuries had become an attraction for powers of rebellion. While steps are taken to culture the thoughts in love, the initiation practices found to be faulty should be remedied. It may no longer be rewarding continuing to work with colours even if they are consistent with the colours of each divinity. Secondly, trumpeting of the MBOKO should be taken seriously. It is here that gains are likely to emerge. The pitch of the sound should be corrected and the temple music balanced through the use of strings, wind and percussion instruments; for example, the native xylophone, particularly the high-pitch ones, and high-pitch drums. All these are required to be attended by good thoughts and aspirations. When all the changes suggested are in place, the result is unlikely to be the EKPE now known.

Initiation should not be restricted to males and the physical nature. This is because the soul is sexless and the lessons of initiation are directed at the soul. Freedom of the soul from confinement of the flesh is attended by benefits that all are entitled to irrespective of sex. Christ himself had acknowledged the status of the soul after it had gained release when he said "they neither marry nor are given for marriage."[2]

For the many, Christian concept of faith is essential for reconciling man with God. It is the foundation of conscious spiritual activity. For some, faith is the natural consequence of their environment. They have for generations benefited from adjustments to their life principles. Others like Thomas the Disciple[7] who may not have benefited much from early training and exposure, do find it difficult, if not impossible, to believe and hope for things they have not seen or in general terms, what

their lower senses of touch, hearing, smell, sight and taste are unable to recognise. The concept is particularly difficult for materialists to comprehend, much less apply. The Western world is generally materialistic, and the senses and education are focused on the physical, whereas the native peoples of Africa, Asia and the America had for generations been conditioned by virgin environment and deliberate training to be balanced, and be in conscious understanding with lives including the various energies and spirits. Belief in things not seen is part of their daily activity, so also is religion irrespective of what colour is given to it. Even though Christianity was not yet, the adherents of the Mithraic religion and EKPE were encouraged to have faith, and were aware of the conflict of good and evil and the reward of virtue and punishment of wickedness in the after life. For such a people departure from this practice is at their peril. The same could not be said of most of the materialists whose religion, if at all they profess, is yet to permeate their psyche. The materialist believes in phenomena his scientific equipment are able to record. Those native people who have opted for Western education and life style to the point of seeing nothing good in their cultural, social and religious heritage, had unwittingly been transformed to materialists and in consequence have lost much of their spirit awareness. Those who have emerged to retain some limited awareness expect God to spoon feed and labour for them.

The materialists are always referring to native population in a derogatory manner. The natives are ignorant and superstitious. Should evidence be presented, they are explained off as either black magic, sorcery or hypnogenesis. Nothing good could be found amongst native peoples who are largely uneducated by Western standard. The native man already knows that for him to bring forth anything, be it by black or white magic or whatever path, he has to firmly believe in the efficacy of his method and the power of his focus. If for argument sake the procedure is suspect, is it not useful that he already knows what hope, belief and faith means, having employed them successfully in the service of his master, be it God or some other power? Hope, belief, faith and love could not be purchased from a super market, nor could they be effectively taught in a physical school without the risk of destroying the personality of the students. This is why the mystic path of ascetic discipline is not commonly recom-

mended. Hope, belief, faith and love are the fruits of dedication, patience and experience. They are spirit-sponsored. Let no one be deceived, God is no stranger to natives. What is required is re-orientation of their focus. This is perhaps a quicker way of turning them round to be useful than adopting a policy that completely destroys their experience with regards to belief, hope and faith, only to commence re-introducing to them conditioning process they had been compelled to abandon. The natives are first turned into unbelievers before it is considered expedient to work on them to believe. It is not a matter of God and the Demon, but the growth of the power of believing, hoping and having faith. Power is spirit-sponsored. Spiritual growth is externally generated and sustained for it to be internally rewarding.

Most of the early missionaries, products of Western education, were by training and exposure materialist. Although they brought the 'word' that has been of much assistance to native peoples, some of them were not spirited enough to recognise the level of awareness of those they met. Had they realised it, the returns from their investment would probably have been much higher. They would have built upon the foundation that already existed and was acceptable, rather than proceed to dismantle all they came across. The result is that there are many pretenders among those who profess to be Christians. Professor Brown supports the charge against the missionaries with the words:

> Many native American groups have learned over generations bitter experiences to preserve their sacred traditions under ground. Some of the current renewal, therefore, simply represents the current willingness of the people to give greater visibility to their sacred rites and beliefs, which have been kept hidden from a materially dominant world intent on destroying these traditions. It seems to me that we are faced today with a pervasive process, on a global scale, of detraditionalization of despiritualization. The world has been experiencing this process in a cumulative manner for many centuries.[3]

In fairness to the early missionaries they did not attempt to dismantle EKPE. In practice EKPE fraternity facilitated the work of the missionaries.

Unless some corrective actions are put in place early, it may be difficult to stem the tide of the dissatisfied souls wishing to fully return to the

old discredited heritage, a movement that is unbeneficial and unrecommended. Rather than dismiss all aspects of EKPE culture outright the modern church may take a cue from the early church and undertake an in-depth study on inculturation and acculturation of cultures and concepts to enable those who have acquired faith by whatever method and others operating from the mental plane to proceed in Christ to the next stage of spiritual activity which by EKPE teachings, will provide man with enhanced degrees of freedom, enabling him to conquer space and time. Solidity will be meaningless during the unfolding period. The way to this feat was known to the ancients but will be commonly available to the sons of God as the Fifth Round of the Earth Planetary chain is approached or as the Christ in man is fully formed.

Singing of hymns and praying have become a culture for most irrespective of faith professed. Very often a good deal of time is invested on these exercises without having much to show for the effort. Having become a habit it should not require much education to be convinced that unless those singing and praying sincerely impress their well-meaning inner thoughts on what they are engaged on, words and the attendant sounds will be empty, meaningless, powerless, and, perhaps, worthless. Employing EKPE technique for the stilling of thought, focusing on spiritual aspirations, amplifying and transferring thoughts of the congregation of God's people, it may be possible to cause Christ spirit to manifest using an improved MBOKO vehicle or trumpet. If the congregation and the trumpeter are of one mind, and are well intentioned, the Christ spirit may manifest with attendant benefits. Prayers placed after a period of silence may receive favourable response. This technique may be particularly useful during fellowship meetings, and may involve fusing of the thought forms of the mental few with the emotional many of human types. If the call is properly made and maintained long enough before entering into a period of silence, it may be realised that the soul had taken over to call in the silence of the heart. This inner call will be maintained by soul's power for some time.

This work has barely touched EKPE teachings. It serves as a curtain raiser to a subject that has had and will continue to have profound influence on a large number of people in different countries over the years, even though at the end EKPE of old may be no more.

Figure 25 OBONG NYAMPKE
(without colour correspondence)

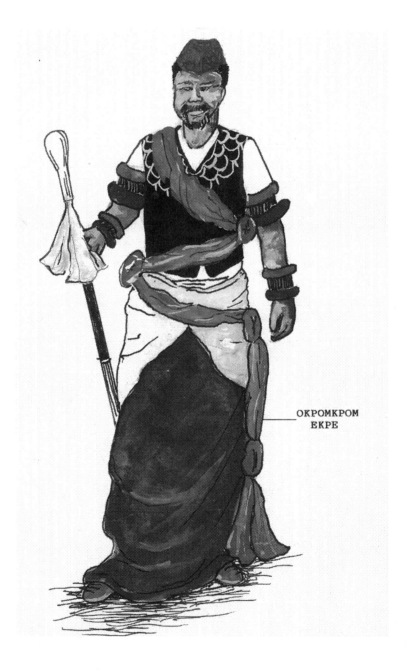

OKPOMKPOM
EKPE

Glossary

1. AYAN ISIM: Fiery spirit of NKANDA
2. Bell provides the call signal, different for each EKPE form. It symbolises music of the globe or divinity.
3. Body:
(a) Cloth cover is indicative of the body constitution of man at the time. It shows that the body was ethereal and not as coarse as it is now. The difference between body and the inner man was not easily discernable during the early days of man's existence on the visible planet, our earth.
(b) Raffia net covering is indicative of present day body constitution of man. It is physical but the physical nature will give way in time for the inner man now visible within the net to become dominant and manifest. The exposed hands and feet lead to the conclusion that they are texturally less coarse than the body consequently are useful terminals of power. The raffia net also signifies the mysterious substance that links all live usually shown in special UKARA. It is probably the ether of the occultists.
4. Colours:
(a) White symbolises purity and chastity.
(b) Black (unbroken) connotes the destroyer, darkness, evil etc.
(c) Orange symbolises endowment.
(d) Red is a symbol of danger and risk that may result in death. It connotes sacrifice, consequently service.

5. God: King of heaven and earth. EKPE concerns itself with the earth planet.

6. Drum, depending on type and usage, may be world consciousness, the world, generator of energy or a transmitter and amplifier.

7. Egyptian gods/EKPE Divinities.

8. Esoterics: relates to knowledge restricted to a small group of Monotheists or Pantheists, and released only through initiation.

9. Evolution in EKPE is a process of ordered change in the spiritual, mental, emotional and physical constitution of man on its own path of growth, distinct and separate from Darwin Theory.

10. Exoteric: relates to commonly available knowledge.

11. Feathers on the hat symbolises purity.

12. Feathers on the forehead indicate higher perceptive powers.

13. Feather in the mouth means silence in golden. It may also mean disembodied soul.

14. Hat at the back of the head, also known as the wing, indicates ability to transcend time and space. It also connotes power.

15. Helmet is the link with the eternal source of life. Its solidity and verticality are indications of the degree of spirituality. It may be called the helmet of salvation.

16. IDEM: Masquerade.

17. Initiation: An expansion of consciousness leading to a growing recognition of inner realities.

18. ITIAT EKPE: EKPE stone.

19. Macrocosm is the all embracing life, the universe.

20. Microcosm is a particular life e.g. man; the earth.

21. MBOBOH or waist band or girdle is the Ankh, the sign of life, the living and the covenant. The Ankh is the most sacred cross of Egypt that was carried in the hands of gods, the pharaohs, and the dummied dead.

22. NYANYA (mane) circling the EKPE (IDEM) is indicative of man coming into manifestation. It also represents a breast plate worn by warriors. Those on the Christ path are warriors.

23. Plume and fresh leaves usually held in the hand are banishing and cleansing agents, or door openers.

24. Rod on EKPE special drum signifies the descent of light into matter.

25. Staff or whip is a symbol of authority.

26. UKARA, is the secret EKPE cloth bearing NSIBIDI discreetly differentiated. Each EKPE House has one relevant to it. There are also specials, some of which are to be hung in EKPE Hall.

Appendix 1

Special UKARA

There is an 'UKARA,' EKPE secret cloth for each divinity. The one shown is special both in size and content. The more common types serve as loin cloth for initiates. An abridged interpretation of the hieroglyphs of the special UKARA is as follows:

The Lord of the Third Round of the Earth Planetary Chain issued the order – "Matter continue to differentiate" and in obedience the elements, water and earth came to be towards the end of that round. During this period the sign of the heavenly man appeared.

All these were formless, consequently relatively spiritual. The end of the Third Round and the beginning of the Fourth Round were sealed by the 7 x 3 wheel that forced a change in state to commence during the Fourth Round. As light continued its descent into matter, the androgyne (bisexual man) came to be but latter separation into sexes occurred and man manifested in form, so also the other creations. Separation into sexes introduced a seducer who caused the man and his wife to eat at the centre of the temple, in other words introduced them to the secret of securing their heart desires. When the rod (trumpet) is activated discriminatingly in a temple of the Fourth Revolution the bench marks of the five divinities may be revealed. After the 3 1/2 Revolutions of the present Earth, man's spirituality commences its ascent and there is loss of his physical nature. The man begins to experience the rising of the fire from the base of the spine towards the brain as proof of him being on the way to be-

coming an Adept. During the last lap of the Fourth Round much of the lion in him is under control and his spirituality is ascending to the level of the Third Round after which he is in control of his inner focus. He is an adept having found the WORD.

Figure 24 Special UKARA

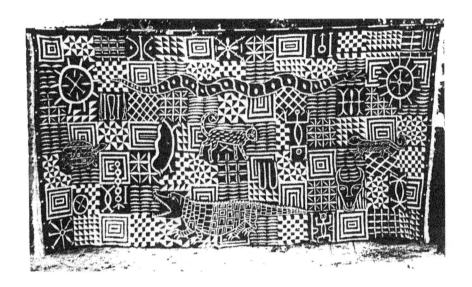

Notes

Chapter 1

1. Alice A. Bailey. Externalisation of the Hierachy. London, 1982, p. 32
2. M.U. Offiong. Ancestral Cult of the Efik and Veneration of the Saints. Rome, 1993, p. 97
3. E. Bolaji Idowu. African Traditional Religion. London, 1977, pp. 26-27
4. Ibid. pp. 97-98

Chapter Two

1. Holy Bible. Colossians 1:15
2. Jay E. Greene. 100 Great Thinkers. Vol. I, Aylesbury, Bucks, England, Heron Books. Hazell Watson and Viney Ltd., 1967, p. 50
3. Holy Bible Romans. 12:1-2
4. Ibid. Mathew. 22:37-39
5. Max Heindel. The Rosicrucian Cosmo Conception. Oceanside, California, Rosicrucian Fellowship, 1977, p. 478
6. Ibid. p. 407
7. H.P. Blavatsky. Isis Unveiled. Vol. II, California, Theosophical University Press, 1976, pp. 42-138
8. E.A. Wallis Budge. Egyptian Book of the Dead. New York, Dover Publications, 1967, pp. ix-xi

Chapter 3

1. H.P. Blavatsky. Isis Unveiled. Vol. II, California, Theosophical University Press, 1976, pp. 99-101

2. P. Amaury Talbot. In the Shadow of the Bush. London, 1912, pp. 9-10

3. D.M. Mcfarlan. Calabar. London, Thomas Nelson and Sons, 1957, p. 9

4. P. Amaury Talbot. In the Shadow... p. 9-10

5. E.O. Akak. Efiks of Old Calabar. Vol. 3, Calabar, Akak and Sons, 1982, p. 288

6. Ekei E. Oku. The Kings and Chiefs of Old Calabar (1785 – 1925). Calabar, APPELAC, 1989, pp. 65-66

7. E.O. Akak. Efiks of Old Calabar. Vol. 3, p. 288

8. P. Amaury Talbot. In the Shadow... pp. 41-42

9. H.P. Blavatsky. Isis Unveiled. Vol. I, Pasadena, California, Theosophical University Press, 1976, p. 545

10. J.J. Williams. Hebrewism in West Africa. New York, Biblo and Tannen, pp. 103, 104, 320, 322

11. Werner Keller. The Bible History. London, Bantam Books, 1982, pp. 134, 142

12. Ibid. p. 14

13. Jay E. Greene. 100 Great Thinkers. Vol. I, Aylesbury, England, Heron Books, 1967, p. 15

14. Holy Bible. Acts 7:22

15. E.A. Wallis Budge. Egyptian Book of the Dead. New York, Dover Publications, 1967, pp. XCII-XCIII

16. Alice A. Bailey. From Bethlehem to Calvary. London, Lucis Press, 1981, pp. 181-183

17. Israel Regardie. The Golden Dawn. Vol. I, Saint Paul, Minnesota, Llewellyn Publications, 1978, p. 169

18. B.F. Thompson. Flash of the Spirit. New York, Random House Inc., 1983, p. 241

Chapter 4

1. E. Bolaji Idowu. African Traditional Religion. London, S.M.C. Press Ltd., 1977

2. F.A. Opoku. West African Traditional Religion. Accra, FEP International Private Ltd., 1977

3. H.P. Blavatsky. Isis Unveiled. Vol 1, Pasadena, California, Theosophical University Press, (1976), p. xxx

4. Holy Bible. Samuel 25:16

5. Ekei E. Oku. The Kings and Chiefs of Old Calabar (1785 – 1925). Calabar APPELAC, 1989, p. 78

6. Ibid. p. 83

7. Monday E. Noah. Old Calabar. Uyo Scholars Press (Nig) Ltd., 1980, p. 71

8. H.P. Blavatsky. Isis Unveiled. p. xxx

9. Ibid. p. 284

10. Ibid

11. E.C. Prophet. St. Germain on Prophesy. Malibu, Summit University Press, Bk. III, Chapter 1., pp. 3-5

12. H.P. Blavatsky. Isis Unveiled p. 326

13. Ibid

14. Ibid. p. 343

15. E.C. Prophet. St. Germain on Prophesy. pp. 22-23

16. H.P. Blavatsky. Isis Unveiled. p. 325

17. Ibid

18. Fr. M.U. Offiong. Ancestral Cult of the Efik and Veneration of the Saints. Rome, N. Dominici – Pencheux, 1993, p. 33

19. E.C. Prophet. St. Germain in Prophesy. pp. 4; 17-18

20. Ibid. p. 24

21. Z.S. Halevi. Adam and the Kabalistic Tree. (1974), p. 39

22. Alexander Horne. King Solomon's Temple in Masonic Tradition. UK, Aquarian Press Ltd., 1979, pp. 29-32

23. E.A. Wallis Budge. Egyptian Book of the Dead. New York, Dover

Publications, 1967, p.L

24. A.K. Hart. Report of the Enquiry into Dispute over the Obonship of Calabar. Enugu, Government Printer, 1964

25. H.P. Blavatsky. Isis Unveiled. p. 519

26. Ibid. p. 133

27. H.P. Blavatsky. Secret Doctrine. Vol. II., Adelphi, London, Theosophical Publishing Co., Ltd., 1977, p. 114

28. Holy Bible. Judge 4:4

29. Holy Bible. 2 Kings 22:14

30. H.P. Blavatsky. Secret Doctrine. p. 88

31. E.C. Prophet. Saint Germain Bk. III. 1980, p. 27

Chapter 5

1. A.I. Hart. "Report of Enquiry into the Dispute over the Obonship of Calabar." Enugu Government Printer, Enugu, Nigerian, 1964, p. 48

2. Max Heindel. Rosicrucian Cosmo Conception. Oceanside, California Rosicrucian Fellowship, 1977, p. 414

3. H.P. Blavatsky. Secret Doctrine Vol. 1, 1977, pp. 152-201

4. Ibid. Vol II, p. 370

5. Alice A. Bailey. From Bethlehem to Calvary. London, Lucis Press 1981, p. 27

6. Holy Bible. Romans 5:3-4

7. Alice A. Bailey. Initiation Human and Solar. London, Lucis Press, London, 1992, pp. 126-141

Chapter 6

1. E.P. Preston and C. Humphreys. An Abridgement of the Secret Doctrine by H.P. Blavatsky. Wheaton, USA, Theosophical Publishing House, 1969, p. 86

2. Alexander Horne. King Solomon's Temple in Masonic Tradition. Wellingborough, U.K., Aquarian Press Ltd., 1979, p. 21

3. Israel Regardie. The Tree of Life. Wellingborough, U.K., Aquarian Press Ltd., 1980, p. 225

4. E.C. Prophet. Saint Germain on Prophesy. Bk. III, Malibu, California, Summit University Press 1980, p. 10. See also Holy Bible. Mathew 2:43-44

5. Israel Regardie. The Tree of Life. p. 2

6. Israel Regardie. Foundations of Magic. Wellingborough, U.K., Aquarian Press Ltd., 1979, pp. 43-46

7. Israel Regardie. The Tree of Life. p. 226.

8. O.O. Mensah. "Ekpe and Efik Society in Traditional and Christian Context." Research Paper, University of Calabar, Calabar, 1994, p. 37

Chapter 7

1. Z.S. Halevi. Adam and the Kabalistic Tree. 1974, p. 279

2. Alice A. Bailey. Esoteric Psychology. Vol. I, London, Lucis Press, 1984, p. 124

3. Ibid. p. 140

4. Holy Bible. Numbers 10:5-7

5. Holy Bible. Numbers 10:1-10

6. Max Heindel. Rosicrucian Cosmo Conception. Oceanside, California, Rosicrucian Fellowship, 1977, p. 123

7. Ibid. p. 124

8. H.P. Blavatsky. Isis Unveiled. Vol. 1, Palisade, California, Theosophical University Press, 1976, pp. 544-545

9. Holy Bible. 1 Samuel 16:23

10. Donald E. Michael. Music Therapy. Springfield, Illinois, Charles C. Thomas, 1976, p. 11

11. Holy Bible. 1 Samuel 9:6-13

12. Ibid. Daniel 8:16-26

13. Ibid. 6:16-24

14. Holy Bible. Genesis 1:28

15. Alice A. Bailey. Initiation Human and Solar. Lucis Press, 1992, pp.

126-141

Chapter 8

1. Holy Bible. Galatians 4:19
2. E. Bolaji Idowu. African Traditional Religion. London, S.M.C. Press Ltd, 1977, pp. 189-195
3. Dion Fortune. Applied Magic. Wellingborough, England, The Aquarian Press, 1981, pp. 2-5
4. Ibid
5. Zolar. New York, Aico Publishing Inc., 1980, p. 90
6. E. Bolagi Idowu. African Traditional Religion. p. 192
7. Holy bible. John 9:16-17
8. Ibid. Luke 5:17
9. Ibid. Acts 14:9
10. Ibid. Daniel 5:11
11. Dion Fortune. Applied Magic. pp. 50-53
12. E. Bolagi Idowu. African Traditional Religion. p. 194
13. H.P. Blavatsky. Secret Doctrine Vol. II. Adelphine, London, Theosophical Publishing Co. Ltd., 1977, pp. 43-44
14. Dion Fortune. Applied Magic. Aquarian Press, p. 29
15. Holy Bible. 2Samuel 6:16
16. Ibid. Ezekiel 8
17. M.U. Offiong. The Ancestral Cult of the Efik and Veneration of the Saints. Rome, Domenici – Peucheux, 1992, pp. 97-98
18. Holy Bible. John 3:30
19. Z.S. Halevi. Adam and the Kalabistic Tree. 1974, pp. 97-98
20. Alice A. Bailey. Externalisation of the Hierarchy. London, Lucis Press, 1982, pp. 28-29
21. Ibid
22. Ibid
23. Ibid
24. Holy Bible. Mathew 22:31

25. Alice A. Bailey. Externalisation of the Hierarchy. p. 32

26. Monday E. Noah. Old Calabar. Uyo, Scholars Press (Nig) Ltd., 1980, p. 40

27. Ibid. p. 41

28. E.A. Wallis Budge. Egyptian Book of the Dead. New York, Dover Publications, 1967, pp. xcii-xciii

29. Monday E. Noah. Old Calabar. p. 41

30. Holy Bible. Colossians 2:9

31. Ibid. 1Peter 4:2-3

32. Alice A. Bailey. From Bethlehem to Calvary. London, Lucis Press, 1981, p. 9

33. Holy Bible. Isaiah 7:14. Jeremiah 23:5-6

34. Alice A. Bailey. Initiation Human and Solar. London, Lucis Press, 1992, p. 2

35. Holy Bible. Mathew 5:17

36. New Lexicon. Webster's Dictionary of English Language. New York, New Lexicon Publications, 1988

Chapter 9

1. Holy Bible. Mark 4:11

2. Ibid. Mark 4:12

3. Ibid. Mathew 7:6

4. Ibid. Genesis 3:24

5. H.P. Blavatsky. Secret Doctrine. Vol: II, London, theosophical Publishing Co. Ltd., p. 374

6. Holy Bible. Leviticus 16:20-22

7. E.A. Adegbola. Traditional African Religion. Ibadan, Daystar press, Ibadan, 1983, p. 6

8. Holy Bible. Judges 112:34-39

9. Ibid. 17:7-11

10. Holy Bible. 1Samuel 15:22

11. Ibid. Jeremiah 7:21-24

12. H.P. Blavatsky. Isis Unveiled. Vol. II, Pasadena, California, Theosophical University Press, California, 1976, p. 42

13. Holy Bible. Deuteronomy 4:16-18

Chapter 11

1. P. Amaury Talbot. In the Shadow of the Bush. London, 1912

2. Holy Bible. Mathew 22:30

3. Joseph R. Brown. The Spiritual Legacy of the American Indian. New York, Cross Road Publishing Co., 1993, p. 48

Select Bibliography

Adegbola, E.A. – (1983) Traditional African Religion. Daystar Press, Abandon, Nigeria.

Akak, E.O. – (1982) Efiks of Old Calabar. Vol. 3, "Culture; and Superstition"; Akak and Sons – ditto Vol. 4 (1983).

Bailey, Alice A. – (1981) From Bethlehem to Calvary. Lucis Press Ltd., London.

– (1982) Externalisation of Hierarchy. London, Lucis Press Ltd., London.

– (1984) Esoteric Psychology. Vol. I, Lucis Press, London

– (1992) Initiation Human and Solar. Lucis Press, London

Bhaktivedanta Swam Prabhupade, A.C. – Sriman Bhagavatam Book Trust, 1446 Looban Street; Paco Metrol Manilla, Philippines

Blavatsky, H.P. – (1976) Isis Unveiled. Vols. I & II, Theosophical University Press, Pasadena, California.

– (1977) Secret Doctrine. Vols. I & II, Theosophical Publishing Co., Ltd., 7, Duke Street, Adelphi; W.C.

– (1968) Secret Doctrine. Edited by Elizabeth Preston and Christmas Humphreys; Theosophical Publishing House, Wheaton, Illinois, U.S.A.

Brown, Joseph E. – (1993) The Spiritual Legacy of the American Indian. The Cross Road Publishing Co., 370, Lexington Avenue, New York, N.Y. 10017.

Encyclopeadia, New Standard. Vol. 9, Standard Educational Corp., Chicago, U.S.A.

Fortune, Dion – (1981) Applied Magic. The Aquarian Press, Welling Borough, Northamptonshire, England.

Greene, Jay E. – (1967) 100 Great Thinkers. Vol I, Heron Books, Hazell Watson & Viney Ltd., Aylesbury, Bucks, England.

Halevi, Zevben Shimon – (1974) Adam and the Kabalistic Tree.

Hart, A.K. – (1964) Report of the Enquiry into the Dispute over the OBONSHIP of Calabar. Government Printer, Enugu, Nigeria.

Heindel, Max – (1977) The Rosicrucian Cosmo Conception. Rosicrucian Fellowship, Oceanside, California.

Holy Bible – R.S.V. and Good News Editions.

Horne, Alexander – (1979) King Solomon's Temple in Masonic Tradition. Aquarian Press Ltd., Welling Borough, U.K.

Idowu, Bolaje E. – African Traditional Religion. S.M.C. Press Ltd., London.

Incognito, Magnus – (1990) The Secret Doctrine of the Rosicrucians. Occult Press, Chicago, U.S.A.

Keller, Werner – (1982) The Bible History. Bantam Books, London.

Manhar, Nurho De – (1985) Zohar. Wizards Bookshelf, San Diego, U.S.A.

Mcfarlan, D.M. – (1957) Calabar. Thomas Nelson & Sons Ltd., London.

Mensah, O.O. – (1994) Eke & Efik Society in Traditional and Christian Context. University of Calabar, Research Paper.

Michel, Donald E. – (1976) Music Therapy. Charles C. Thomas, Springfield, Illinois, U.S.A.

Montgomery, J. – (1988) Methodist Hymn Book No. 533. Methodist Church Nigeria, Lagos.

Noah, Monday E.– (1980) Old Calabar. Scholars Press (Nig) Ltd., 16, Utang Street, Uyo, Nigeria.

New Lexicon – (1988) Webster's Dictionary of English Language. Lexicon Publications Inc., New York, U.S.A.

Offiong, K.U.– (1993) The Ancestral Cult of the Efik and The Veneration

of the Saints. N. Domenici – Pecheux, Via C. Teia 29-D-Roma 00157.

Oku, E.E. – (1989) Kings and Chiefs of Old Calabar (1785-1925). APPELAC, Calabar.

Preston, E.P. And Humphreys, C. – (1969) An Abridgement of the Secret Doctrine by H.P. Blavatsky. The Theosophical Publishing House, Wheaton, Illinois, U.S.A.

Prophet, E.C. – (1986) Saint Germain on Prophesy. Summit University Press, Malibu, California, U.S.A.

Opoku, K.A. – (1978) West African Traditional Religion. F.E.P. International Private Ltd., Accra, Ghana.

Prophet, M.L. & E.C. – The Creation of the Cloud. Summit University Press, Malibu, California, U.S.A.

Regardie, Israel – (1978) The Golden Dawn. Vol. I, Llewellyn Publications, Saint Paul, Minnesota, U.S.A.

Regardie, Israel – (1980) The Tree of Life. Aquarian Press Ltd., Welling Borough, U.K.

Sinnet, A.P. – Esoteric Buddhism. Theosophical University Press, Pasadena, California.

Talbot, P. Amaury –(1912) In the Shadow of the Bush. London.

Unoh, S.O. – (1986) Cultural Development and Nation Building. Sectrum Press Ltd., Abandon, Nigeria.

Wallis Budge, E.A. – (1967) Egyptian Book of the Dead. Dover Publications, Inc., New York.

Williams, J.J. –Hebrewisms in West Africa. Biblo and Tannen, New York

Zlar – (1980) Acro Publishing Inc., New York.

Printed in the United States
By Bookmasters